# The Arts 5-16

*Practice and Innovation*

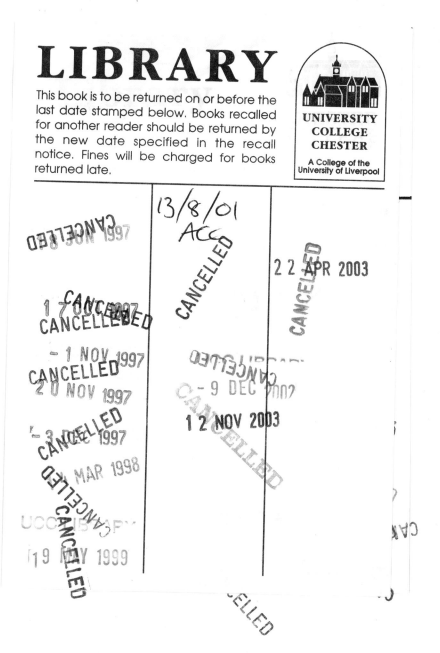

The Arts in Schools project was launched by the School Curriculum Development Committee in September 1985 and completed under the auspices of the National Curriculum Council in August 1989.

**The central project team**

*Director*
Dr Ken Robinson

*Project Officers*
Gillian Wills (1985-86)
Dave Allen (1985-88)
Jill Henderson (1986-89)
Phil Everitt (1988-89)

*Information Officer*
Mike Cahill (1986-89)

*Administrator*
Andrew Worsdale

The project team has produced three major publications in this series.

**The Arts 5-16: A Curriculum Framework**
Oliver & Boyd 1990          0 05 004579 2

**The Arts 5-16: Practice and Innovation**
Oliver & Boyd 1990          0 05 004580 6

**The Arts 5-16: A Workpack for Teachers**
Oliver & Boyd 1990          0 05 004581 4

**Slide Sets**                   0 05 004587 3

# The Arts 5-16

## *Practice and Innovation*

The Arts in Schools project team

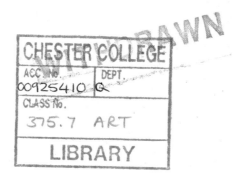
Oliver & Boyd

ISBN  0 05 004580 6

First published in 1990
by Oliver & Boyd
Longman Group plc
Longman House
Burnt Mill
Harlow
Essex CM20 2JE

Typeset by Presentation Solutions, Harrogate
in New Baskerville ITC (Linotron 300)
Printed in Great Britain by
Longman Resources Unit
62 Hallfield Road
Layerthorpe
York YO3 7XQ

Copyright © 1990
SCDC Publications

National Curriculum Council
15-17 New Street
York YO1 2RA

**Photo acknowledgements**

We are grateful to the following for permission to reproduce photographs:

Phillip Polglaze, pages 9, 18, 23, 24, 31, 34 (left), 47, 71, 73, 119, 121; Chris Davies, page 10; John Morton, pages 11, 21, 34 (right), 39, 57, 58; David Howe, page 20 (bottom); Margaret Phillips, page 29; Joyce Mallon, page 42; Tony Murray, pages 43, 173; Jan Rule, pages 44, 64 (bottom); Phil Everitt, pages 51, 125, 174; Michael Evans, page 54; Jackie Binns, page 61 (top); Alan Benson, page 61 (bottom); Rod Taylor, pages 64 (top), 158; Sandie Pare, page 65; Ed Barber, page 68; Syndication International (OYEZ Stationery Group), page 77; David Menday, page 83 (top); Mik Ayre, LMPA and Laing Art Gallery, page 83 (bottom); Colin Humphreys, page 89; Jill Heller, pages 95, 96, 115; Hannah Lee, page 128; Steve Herne, page 129; Frankie Tracey, page 132; Sue Taylor, page 135; Jane Tarr, page 144 (top); Richard Penton, pages 150 (top left, bottom left and right); Robert Cheesmond, page 150 (top right); Dave Allen, page 160; Keith Thomson, page 164; John Towson, page 167; Pauline Burbidge (quilt-maker), Sholeh Farnsworth (photographer), the Crafts Council, page 183.

We apologise for the fact that although every effort has been made to trace the copyright holders of the photos on pages 20 (top), 99, 141, 144 (bottom) and 152 this has not proved possible.

*Front and back covers*
We are grateful to Frankie Tracey for permission to reproduce the top photo on the front cover, and to Phil Everitt for all the other cover photos.

# Contents

# Acknowledgements

The Arts in Schools project involved extensive and intensive collaborations over four years between teachers, advisers, artists, pupils and administrators at all levels in the arts and in education. The project also involved partnerships with the Arts Council of Great Britain, the Crafts Council, National Foundation for Educational Research, the Calouste Gulbenkian Foundation and the regional arts associations with responsibility for each of the local areas involved. We have drawn deeply on the ideas and enthusiasms of all of these in developing these publications. We want to express particular thanks to the project co-ordinators in the eighteen partner local education authorities and to the teachers in the principal development groups; to the full-time support staff of the School Curriculum Development Committee and the National Curriculum Council, and to the project's national monitoring group. We list individuals' names in the Appendix.

Ken Robinson
*Director*

# Preface

This publication is one of the results of the Arts in Schools project, a major curriculum initiative launched by the School Curriculum Development Committee in September 1985 and completed under the auspices of the National Curriculum Council in August 1989. The aim of the project was to give practical support to primary and secondary schools in improving provision for the arts in the education of all children and young people. The project was concerned with all of the arts — including music, dance, drama, visual and verbal arts — and with the whole compulsory school age range from 5 to 16.

The project was stimulated by the response to the report of the national inquiry *The Arts in Schools: Principles, Practice and Provision* (Calouste Gulbenkian Foundation 1982). It was organised as a partnership with eighteen local education authorities (LEAs) and involved sustained work with over two hundred primary and secondary schools, their headteachers, teachers from all arts disciplines, LEA advisers and institutions of higher education. The project enjoyed close co-operation with the regional arts associations, professional arts associations, the Arts Council of Great Britain, the Crafts Council, and the National Foundation for Educational Research.

Through practical work in schools the project considered six main themes:

- the arts and the whole curriculum
- the content of arts teaching
- progression and continuity
- assessment and evaluation
- special educational needs
- the school and the community

Drawing on its extensive work in schools, the project has developed the following three main publications.

### The Arts 5-16: A Curriculum Framework

Given the many pressures on time and resources, and the wide range of arts disciplines to consider, schools have repeatedly called for advice on the sorts of arts provision they might offer. This publication discusses the central issues for curriculum planning and assessment and offers a general framework of ideas for schools to consider in developing their own arts policies.

### The Arts 5-16: Practice and Innovation

The teachers taking part in the project documented more than three hundred initiatives to enhance provision for the arts in the curriculum. This publication draws from this rich reservoir of experience to discuss and illustrate approaches to a range of practical issues from curriculum planning to improving continuity and meeting special educational needs. Each chapter summarises major issues, reviews relevant practical work, identifies the lessons of the project and offers practical guidelines for future development in teachers' own schools.

### The Arts 5-16: A Workpack for Teachers

Curriculum development involves staff development. This workpack offers ideas, resources and suggestions for organising in-service workshops with staff in primary and secondary schools and for use in

initial training courses. The workpack helps teachers to tackle issues raised in the project's other publications and to relate them to the development of a coherent arts policy for their own school. The pack is designed to meet a wide range of INSET needs including use by cross-phase LEA groups and by teachers from individual primary and secondary schools.

The publications of the Arts in Schools project are directed at all of those who shape and implement education in schools: teachers, headteachers, school governors, parents, teacher trainers, educational advisers, administrators and policy makers.

The project team began its work in September 1985. The Education Reform Act became law in August 1988, introducing the new vocabulary and expectations of the National Curriculum. In shaping these publications we have aimed to take account of this new context and to suggest ways in which schools can develop provision for the arts within and through the new statutory framework.

# INTRODUCTION

What practical steps can primary and secondary schools take to improve teaching and learning in the arts? Every school is required to make and keep up to date a written statement about its curriculum. This statement should describe the aims and range of the curriculum and the balance between its different components, including provision for the arts. The National Curriculum provides a statutory framework for planning, but schools continue to have scope to develop provision in their own ways within and around this. As HMI comments:

> Each school as it seeks to develop its curriculum (which in future will include satisfying the requirements of the National Curriculum) needs to draw on agreed aims and purposes defined in terms of more specific objectives through consideration of the contributions of areas of learning and experience, subjects (or other forms of curricular organisation) and cross-curricular themes, each associated with elements of learning.

(DES 1988a)

In our related publication *The Arts 5-16: A Curriculum Framework,* we have looked in detail at the principles and ideas that should underpin a school's arts provision. Our concern in this book is how schools can tackle the practical issues of making such provision.

During its three-year development programme, the Arts in Schools project explored six main themes:

1. *The arts and the whole curriculum*
How should the arts fit into overall school policies? Should all children work in all of the arts? If not, on what basis should choices be made? What relationships should be encouraged between the arts and other disciplines?

2. *The content of arts teaching*
What should be included in arts courses? What are the relationships between critical studies, personal expressive work and the learning of skills? How should arts teachers respond to the changing cultural context of education?

3. *Progression and continuity*
Do children and young people follow identifiable patterns of development in the arts? If so, what are the practical implications for curriculum co-ordination between primary and secondary schools? How can continuity within and between schools be improved?

4. *Assessment and evaluation*
By what criteria should children's progress be judged? What forms

and methods of assessment are most suitable for describing attainment in the arts?

5. *Special educational needs*
What are the roles of the arts in meeting special educational needs? How can the arts enhance work in special schools and how can experts in meeting special needs advise and support arts teachers in ordinary schools?

6. *The school and the community*
How can the local and national arts communities be used to enrich the teaching of the arts? How can the arts enhance schools' own roles in forging closer links with the communities they serve?

In discussing these and other issues, this book draws on detailed accounts of work in over two hundred primary and secondary schools. This work was based on three assumptions about effective curriculum development:

- it should take account of local needs, circumstances and resources;
- it needs the active support of headteachers and other key staff;
- it needs a climate of support beyond the school.

There is a difference between curriculum *enrichment* and curriculum *development*. It is relatively easy to arrange a novel scheme that lends a temporary vitality to routine work. The more difficult task is to find ways of bringing about longer-term change and development in schools. This book illustrates a wide variety of attempts to do just that.

In Chapter One we outline the conceptual framework for developing the arts in schools which emerged during the work of the project. This includes various terms and ideas which are used throughout in discussing the practical examples. The framework, which is only summarised here, is presented in detail in *The Arts 5-16: A Curriculum Framework*. Chapter Two discusses the roles of the teacher in the arts and the need to achieve a balance between practical work and critical understanding, a central principle of the framework.

Chapter Three discusses the roles of the arts in the curriculum of the primary school. We distinguish between the teaching of the arts in their own right and the use of the arts in theme- and topic-based work across the curriculum. Chapter Four looks at the arts in the secondary school curriculum, including issues in combined arts teaching and the roles of the arts in teaching cross-curricular themes.

In Chapter Five we look at issues of assessment. What sort of progress do pupils make in the arts? How can this be described and reported? Chapter Six relates all of these issues to the need to achieve greater curriculum continuity and coherence between and within primary and secondary schools. Chapter Seven describes the roles of the arts in providing a differentiated curriculum for pupils with special educational needs.

Chapter Eight looks at the various contributions that professional artists can make to the arts in the curriculum. Chapter Nine describes how work in the arts can enable schools to develop closer links with the communities they serve. Chapter Ten draws together the central themes of the book in a series of practical guidelines for schools wanting to review and revise their own provision for the arts in the curriculum.

The work represented in this book illustrates three features of the national context of arts education:

- the recognition in many schools of the fundamental importance of the arts in contributing to a broad, balanced and relevant curriculum which addresses the wide variety of young people's aptitudes and abilities;
- the growing recognition of the common ground between teachers of different arts disciplines and the benefits of co-operation in curriculum planning and provision;
- the increasing rapport between education and the professional arts communities.

This book does not offer a blueprint for change. Schools need to adapt general principles to their own circumstances and resources. What works in one school may not in another. A successful approach with one group may disaffect the next. As in all education, the need is for sensitive adaptation of ideas to different circumstances. Consequently, this is not exclusively a book of 'good practice'. It includes accounts of difficulties and mistakes as well as of success and inspiration. Most chapters end with a number of questions and action points for schools to consider in reviewing and developing their own work.

In *The Arts 5-16: A Curriculum Framework* we offer a set of ideas and terminology as a basis for coherent planning and provision for the arts in schools. The framework addresses eight main questions.

1. What are the arts?
2. What is distinctive about the arts?
3. What are the differences between the arts disciplines?
4. What are the general roles of the arts in education?
5. What are the roles of the different arts disciplines in education?
6. What range of arts provision is necessary in the school curriculum?
7. What should be included in arts courses?
8. How can pupils' progress and attainment in the arts be assessed?

In this book and in *The Arts 5–16: A Workpack for Teachers,* we aim to provide schools and teachers with practical advice to tackle issues of curriculum development and to turn ideas and principles into daily practice.

# THE ARTS 5-16: A CURRICULUM FRAMEWORK

## INTRODUCTION

In this chapter we introduce a general framework and terminology for supporting curriculum planning, teaching and assessment in the arts. The ideas summarised here are applied and developed throughout this book and are presented in detail in the project's related publication, *The Arts 5-16: A Curriculum Framework.*

## WHAT ARE THE ARTS?

Outside schools the need to define the arts may seldom arise. Inside schools, where the curriculum has to be planned and agreed, definition of the arts and of their roles in education is essential. Defining the arts is difficult and controversial. Conceptions of the arts have varied through history and in different cultures. In Western/European cultures the arts are usually taken to include music, drama, dance, visual arts and verbal arts. However, many cultures do not distinguish between art forms in these ways. A good deal of work in Western/European arts also challenges these distinctions, including the new forms of artistic practice which have been stimulated by technological developments in film, video, photography, and electronic instruments, computers and so on. In trying to describe the arts we need to go beyond the art form categories of individual cultures to try to identify the basic characteristics of arts activities in general.

The practice of the arts, in whatever form, involves the creation of objects or events that express and represent ideas and perceptions. The arts emerge from the fundamental human capacity for making sense of experience by representing it in symbolic form. In these terms, the arts are *modes of understanding*. Human experience is of many kinds of qualities and we use a wide variety of ways to make sense if it. Verbal language enables us to formulate some ideas but not others. There are thoughts for which there are literally no words. For these we may use other modes of understanding, such as visual imagery. The painter is not creating pictures of ideas that would be better expressed in words. He or she is formulating visual ideas using an essentially visual mode of understanding. The many different

cultural forms of the arts emerge from the following elemental modes of understanding:

- the visual mode — using light, colour and images
- the aural mode — using sounds and rhythm
- the kinaesthetic mode — using bodily movement
- the verbal mode — using spoken or written words
- the enactive mode — using imagined roles

Arts education in schools should provide all pupils with opportunities to work in all of these modes of understanding. This is important in itself, within the accepted aims of education, and also because the arts make an essential contribution to *cultural education.*

## THE ARTS AND CULTURAL EDUCATION

The term 'culture' is sometimes used specifically to mean the arts. Increasingly it is used to mean a society's whole way of life including its political and economic structures, its patterns of work and social relations, its religious beliefs, philosophies and values. Each of these various aspects of the social culture interacts with the others to give different societies and cultural groups their distinctive character and dynamic. The arts are not a separate domain of cultural life. The forms they take and the ideas and perceptions they express are woven deeply into the fabric of social culture, stimulating and interacting with developments in all areas of social life. Consequently an effective and coherent programme of arts education is an essential part of *cultural education,* that is, one which:

- helps young people to recognise and analyse their own cultural values and assumptions;
- brings them into contact with the attitudes, values and institutions of other cultures;
- enables them to relate contemporary values to the historical forces that moulded them;
- alerts them to the evolutionary nature of culture and the potential for change.

Within this general conception of cultural education, the arts fulfil the following specific roles in the education of all pupils.

**Intellectual development**
Through experience in different modes of understanding, arts education enables young people to develop the wide range of their intellectual capabilities and to make sense of the different qualities of their experience.

**Aesthetic development**
Arts education is concerned with deepening young people's sensitivities to the formal qualities — and therefore the pleasures and meanings — of the arts and with extending the range of their aesthetic experience and judgement.

**The education of feeling**
Work in the arts contributes to the education of feeling by giving a positive place to personal feelings in school and by providing ways of exploring and giving them form.

**The exploration of values**
The arts offer direct ways of raising questions of value — personal, moral and aesthetic — and of exploring the ideas and perceptions to which they relate.

**Personal and social education**

The experience of success in achievement and of enjoyment in learning and working with others which the arts promote can raise immeasurably the self-esteem and social confidence of young people.

**Practical and perceptual skills**

Work in the arts requires and leads to the development of a wide range of practical and perceptual skills with a wide application and value.

To make these contributions, provision for the arts has to be coherent and balanced. In making this provision it is useful to distinguish between learning *in* and learning *through* the arts.

## LEARNING IN AND THROUGH THE ARTS

In describing the roles of the arts in the curriculum, a distinction can be made between learning *in* and learning *through* the arts. Although they emerge from innate capacities, mature achievement and understanding in any of the arts call for increasingly sophisticated skills and knowledge. The distinctive roles of arts education are to deepen young people's knowledge of and competence in the arts themselves:

- to develop the concepts and skills which will enable young people to use the processes of the arts;
- to widen their knowledge and understanding of the arts;
- to develop their critical sensibilities.

The working processes of the arts have many applications within teaching and learning in all parts of the curriculum. They bring to life themes, issues and events in history, in social studies, science and personal and social education, and in the teaching of humanities. In learning *through* the arts, the prime focus is likely to be on the theme or subject matter, or on personal and social education; in learning *in* the arts, on the aesthetic or technical qualities of the work. These are complementary roles — in principle, at least. In practice, successful use of the arts in other areas of the curriculum depends on the teachers' and pupils' levels of expertise in the arts: learning *through* requires learning *in* the arts. This balance is not always struck in schools.

## THE NEED FOR BALANCE

Provision for the arts in schools is unbalanced in various ways. In the topic-based curriculum of the primary school, teachers tend to emphasise the value of learning *through* the arts and spend too little time on learning *in* them. As a result they can miss opportunities to develop positive attitudes and necessary skills in the arts. The result can be underachievement in the arts and in the topics they are used to explore. Secondary schools tend to emphasise learning *in* the arts and miss equally important opportunities to use the arts to enrich the curriculum as a whole.

In schools where the arts are making a full contribution to young people's education, provision is based on three principles of balance:

1. within the curriculum as a whole;
2. between the arts disciplines;
3. within the teaching of the arts themselves.

### 1. Balance in the whole curriculum

The first principle of provision is that *all pupils should have a broad and balanced education in the arts comparable to that in other major areas of the curriculum including science and humanities.* The various arts disciplines have common characteristics and related roles in education. It follows that they should be planned for collectively, like sciences and humanities, as a generic area of the whole curriculum. A common policy is needed to ensure that pupils' opportunities in the arts are in balance with their educational experience as a whole and that the arts collectively have the necessary time, status and resources in relation to other major areas of the curriculum. This balance is difficult to achieve where the arts are provided for as an unrelated assortment of separate subjects. This is not to say that all of the arts are the same. Indeed one of the purposes of co-ordinated planning is to recognise differences between the arts and to relate them to pupils' individual interests and aptitudes.

### 2. Balance between the arts

The second principle is that *provision should be balanced between the arts.* There are two related points here: first, equal provision should be made for each of the major modes of artistic activity; second, pupils should have opportunities to specialise in areas of the arts that best suit their different aptitudes and abilities. Arts education is conventionally taken to include music, dance, drama, visual and verbal arts. We noted earlier the cultural difficulties of defining the arts in these terms and suggested that a different classification is needed for the planning of the arts in the curriculum. We identified five elemental modes of understanding that underpin the many different cultural forms of the arts: the visual, aural, kinaesthetic, verbal and enactive modes. Young people should have experience in each of these. Artistic expression in these different modes uses a variety of media and it is these media that distinguish the conventional arts disciplines in schools.

### 3. Balance within the arts

The third principle of balanced provision is that *there should be balance in the teaching of the arts between pupils' own creative work and their critical understanding of the work of other people.* At various times, the balance between these has tilted one way or another, varying both historically and between the various disciplines. Not only are both of these aspects equally important in themselves, they can also be mutually enriching.

## TWO WAYS OF ENGAGING IN THE ARTS

There are two general ways of engaging in the arts. Individuals can be involved in producing their own original work, and in responding to existing work. We refer to these two respectively as *making* and *appraising.* Both are of equal and fundamental importance in arts education: each is important in itself and each can stimulate and enrich work in the other. In the practice of the arts young people can be enabled to clarify and communicate their own ideas and values. Through critical engagement with existing work they can be brought

into vivid contact with the ideas, values and sensibilities of other people in their own and in other cultural communities. Working in and learning about the arts are essential and mutually enriching elements of cultural education.

**Making**    Making describes all the processes in which pupils are actively producing their own work. Making may be an individual or, as below, a group process. It includes work originated by the individual or group and the performance of other people's material, including scores and scripts. Making is literally what artists do, creating physical objects — paintings, sculptures, prints and so on, and events — music, a dance, a drama. Making in the arts is both a conceptual and a practical process. It is conceptual in the sense that it is concerned with ideas and understanding. It is practical in that artists explore ideas through the manipulation of various media — sounds, words, images, movement, paint, clay and so on — to create forms which embody their perceptions. Making is not only a way of expressing ideas, but a way of having ideas. Just as a grasp of mathematics can lead to the generation of ideas which are otherwise inconceivable, so the ability to make music or to dance or paint opens up forms of aural, kinaesthetic and visual thinking which are otherwise inaccessible. Arts education should enable young people to get inside these ways of thinking and to generate new insights for themselves.

## Appraising

Appraising describes all the processes through which young people engage with existing work. This includes reflecting critically on their own work as well as on other people's work. We use the term appraising to suggest the need for critical judgement and discrimination. Individual response to specific works includes their direct sensory appeal — with music, for example, to its immediate tonal and rhythmic qualities; with photography, painting and sculpture to their direct visual presence. Arts education should deepen young people's sensibilities to actual works by making them more aware of these qualities. A knowledge of artistic concepts and terminology is necessary to facilitate critical perception of other people's work and to articulate personal responses.

Artists work within particular cultural settings and with particular and diverse intentions. Understanding their work requires some knowledge of the context and conventions within which it was made, and of its purposes. One role of arts education is to deepen young people's understanding of the diversity and purposes of the arts in different cultural settings. They should be enabled to understand the different ways in which the arts are produced and used socially and economically, and to develop a critical understanding not just of individual works but of the arts as cultural processes, institutions and, often, commodities.

*Work in the arts can contribute to the development of greater understanding across cultures.*

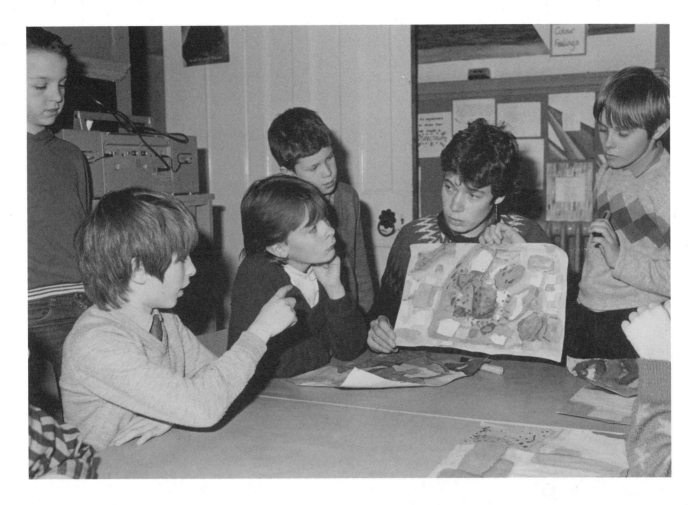

*Appraising describes all the processes through which young people engage with existing work. This includes reflecting critically on their own work as well as on other people's.*

## THE PROCESSES OF THE ARTS

Making and appraising involve a number of related processes including exploring, forming, performing, presenting, responding and evaluating.

**Exploring**

The arts are ways of exploring ideas. In improvised drama, for example, a group looking at the social issues of poverty may experiment with a variety of situations and roles to explore their different perceptions of these issues. The processes of dramatisation are used to formulate and share ideas around the theme. Equally, individuals or groups may use the forms and media of visual arts, dance, music or writing in the same speculative ways to open up areas of interest and to begin to shape their ideas about them. This exploratory work need not lead to a finished piece for others to see: it may be tentative and its outcomes immediate and self-fulfilling. Exploratory work is also important in the media of the arts in developing new forms and techniques of expression. This includes experimenting with new materials, movements, colours and sounds to test their range and potential.

**Forming**

Making involves the forming of objects or events which embody and present artists' perceptions. These perceptions are not simply translated into dramatic, visual or musical forms. They are conceived as dramatic, visual or musical ideas whose meanings and nuances are only fully available in that form. The initial idea for a new work may

be vague and the first form very approximate: some jotted notes, a sketch, a tentative phrase of movements, a first model or maquette. The process of making is one of working on the form itself, and bringing ideas into clearer focus. Ideas are often reassessed, reworked, refined and clarified through shaping the form.

**Performing**

In the performing arts there are two related and dependent processes of making: those of the choreographer, dramatist or composer who originates the work, and those of the performers who bring it to life. Performing is a process of re-making. Working on a role in a play or interpreting a dance or music composition can be as creative as the original act of composition, as the performer evolves a personal interpretation of the work.

**Presenting**

Presenting is any process of sharing work with another person and ranges from sharing ideas, notes and preparatory studies in the classroom to participation in public performances and exhibitions. Sometimes this may be to other members of the class, the rest of the school and sometimes more publicly. Aspects of this process are a natural and informal part of any arts lesson, for example in the discussions which take place about work in progress between pupils and with the teacher. Presenting involves an audience, however informal. The experience of sharing work with other people, of hearing their responses and testing their perceptions, can be positive and beneficial for all pupils. The sense of audience can also be a powerful and valuable influence in sharpening the focus of individual work and its powers of communication. Presenting requires pupils to pay careful attention to detail and to how their work is displayed or performed to best effect. Pupils should be encouraged to experiment with different ways of presenting their own work. The appraisals of others can greatly increase their sense of ownership and pride in their work and can be a significant stimulus to further work and development.

**Responding**

The arts have to be experienced at first hand. The nature of our response is influenced as much by the personal and cultural values and attitudes which we bring to the works as by what they offer to us in themselves. That is, aesthetic response is influenced by artistic understanding. Arts education is concerned with deepening young people's sensibilities to the arts, and the range and depth of their aesthetic experience and understanding.

**Evaluating**

To make an artistic judgement we need to know about the themes, content and conventions of the work. There are no absolute criteria or rules which can be applied automatically to works of art. Judgement develops from experience and acquaintance. It is important to be able to justify appraisals by giving reasons for them. This includes citing details and offering descriptions of work to support these evaluations.

The different processes of making and appraising may be intimately related. A piece of work may provide the opportunity for pupils to engage in several and even all of these aspects of the arts. Their responses to the work of other people will stimulate new work of their own, and their experience of making will deepen their understanding and enrich their perceptions of existing work.

There is a logical distinction between the various processes. Pupils need to have acquired certain concepts and skills before they can begin making. Something must have been made before it can be presented, and presented before it can be appraised. At each stage the pupils need to have learnt certain ideas and information in order to proceed and they acquire new skills and information as the work progresses.

## THE ELEMENTS OF LEARNING

Making and appraising are one dimension of our framework for planning courses. The second distinguishes four main elements of learning in the arts: concepts, skills, values and attitudes, and information.

**Concepts**  Artistic activity involves artistic intentions. Though they may produce works with aesthetic intentions and merits, young children cannot *intentionally* produce works of art without some understanding of the concepts and skills of art-making. Young people develop such conceptions as they grow, just as they learn about other aspects of their cultural environment. Arts education partly consists in extending pupils' conceptual understanding of the arts. Such concepts can be broadly distinguished into two groups: contextual and aesthetic.

### Contextual concepts
There is no universal, defining feature of art which crosses all historical or cultural boundaries. What counts as art in one time and place may not in another. Young people develop conceptions of the arts not by definition but by acquaintance with artistic practices and conventions; these are bound up in the complex networks of values and ideas — religious, moral, political — which characterise different cultures. Consequently, artistic appraisals require an understanding of the context in which a work was made. Relevant concepts include genre, period and convention. Concepts of context are not only important in appraising other people's work. It is just as important that children should see that their own work is growing within cultural contexts which are likely to exercise a strong influence on its form and style.

### Aesthetic concepts
Aesthetic concepts relate to the form and organisation of the work itself. Relevant concepts include: rhythm, repetition, unity, symmetry, contrast, sequence, climax, balance, harmony, counterpoint, pace and tone. Some of these are common to many disciplines; others are more specific: pitch and volume in music, for example; energy in dance.

**Skills**  The arts are natural forms of expression in the sense that they grow out of innate capacities in us all; but they also outgrow them. Sophisticated expression in the arts is not a result of simple maturation. The ability to play an instrument or to achieve complex visual effects in paint or movement is not an inevitable result of getting older. Creative work in the arts, as in all other areas of human achievement, needs skills and expertise which have to be learnt and, in both senses of the word, practised. There are three main groups of skills which

arts education should aim to develop in all pupils: perceptual, productive and discursive.

### Perceptual skills

Observation is a central skill in all art forms. In visual arts, observational drawing is practised not just for its own sake but to sharpen perceptions of the visual environment as a basis for all forms of visual representation. Similarly in literature, dance and drama, the observation and description of actual experience can be the foundation of creative work of all sorts. Perceptual skills include those of discriminating and reflecting on material relevant to one's own and other people's work. They also include aesthetic skills in shaping and organising materials into appropriate forms. The artist incorporates aesthetic qualities in the work to affect the observer or audience's perception and to engage their responses. Pupils can be made more sensitive to such qualities by the teacher's questioning and by experience of observation, description and interpretation.

### Productive skills

Making involves skill and control in the manipulation of the chosen media. It is sometimes argued that teaching skills can impede a natural spontaneity in children which is necessary for genuine creative work. An emphasis on learning skills without proper opportunities to use them is certainly frustrating and self-defeating. It is also frustrating for young people to be encouraged to express their ideas freely without being given the means to do so effectively. For all pupils there are times when their creative ambition outruns their ability. They cannot formulate their ideas in the arts because the media they need to use are beyond their control. Teaching skills in the media is essential as part of the development of creative work.

### Discursive skills

Children should be enabled to develop a vocabulary and understanding of the arts which can sharpen discrimination in their own work and in their responses to the work of other people. These abilities can be encouraged through pupils:

- talking to each other and the teacher and writing about their own work;
- responding to and learning about the work of other artists;
- visits to galleries, museums, theatres and concerts;
- artists' residencies and meeting and working with artists.

Developing pupils' critical understanding of other people's work should include encouraging them to make use of and respond to each other's work, through displays, performances and exhibitions.

## Values and attitudes

The arts are deeply concerned with questions of value. This is the case in two main senses: in general, with social and moral values and, in particular, with aesthetic and artistic values. Feelings are evaluations of events. Many feelings are given a social value — as vices or virtues, for example. No teacher can go far into the education of feelings, therefore, without encountering questions of social morality and of moral education. The arts offer positive and immediate ways of raising questions of value and of exploring the cultural perceptions to which they relate.

Arts education is also concerned with enabling young people to make

informed and increasingly discriminating judgements about their own and other people's work in the arts. Artistic judgement of existing work is not simply a matter of expressing personal preferences and tastes. It requires:

- objectivity in specifying the qualities and characteristics of the work which support the judgement;
- clarification of the aesthetic and artistic values on which the judgement is based;
- an appropriate conceptual vocabulary with which to formulate and express it.

Successful work in the arts requires positive attitudes to them and an interest in the forms of understanding and processes of work that they promote. Attitudes that should be encouraged through arts education include:

- confidence to make independent judgements;
- willingness to consider different social and artistic values, beyond the pupils' direct experience;
- readiness to search for alternative solutions to problems;
- openness to the work of others;
- curiosity about the arts, their cultural roles and means of production;
- sensitivity to other people's feelings and points of view;
- sense of self-worth resulting from positive achievement.

**Information**    Whichever processes pupils are involved in they will need relevant information in order to proceed, about the media and materials being used, including their own bodies, voices etc., or about the historical, artistic and social context of the work they are experiencing. In discussing the elements of learning, HMI uses the term 'knowledge' where we are now using 'information'. HMI's use tends to imply factual or propositional knowledge. 'Information' seems a better term for this and allows 'knowledge' to include non-propositional forms. This is particularly important in a framework for the arts. Relevant information in arts teaching includes that which:

- enhances pupils' understanding of the media and how to use them: e.g. the dynamics of harmony in music; the mechanics and restrictions of the muscles and joints in dance; properties of pigments and colours in visual art, and so on;
- increases pupils' understanding of the context and conventions of other people's work.

As HMI emphasises, information should have an important contribution to make to the development of concepts, skills and attitudes. It should be 'worth knowing; comprehensible; capable of sustaining interest; useful, now and in the future' (DES 1985).

## A FRAMEWORK FOR DEVELOPMENT

The figure on p.16 shows the relationships between the modes and elements of arts education as two dimensions of a general framework. It can be filled in with the further details we have described: the types of skill and concept, the different processes of making and appraising, and so on. We have not included all of these details here for fear of losing the basic purpose of the diagram, that of offering a simple

guide to our proposed framework. There is a point beyond which generalisation cannot be made, where the special characteristics of different disciplines need to be identified. The productive skills needed in music are different from those of fine art or dance. Within music the skills needed for keyboard playing are different from those needed for wind or untuned instruments. The specific concepts and critical terminology of dance are different from those of literature and drama, and they differ within the specialist traditions of dance.

| ELEMENTS OF LEARNING | WAYS OF ENGAGING | |
|---|---|---|
| | *Making* | *Appraising* |
| Concepts | | |
| Skills | | |
| Values/Attitudes | | |
| Information | | |

We elaborate on these terms and ideas in the coming chapters as we use this framework and language to discuss questions of curriculum planning, methods of teaching and evaluation and assessment in the arts in schools.

## SUMMARY

The arts are fundamental ways of making sense of experience. The different arts disciplines draw on distinctive modes of understanding: visual, aural, kinaesthetic, verbal and enactive. A coherent and balanced arts education makes significant contributions to intellectual and aesthetic development, the education of feeling, to values education and to personal and social development. A general distinction can be made between learning *in* and learning *through* the arts. Provision for the arts in schools should be balanced in three ways: within the whole curriculum, between the different arts and between *making* and *appraising*. In the next chapter we look at the implications of this framework for the teaching of the arts in primary and secondary schools.

# TEACHING THE ARTS

## INTRODUCTION

This chapter identifies the implications for the role of the teacher of the conceptual framework outlined in Chapter One. This framework calls for a careful consideration of teaching methods and of the differing roles of the arts teacher. This is not because certain styles always produce better results but because, more fundamentally, *how* one teaches is inseparable from *what* is being taught.

## THE CHALLENGE FOR THE TEACHER

In the following extract a nursery teacher with expertise in visual art expresses the concerns of arts teachers in all the phases of education.

Perhaps one problem is that we expect a lot from children in art that is exactly the opposite of what we require in other subjects. I am more likely in an art activity to use phrases like 'What are you going to do?' and 'What would you like?' because there is no *correct* answer. I ask more open questions than in other areas of the curriculum, and expect the children to be able to assert their own ideas and opinions.

A child can get something wrong in other areas but not in art. In other areas experimental play is planned and safe for the child (for instance with maths equipment or construction toys) and they get a 'yes' or a 'no' from me. In art, I expect them to sit down in front of a piece of paper and just...go! Some children can and some can't, and of the latter, some can and don't realise it. If children are confident enough to try in art activity, then they succeed, in a small way or on a greater scale. I'm sure confidence breeds competence, not only because hand/eye co-ordination, pencil/brush grip and control are being practised but because by *doing* a child knows he or she can 'do' again, and by having made marks on paper he or she sees them as worthwhile, perhaps an extension of self....

I ought, as a teacher, to be promoting confidence in children's own abilities as well as issuing expectations for end products. Perhaps such expectations may in reality become limitations....

How can my input find a balance between providing a framework for the child to take off from, and overloading the child with teacher decisions to an extent that these become restrictions, and the activity a dead-end, bearing in mind that this balance is different for every child?

The greatest challenge in arts teaching is sustaining the parallel development of *making* and *appraising*. The teacher needs to balance activities between those which require spontaneous and unrestricted exploration of arts media, ideas and intuitions, those which require

*If children are confident enough to try in art activity, then they succeed... confidence breeds competence, not only because hand/eye co-ordination, pencil/ brush grip and control are being practised but because by* doing *a child knows he or she can do again, and by having made marks on paper he or she sees them as worthwhile, perhaps an extension of self...*

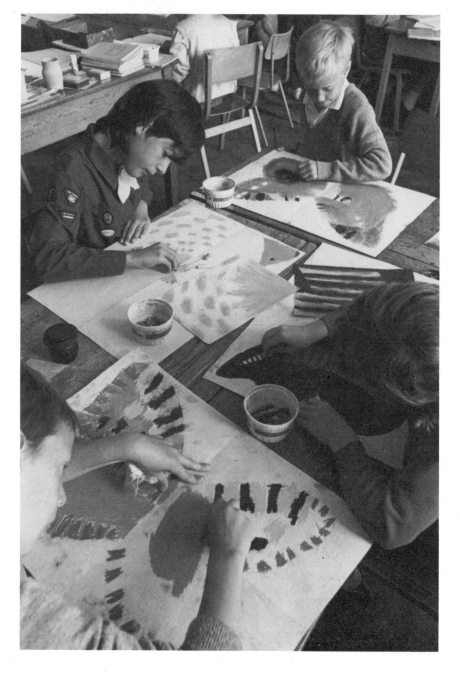

careful application of skills and those which require observation, reflection, critical analysis and discussion. To have teaching programmes solely concerned with making or appraising would be to lose sight of the interdependence of the two modes. There will be times when it is appropriate to separate them, especially with pupils in the upper secondary school, but in essence the two ways of working enhance each other's development.

This may mean that at a certain moment in the lesson the pupils take a short break from their own art-making to look at and discuss a relevant piece of arts work, perhaps in another medium, from another culture, or from a particular period in history. This can serve as further inspiration for practical work and also be part of a programme of developing conceptual and contextual language. This may include looking at or listening to the work of an established artist or discussing another pupil's work.

## THE ROLES OF THE ARTS TEACHER

Teaching the arts demands a flexibility of style and requires the teacher to take on a variety of roles: facilitator, mediator, assessor, partner, questioner, instructor and artist.

**Facilitator**

In this role the teacher enables pupils to participate in all aspects of arts education by providing source materials, appropriate tools, media and equipment, and a stimulating environment for learning. Skills, concepts and methods of working are taught which enable pupils to work in a confident, informed and creative way. Relevant information and resources are provided from within and beyond the school. These resources — including professional artists, visits to galleries, theatres or concerts — enable pupils to experience the wider world of the arts.

Sometimes facilitating means standing back and letting pupils experiment freely, intervening occasionally to help a pupil who is stuck or to challenge a pupil who is complacent. The teacher is enabling pupils to direct their own learning and to take responsibility for their own art-making.

**Mediator**

The teacher helps the pupils to make connections between their own experience and the wider context of the world of the arts. Different ideas or values may need explaining and reconciling in order to help pupils to understand and contextualise their own thoughts and feelings. This can be uncomfortable for pupils and the teacher will need to mediate when pupils are asked to respond to work which does not suit their personal preference or is beyond their comprehension. The teacher can help to make connections between the ways in which artists communicate their ideas and perceptions and the ways in which the pupils can do so.

**Assessor**

Assessing pupils' progress and achievements is an integral part of everyday teaching. Within each lesson the teacher is checking pupils' progress and is ready to give advice or support. The development of a conceptual language enables teacher and pupil to discuss work together, and through this process of negotiated assessment the teacher is building the pupils' powers of self-assessment, which are fundamental to the process of art-making.

It is important to have criteria for success in any art-making and pupils and teachers should negotiate these, particularly where there is room for a variety of responses. The kinds of criteria which might be agreed are:

- applying certain skills
- communicating ideas appropriately
- understanding particular concepts
- sustaining work from initial idea to realised form

If basic criteria like these are understood from the outset by the pupils and discussed as work progresses, assessment becomes an integrated process within teaching and learning (see Chapter Five).

**Partner**

In the *making* mode the arts lesson is a laboratory for the transform-ation of ideas and requires an open-ended, negotiated and supportive

*In the role of facilitator, the teacher enables pupils to participate in all aspects of arts education by providing source materials, appropriate tools, media and equipment, and a stimulating environment for learning.*

*After the arts experience, the teacher can question and challenge attitudes and assumptions through discussing the ways in which ideas were introduced and developed in the art form.*

teaching style where the pupil and teacher are in partnership, both expecting the unexpected. Artistic solutions are not predetermined. Success and failure are moments in a process of experimentation as the pupil tries to achieve a satisfactory resolution to an artistic task. The teacher should encourage pupils to be adventurous.

**Questioner** Sometimes the teacher will play a more provocative role in raising issues and discussing ideas. For example, a performance by a visiting theatre-in-education or dance company, a visit to an exhibition, or a class improvisation with teacher and pupils in role, can provide a safe environment for confronting ideas. After the arts experience, the teacher can question and challenge attitudes and assumptions through discussing the ways in which ideas were introduced and developed. The questions posed need to be open-ended and designed to move forward the pupils' thinking. Alternative points of view should be generated, encouraged and tolerated.

**Instructor**    There will be moments in any lesson, and at different stages in pupils' development in the arts, when it is appropriate to teach in a more instructional manner, for example in the development of technical skills or where all pupils need certain factual or conceptual information. These sessions will need to be balanced with those which foster pupils' independent self-directed learning.

**Artist**    Some teachers have considerable personal skills in the arts. There will be times when it is appropriate for the teacher to demonstrate his or her own art-making skills as a teaching strategy. For pupils to see their own teacher as a painter, musician, dancer, actor or poet can be a source of inspiration to them and provide valuable examplars for their own work.

## DEVELOPING MAKING AND APPRAISING TOGETHER

**Using artists' work**    The following example from a small rural primary school illustrates a project with *making* and *appraising* evolving together. Part of a whole curriculum topic, it involved the pupils engaging with the work of a professional artist through a borrowed exhibition of drawings of trees.

This project has been stimulated by the loan to us of six of an artist's framed drawings of trees. In preparation the children made their own drawings of trees around the school site. They selected papers, materials and chose lining paper of just the right shade of green to match the chestnut leaves with the sun shining through, to line the walls. Next we brought together their small collection of potted little trees, always available in a school where caring for and growing on is the normal sequel to pips in pots.

Resources were discovered on site. Logs, dead branches, lichens and mosses were investigated. Rubbings of leaves and bark prints were also made. Logs and pieces of bark from the woodyard were brought in. More seedlings came, then a little oak sapling from the potato rows in the farm across the way.

After the arrival of the drawings the children sat down and studied the display, their

conversation showing perception and appreciation. We have a custom of using clipboards for notes and drawings during discussions and I try to build vocabulary by this means.

The infants joined in and everyone brought along their clipboards to note down good ideas. After discussing and comparing all the drawings, speculating about the artist's reasons for selecting subject and method, we talked about our reasons for selecting a favourite drawing if we could be allowed to keep one. Conversation turned to reactions evoked by the drawings. Teachers and children shared their reactions and spontaneously searched for fitting phrases to communicate their ideas. We did not say anything about alliteration or comparison but these skills were present. 'You could walk through the wood like getting lost in the mist.' 'The crispy leaves crunch and crackle under my feet.'

The children discussed the techniques of drawing: 'I think that's clever the way he's left little bits of white between the shadows. It makes it look like sunshine.' 'The squares are a good idea. I had a problem fitting mine onto the page. Is that why he uses squares?' We remembered the phrases and jotted them down for future use.

The children's exploration of trees is balanced with the critical processes of examining an artist's interpretation of trees. This is an example of how children's creative work can be enhanced by reference to equivalent work by an 'expert'. Through the discussion of the drawings conceptual language was beginning to emerge which would support further development in both making and appraising.

A teacher from another rural primary school introduced the work of famous artists to her Key Stage 2 pupils in order to develop their appreciation of visual art. Her objectives were to develop the pupils' observation skills, particularly in relation to pattern and colour, and to introduce them to Van Gogh's particular style.

In the preparation lesson I gave the children some facts about Van Gogh's short and sad life. We proceeded to observe his self-portrait and spoke of the colours and the particular brush strokes he used. The children were then given the primary colour and white paints, and tried to mix similar colours to those used by the master. They found that the hog's hair brushes lent themselves favourably to the particular style they were trying to emulate.

In the next lesson a boy posed as Van Gogh. Other pupils dressed him up in a hat and scarf similar to those worn by Van Gogh in his self-portrait. Once the drawings were completed they proceeded to paint them. Having already practised mixing colours in the previous lesson they continued quite confidently and with very little fuss.

In a later lesson, after further experimentation with the medium, the pupils looked at all the portraits and decided which they liked best, giving reasons for their choices; consequently the pupils' developing conceptual language was used in a critical way as they made judgements about the value of arts work. This is an unusual approach to the visual arts in the primary school, where the emphasis tends to be on spontaneous *making*. Its strength is in the development of skills and concepts through *appraising*.

*Appraising* one piece of arts work can stimulate work in a range of art forms. A dance teacher from an inner-city sixth-form college, inspired by her cross-arts involvement within the project, took on a performing arts project in 'recreative and general activity' time, involving GCSE dance students, A-level drama students and a craftswoman in residence.

The work centred upon a study of Picasso's painting, *Guernica*. The history was discussed and contemporary poetry used to further understanding of the context. The group explored themes from the painting using movement, drama and Spanish song. They created a ten-minute dance piece with a dramatic section within it, and with the craftswoman made masks, props and costumes for the piece. (See picture at the top of p.61.)

The project gave teacher and students an opportunity to explore the possibilities of working across the arts and responding to a theme. It also gave pupils with expertise in one arts area the opportunity to coach their peers, as the dance students helped the drama students with their dance movement. The teacher maintained a flexible teaching role, delegating aspects of her teaching to the students as the group explored a new way of working.

## Broadening conceptions of the arts

Some art forms suffer stereotyping which hampers work within the curriculum. Dance for example has suffered from many forms of misconception and bias, particularly in the area of gender. By closely relating *making* and *appraising*, misconceptions and false assumptions about particular art forms can be challenged. By introducing pupils to professional arts practice which does not fit stereotypical images, opportunities can open up for pupils in their lives outside school. By exposing pupils to work which challenges their assumptions about aspects of dance, larger issues are opened up such as body image, gender and racial stereotyping, and different cultural values in the relationship between mind and body.

A dance teacher with a county-wide brief set out to explore and affect boys' attitudes to dance, providing them with different role models in order to research their attitudes. They worked for a series of lessons with a male dancer, a female dance teacher and also watched an all-male dance company in a lecture demonstration. One of the issues which emerged was the boys' conflicting perceptions of dance and how it is created. The strongest confusion was between what they

*Work in dance can be particularly valuable in enabling pupils to confront gender stereotypes.*

believed dance to be, based on a very limited view, and what they were doing in the lessons. They had strongly associated dance with the commercial dance they saw on television: jazz dance or ballet, both of which have very specific styles based on highly refined techniques. They could not relate this to the creative process undertaken in dance lessons.

To make the link between the course and these perceptions of dance, either the classwork has to become closer to their perceptions of dance or their perceptions have to be broadened. As the boys' view of dance tended to be narrow and negative, it would be inadvisable to use material closely aligned to the dance forms which influence their perceptions. It might be more acceptable to introduce dance through exercise-based creative movement and at the same time extend their definitions through exposure to visiting artists, performances and film or video.

By including in the dance course exemplars of dance work which contradicted some of the stereotypical images of dance among the boys, the teacher aimed to affect the boys' misconceptions and to expand their view of what dance could be for them in school.

## THE ELEMENTS OF LEARNING

As well as considering the two fundamental ways of engaging in the arts and the processes which they encompass, it is important to consider the elements of learning which are involved: concepts, skills, values and attitudes, and information. These can be used to plan and evaluate the learning content of any arts project or lesson, in either *making* or *appraising*, and to assess the results of the pupils' work.

In the following examples making and appraising are closely related but with different emphases on the elements of learning. The first three demonstrate a progression of conceptual learning in visual art. In the first example from a Year 1 class teacher, the conceptual learning is embedded in the teacher's approach to all learning and it is rooted in the children's direct experience. The children are

beginning to classify and discriminate and to use their emerging conceptual knowledge in their arts work. The teacher is encouraging the development of critical language through her questioning.

In the second example, with Year 2 pupils from a rural primary school, the concept of pattern is dealt with more directly. The teaching style is more formal and there is a focus on developing critical language, the basis for *appraising*. In the third example from a secondary teacher, the teaching is concerned with transferring conceptual understanding from one arts medium to another.

**Conceptual learning: *learning through touch***

In the first example the teacher carefully built the development of artistic concepts into the pupils' learning. She developed a series of learning experiences through touch, starting with snow-play in early spring and leading through to more arts-specific activities in the summer term. She used as her resources fabrics, junk materials, paper, card, fibres, sand, water, snow, plastic, metals, cardboard boxes, clay, plasticine, glue and paint. In her flowchart of the intended learning through this project she listed under 'manipulative skills':

building, cutting, carving, adding, shaping, pressing, stretching, bending, coiling, flattening, joining and rolling.

In terms of conceptual learning she listed:

light and shade, collage of texture, scale and proportion, environment, texture and colour, texture and sound, vibrations, warm and cold, soft and hard, rough and smooth, indoors and outdoors.

The following is her description of how the project started:

An unexpected fall of snow early in the spring term provided a good opportunity to begin work on the project. 'Can you catch a snowflake?' I asked the children. They rushed outside but were rather disappointed to find the flakes had melted by the time they came back to show me. They set to filling up buckets and bowls of snow which we put in the water tray. This was placed in the coldest part of the room, away from the radiators. Much language activity ensued from feeling, squeezing and poking the snow: cold, wet, scrunchy, freezing, frozen, damp, lollipops, ice, icy, frosty, claggy, hard, soft, smooth, watery, white, bright.

The development of appropriate language is central to pupils' understanding of their experience at all levels of learning. Just as this teacher constantly questioned her infants about their experience, so with all arts learning it is important to develop the language skills and appropriate vocabulary to engage critically with the experience and the subject matter.

The class moved from snow-play to water-play and then on to working with collections of familiar objects. The children discussed and explored the objects.

The cloths were crumpled and folded. The sponge was squashed in the hand and allowed to spring back again. The plastic bottles were squeezed and blown into. Cotton wool was pulled and teased out so much that by the end of two days it had lost its fluffiness and become dirty grey in colour. Holes appeared in the sponge where little fingers had pulled pieces away.

The children explored objects from the nature table and then moved on to a collection which introduced unusual textures. Questions asked here included:

What does it feel like? What shape is it? What noise does it make? What does it look like? What could we use it for?

The teacher then devised exercises to develop the children's capacity to describe objects. They worked with 'feely' boxes through an increasing complexity of tasks. They put their hands into a box of dry leaves and described the experience without looking, discovered two-dimensional shapes with their hands and the older children in the group described three-dimensional shapes.

At this point the learning shifted into exploring a specific medium. Inspired by the discovery of some rope on the beach, the children spent a week making a collection of ropes, wools, string and braids.

Having made the ropes and braids I wondered whether the children would be able to manage weaving. I hit upon the idea of using a round table in the classroom which had a hole in the middle for a bucket containing clay. This was the right height for the children and would produce a circular piece of weaving.

I fixed the warp threads around the table to the centre and underneath, knotting them at the edges. The children were then able to use their braids, adding long lengths of material like straw and paper as the wefts. The children picked this up very quickly and for a week the classroom echoed to the sound of children chanting 'over, under, over, under' as they were weaving. Every child had a go and by the end of the week I had decided that weaving in the round was probably a better introduction than weaving in straight lines. The result was an exciting piece of textural collage which was attached to a large wooden hoop. It was proudly displayed on the wall and the children were able to show their parents that 'I did that bit.'

The children were encouraged to continue their search for unusual textures. A boy brought in a shell from the beach and after observing spiral patterning on the shell the class explored the concept of spirals with a variety of media. They then experimented with shining a light on the shapes from different angles, observing how the shadows changed as the light moved around. Later this was picked up in mixing dark and light colours in paint. The children were now beginning to grapple with three-dimensional concepts and the last phase of the work involved building sculptures from cardboard boxes.

This example demonstrates how all learning can spring from a young child's direct experience. It also demonstrates how a teacher can feed in layers of conceptual learning to a child's store of aesthetic knowledge. Starting with the experience of playing with the snow, an early stage of *making*, the pupils were developing their general descriptive language. As they progressed through a series of planned activities — water-play, feely boxes, rope- and braid-making, weaving, collage and the making of cardboard box sculptures — the pupils learned to distinguish concepts of contrast in shape, texture, colour; of pattern in two-dimensional shapes; and, finally, to distinguish between two- and three-dimensional shapes.

## Conceptual learning: *pattern in the environment*

The second example explores the development of the concept of pattern. The aims of the first phase were:

- to use the technique of block printing in order to develop an awareness of pattern in the environment. The activity was designed to develop motor skills and control;
- to encourage accurate observations and a critical awareness of the environment;
- to encourage classification and discrimination of colour and pattern.

The following is an extract from the teacher's evaluation of the first phase of the project.

The children went on an observational walk to look at patterns of brickwork on houses in the locality of the school. They worked in pairs and made rubbings of brickwork. Photographs were also taken as reference material. Over the next few days the children worked in small groups to produce block prints depicting patterns of brickwork.

When the prints were dry the children were encouraged to study them and make their own evaluations. The children observed that some designs turned out quite well but others were faint, depending on the amount of colour used and the pressure applied with the roller. They also noticed that some were smudgy and felt this was due to not holding the tile still or again to too much colour on the roller. The pattern of brickwork was reinforced by producing paper batik houses depicting brick or stone work and these were arranged to indicate detached, semi-detached and terraced houses. This repeat pattern approach was later used to design the children's own wallpaper patterns using resist technique.

The next phase of this project involved a visit to a local country house, intended to enhance the children's observational powers and their critical awareness of the environment.

The children were told about the history of the house before being asked to observe the patterns, particularly those on the chimneys, windows and doorways. Each child then made sketches of these, with emphasis on shading to depict light and dark areas. Photographs were taken for use later.

After lunch the children were taken to the maze to observe the pattern on which it was based. During walks from one venue to another the children were given the opportunity to observe the multitude of patterns in the environment.

Follow-up: using sketches and photographs from the visit, the children were placed in groups of four. They were each given a foot-square clay slab on which they were encouraged to depict one of the patterns they had sketched. They could either cut the pattern or roll out the clay and make a raised pattern. These tiles were then fired in the school kiln, with the children observing.

This teacher is confident in the conceptual language of arts education and is able to describe and analyse her teaching and the learning outcomes she is promoting. This is vital in enabling her pupils to develop powers of self-assessment and critical awareness, both essential for *appraising.*

The four learning elements are implicit in her evaluation. The children have explored the *concepts* of pattern through observation of the environment and their own art-making. They have explored new arts media and acquired new *skills,* and have also engaged with contextual *information* concerning the history of the house. Implicit in the teacher's encouraging her pupils to make critical statements and judgements is the development of artistic *values and attitudes.*

## Conceptual learning: *jazz/ visual art project*

An art teacher from a rural comprehensive devised a jazz/visual art project for her lower school pupils in response to their stated prejudices about abstract art. The comment 'A child of five could do that' summed up their attitude. The teacher felt that an exploration of the shared abstract qualities of music and visual art might help them when they responded to works of art.

I decided to start the project with a series of exercises which were an attempt to provide the pupils with a vocabulary they could later use in response to jazz music. The idea of relating marks and lines to sound was introduced simply by asking them to record a rhythm of a single drum beat. This was a prelude to visual note-taking while listening to jazz. From their notes I asked them to develop a collage based on their response to a particular piece of music....

A series of worksheets was devised to guide pupils through an exploration of the qualities of their own mark-making and then the comparable qualities in jazz, in terms of the concepts of shape, line and colour. One homework sheet was particularly successful.

Artists have often been inspired by music or sound. Stuart Davies was an American artist who lived between 1894 and 1964. Davies concentrated on sketching the life of the streets, their signs, people, places, colours, shape and music. Look carefully at the photocopy of the painting by Davies called *Swing Landscape,* painted in 1948. Then complete the following in your sketch book.

1. *Swing Landscape* is an abstract painting but some of the shapes Davies used are meant to suggest parts of the landscape. Trace or copy the sections of the painting that remind you of parts of the landscape and name them.
2. Describe the sorts or types of shapes that the artist has used in the painting. Trace or copy a selection of shapes from different parts of the painting. Are some of the shapes used more than once?
3. What connection, if any, do you think the shapes have with the title of the painting?
4. The photocopy does not show the colours Davies used. Make a list of a range of colours that you would have used for this painting if you had been the artist. Choose colours that you think best match the shapes and mood of the work.

These tasks were then followed up in class.

The homework was followed by a discussion with the pupils about their responses. This raised many interesting points and the effect of seeing a colour reproduction of the painting after examining it closely in black and white was startling.

Discussion followed about Mondrian's painting *Boogie Woogie Broadway* and many pupils made comments which indicated an increase in their level of perception. There was a general feeling among them that they now understood the work. I feel that examples of relevant artists' works could form the basis of similar projects, and that relating different art forms to each other is worthy of further exploration.

This example demonstrates how concentrating on conceptual language, both for practical exercises and discussion, enhances the relationship between making and appraising. It also shows how contextual information can be fed in to reinforce the conceptual learning, and how transferring knowledge from one arts discipline to another can be used as a strategy for increasing pupils' understanding of the function of the arts in general and the way they represent meaning.

**Skills learning**    Arts education requires the mastery of many different kinds of skill. These include the technical skills which pupils require for controlling the media, the perceptual skills for composition and evaluation, the discourse skills for discussing and writing about work, and the social skills which are vital to the collaborative work which many arts disciplines require.

Observation is one skill that uses different senses depending on the arts medium. For visual artists drawing from observation is an essential aspect of art education, for dancers the ability to observe and replicate movement accurately is a prerequisite of dance education, and drama students use skills of observation in the creation of roles. The equivalent for musicians is the ability to hear fine distinctions of sound and to listen accurately. In this example a primary music specialist describes how she worked on the development of her pupils' listening skills in music.

A recurring concern for me has been listening. Often, in common with other teachers, this is a response to a noisy or fidgety group of children: the class is not 'attending', therefore it cannot be learning. For the music teacher this involves a good deal more. There is a vast difference between listening and hearing properly. Since listening effectively is a *sine qua non* of all musical activities, it seemed important to look at criteria for listening and their appropriateness to a variety of activities, against which I could assess the pupils I taught. I suspected that a good deal more listening took place than I gave credit for and I wanted to investigate ways of collecting classroom evidence of children's listening responses to particular tasks.

Broadly, there are several ways of listening to music, each for a particular purpose though not mutually exclusive:

- listening to music as an end in itself
- listening in order to stimulate another activity such as dancing or painting
- listening in order to repeat a pattern or perform a piece
- listening to compare, alone or in a group
- listening to analyse musical information

In her lesson plans the teacher decided to categorise her activities in the following way in order to consider the above ways of listening:

- listening to pieces of music where no physical response (playing or writing) was required;

- listening activities involving answering questions verbally or writing answers to listening exercises, e.g. identifying pulse;
- group compositions.

After recording and evaluating a series of lessons, carefully planned to explore and develop her pupils' listening skills, she was able to draw some conclusions.

The creative lessons (the group compositions), although they may have appeared undisciplined to an outsider, were by far the most successful in terms of listening and learning. Getting children to be creative first and then introducing them to the compositions of others seems to me to be a better way of addressing the common complaint about poor listening skills. Once the younger children have discovered the various sounds and rhythm patterns available they can put them together and progress to the work of others and the more conventional methods of composition.

This example underscores the importance of the integrated relationship of making and appraising described earlier. The pupils learned to listen through making their own music and critical language developed out of their eagerness to talk about their own compositions. This listening skill can then be transferred to the wider context of the work of professional artists.

### Developing technical skills and attitudes and values

The next example describes a craftwoman's residency in a special school for pupils with both moderate and severe learning difficulties. The development of manipulative skills in handling fabrics and materials for the project is a central concern. So too is the exploration of values and the generation of positive attitudes to creative work in the school as a whole.

The residency produced a large wall panel mounted on the balcony fascia of the school hall to which all the pupils contributed. Its theme was the four seasons and it was produced from scraps of material, old clothes and curtains collected by pupils and teachers. The craftswoman taught both groups the skills of cutting, tearing, knotting, cord-making and plaiting, together with the more sophisticated techniques of knitting, quilting and weaving. There were moments when the ideas of theme and colour were beyond the children's capabilities but they were all able to contribute at the practical level.

Once the boards had been painted the craftswoman began to mount some pieces of work on them. The children's response in producing small pieces was tremendous but some of us wondered how on earth we were going to fill nearly ten metres of soft board. By the end of this three-day session each of the four seasons had been started. Strips of knitting, large fabric weaves, cords, plaits and knotted strips were transformed into hills, fields and hedgerows. Now everyone had a clearer idea of how the panel was going to look. This helped spur people on to make more pieces.

By now the craftswoman had developed a particular working method whereby children arriving on the balcony would discuss with her exactly where in the panel their piece should go. With less articulate children she encouraged a tactile exploration of the wall hanging. Come the last two days of the residency there was a pressure to finish the whole piece which inevitably meant a reduction in the time she could spend with the pupils. This did not stop groups of children who had by now become deeply involved in the work from popping up to see how it was progressing. On these occasions the emphasis had changed from doing the work to talking about it and this was seen as a vital process in the whole enterprise. On the last afternoon

*In music education, pupils learn to listen through making their own music and critical language develops out of their eagerness to talk about their own compositions.*

of the residency it was clear we could not let the craftswoman go without a special ceremony in which she handed over the final hanging to the children.

The first paragraph of this description points to development of motor skills, and provision for considerable differences in physical and intellectual ability. The second paragraph illustrates the power of such a project in developing pupils' artistic and personal values: every pupil was valued for his or her own contribution. An essential element was the way in which the craftswoman encouraged the children to talk about the progress of the work and where pupils' individual contributions fitted in. She took account of all the pupils' responses, verbal and non-verbal.

The deputy head of a primary school describes a dance and visual art collaboration which he devised with a painter in residence. He is planning how to follow up a day's workshop for his junior class which he and the artist had taught together. The children had spent the morning exploring the relationship between movement and drawing through sketching body shapes in stillness and movement, and then in the afternoon they created a huge collaborative mural of dancing figures. (See lower picture on p.61.)

They had worked so well together during the whole-day session that I decided to extend the movement work. This time we developed the idea of relying on and

trusting in someone completely. Our movement revolved around trusting your body weight to the care of someone who was supporting you. Some ideas were put together and performed to music. I found it hard to take in how implicitly they seemed to trust each other with their own bodies. There was a tension there, not a tension created through any form of awkwardness or embarrassment, but a tension which was a major part of their movement. They were not moving in an isolated fashion. Feelings and emotions were being created, explored and tested.

We talked about these ideas after the lesson. They talked freely about their experiences, about trust and friendship. These feelings were strong. It seemed a natural step to commit them to paper. The result was a piece of writing entitled *The Bond.* Here is one boy's poem:

### The Bond

Help! He screams.
I turn stunned.
I see him.
I know at once
I can trust him.
Help, please!
He screams again.
I stare.
There is a friendship between us already,
I grab him.
I can feel the warmth from him flow through me
As I pull.
He trusts me,
I can feel it in my bones.
He is free.
I have been rewarded.
There is a unity here
That no one could ever match.

The writing was a further expression of what their bodies had described, their eyes had seen and their hands explored through pastel. Each of the areas of pastel, writing and movement became an extension of the others. The experiences, skills and responses which had developed in one area were tested and used in others. Feelings were communicated and adapted through the different media. A valuing of their own and others' work grew. Communication between one another developed quite naturally. It was certainly a 'bond'.

In retrospect one of the strongest aspects of the project was the children's sense of belonging. The whole project was theirs and they were proud of it. They guarded it jealously but eagerly chatted to others about it. They readily displayed their work, explaining the mural knowledgeably, and keenly performed their dance work, enthusiastically discussing the emotions, feelings and artistic decisions behind it. In doing this they were allowing others into a world they had developed, knew intimately and took very seriously.

It is evident from this last paragraph how powerful the residency had been in the education of these pupils. The artist's work with them developed their technical and perceptual skills and conceptual language beyond what might usually be expected in a primary school. For the teacher, the most important outcome was in his pupils' personal values: in the way that the dance movement gave access to feelings, and the whole process built a strong feeling of group ownership.

Many teachers cite attitudes and values such as co-operation, curiosity, tolerance and perseverance as ones that can be fostered through successful arts learning. But the arts can also challenge attitudes and values.

**Challenging attitudes and values**

In arts lessons difficult ideas can be transformed and given expression. Drama teachers are particularly adept at using the arts to explore ideas and issues. In the 'safe' space of role play pupils are able to explore controversial issues distanced from the normal context of class discussion. One teacher devised a series of drama workshops to explore pupils' attitudes to race, gender, religion and mental and physical ability. The first workshops were devised by her Year 10 drama group for pupils from local primary schools. The main aim in these workshops was to break barriers between older and younger children. The second workshop involved collaboration over two terms with a school of pupils with severe learning difficulties. The main outcome was that pupils from both groups found a new respect for the other group and some disaffected secondary pupils become motivated enough to enjoy participating in drama lessons. These children gained a sense of purpose because they felt successful in helping the pupils with special needs to realise that they too had something to offer.

The next phase involved team teaching. Drama, history, and geography were used to explore the history of slavery. Then, as a part of a GCSE course called 'Understanding Industrial Society', pupils explored attitudes to gender. The final phase involved Year 8 pupils making a play about equality called *The Person in the Wheelchair is Invisible.* The play was performed in assembly and recorded on video, its purpose to reveal conscious and unconscious prejudice and to stimulate debate.

Dance is rarely seen as having the same potential for raising issues and challenging attitudes as drama. Like music, dance has no direct comparison with verbal language. Some teachers assume that dance is drama without words, and an imperfect imitation of verbal meanings. But dance would not exist if words could be used to communicate those meanings.

Dance is a valuable forum for exploring gender stereotyping. As it is traditionally a girls' subject, giving boys the opportunity to study dance raises many issues of gender and stereotyping. The dance teacher mentioned earlier set out to examine and affect boys' attitudes to dance by providing them with the opportunity to work with male dance teachers and male professional dancers. Here she describes her concerns when embarking on the project.

I believe that boys are actively discouraged from dance by parents, peer group, teachers and the media. It is perceived stereotypically as wet and pretentious and not for 'men'. To reflect society's norms, women and girls are expected to move in a light, gentle and sustained way, as in ballet, and men and boys are expected to move in a strong, aggressive and speedy way, as in competitive sport. Yet dance vocabulary draws upon all human movement and is capable of releasing a vast range of dynamic expression associated with common experience across the sexual divide. Dance is physically and psychologically emancipating.

In her conclusions the teacher points to the impossibility of changing deeply entrenched attitudes in a short-term project and to the need

for whole-school commitment if such work is to be successful. One thoughtless remark can undermine such a project, which needs positive reinforcement wherever possible.

A project in an urban sixth-form college provided another example where attitudes to gender were challenged. Its basis was an exhibition of paintings by a woman artist, the theme of whose work was the female nude, particularly the pregnant nude. The paintings were hung in the college foyer where the students congregate every day (see upper picture on p.64). The college principal takes up the story.

I had deputations from the staff who insisted the paintings were moved, calling them obscene, disgusting, saying they had to avert their eyes, that they couldn't cope with them and that they really should not be in a college like this. There were deputations from the student council to me and to the teachers whom the students felt would support them in having them taken down. Many girls said they found it embarrassing sitting with the boys in the foyer and felt that femininity and sexuality were being flaunted in a way which was hard to take.

As well as an issue of femininity, of women's image, of pregnancy, of whether this aspect of women's bodies should be hidden away, it became an issue of censorship and of who is the arbiter of taste in the college. These issues were debated between staff and students while the paintings stayed up.

*To reflect society's norms, women and girls are expected to move in a light, gentle and sustained way, as in ballet, and men and boys are expected to move in a strong, aggressive and speedy way, as in competitive sport.*

Gradually attitudes began to change, objections faded away and new discussions took over. A key moment was a lunchtime open session in the main hall, chaired by the principal, at which the head of art and design and the local art adviser made a joint presentation about the nude in art throughout history, and how there was a long tradition of

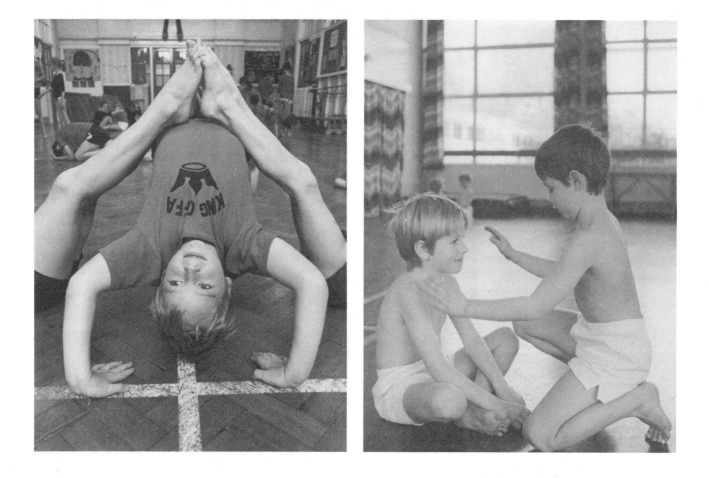

it dividing opinions. This was followed by the artist talking about her friend, the model for the two works, and why she was motivated to produce them. An open forum followed. Most of the paintings' outspoken critics were absent, losing their case by default.

Following this session some students began to say that they liked the paintings and it was obvious that they were now studying them, not simply glancing at them. They were also studying the artist's written text, her testimony, which accompanied the exhibition. Girls described how they moved from embarrassment to acceptance and then on to defiance as they considered their reactions to the boys' responses. A loyalty to the paintings developed and the following girl's response echoed those of many.

She said it was the best thing that had happened to her in the whole lower sixth year and  it was the best learning process. She had learned about herself and people's perceptions about women. By the time the paintings were taken down the majority of the girls would challenge anyone who questioned the value of the exhibition.

The boys were not so articulate about the issues, and apart from those in the arts community the principal suspected that there was less change in attitude.

The irony was that in the same staffroom I regularly see copies of the tabloid press with page three pin-ups and nobody has ever objected, and yet they came to object about an exhibition which they know was painted and exhibited in good faith. I don't think that will happen again here. I think it was something we had to go through and I think the battle, if it was a battle, has been won.

This is a powerful example of the ability of the arts to disturb and challenge accepted attitudes. This artist was a powerful agent in developing these students' perceptions of themselves and their images of women.

## SUMMARY

Arts teaching requires a flexible and responsive pedagogy which simultaneously develops *making* and *appraising*. Arts education should look to the wider cultural context of the arts and provide pupils with a range of experiences, both in and out of school. The teacher is required to play many roles.

The arts teacher guides the pupils' creative work from the beginning through to complete work and guides pupils' understanding of that work in relation to their own cultural experience and the work of others. The arts teacher also plans and balances the elements of learning within arts work in terms of the concepts, skills, values and attitudes, and information.

## A checklist for evaluating teaching style

When you are teaching:

1. what resources do you provide to stimulate art-making?
2. do you sometimes give contextual information or explain concepts to the whole group?
3. how often do you stand back and let pupils experiment freely in their art-making, only intervening occasionally? Do you check your reasons for intervening?
4. do you balance your relationships with your pupils between talking on a one-to-one basis and talking to groups?
5. how do you encourage pupils to challenge their own, and your, assumptions and expectations?
6. how do you support your pupils in using their own thoughts and feelings as resources for art-making?
7. do you encourage pupils to talk about their own work in relation to their thoughts and feelings and to the work of others?

## A checklist for evaluating lesson or course content

When you are planning a scheme of work or a particular lesson in what ways do you introduce:

1. a balance of making and appraising?
2. reference to professional artists working in different cultural and artistic traditions?
3. time for pupils to reflect upon and discuss their own work with you as the basis for negotiated assessment?
4. relevant contextual information for all projects?
5. the concepts you wish the pupils to understand, whether in terms of the media or the context?
6. the skills you wish the pupils to acquire?
7. the attitudes and values which you would like the pupils to develop?
8. opportunities for the pupils to make their own critical judgements about arts work based on their own or agreed criteria?
9. opportunities for individual and group work?

# THE ARTS IN THE PRIMARY CURRICULUM

## INTRODUCTION

In this chapter we look at the general roles of the arts in the primary curriculum. We emphasise the need for primary schools to adopt an arts policy, and for teachers to differentiate in their curriculum planning between the contributions of the arts to the curriculum within a thematic approach, as areas of study in their own right, and to pupils' personal and social development. In order to provide for these three contributions, primary schools need teachers with enough knowledge and expertise in the arts to fulfil one or more of three teaching roles: generalist, specialist and curriculum leader.

## THE NEED FOR AN ARTS POLICY

Most primary schools acknowledge the importance of the arts in the education of all children but there is a great variety in the quality and range of arts provision. Few primary schools have a policy for the arts. Provision tends to develop in an arbitrary way, depending on individual teachers' commitment to the arts. In some schools there are no teachers with specialist skills in the arts, although they may be excellent generalists. Such teachers often feel uneasy about tackling work in which they have no training. Primary teachers often see the arts as an excellent medium for learning and use them either to reinforce learning in other curriculum areas or to promote children's personal and social development. The arts are less often seen as essential areas of learning in their own right, with specialist skills and concepts to be developed. In other words, the emphasis tends to be on learning *through* the arts rather than on learning *in* the arts.

Most primary schools include singing and percussion work for all children at Key Stage 1, but music in particular depends on the interests and talents of the staff. If no teacher plays an instrument, music education may be at a disadvantage. The provision of choirs, bands and instrumental teaching varies considerably. Dance is usually taught as part of PE, often as 'movement' or 'music and movement', at Key Stage 1. Drama and poetry also tend to depend on members of staff with particular interests. Only visual art, or 'art and craft', is

provided for in every primary school, and then not always consistently.

The three forms of balance discussed in Chapter One are central to the development of a coherent policy for the arts in the primary school. The objective is to provide pupils with the widest possible range of arts experiences so that they can begin to identify their own interests and aptitudes in the arts. There are three considerations.

1. Are the arts fully represented in the school's curriculum policy along with the other curriculum areas?
2. Is a range of arts disciplines provided within the school?
3. Do the pupils have balanced opportunities for both *making* and *appraising* in the arts?

## THE ROLES OF THE ARTS IN THE PRIMARY CURRICULUM

The most common approach to learning in primary schools is through themes or topics. These two terms are largely interchangeable, but usually a topic is part of a broader theme. The arts can flourish within a thematic approach, provided that their contribution to the theme is carefully planned and adequately resourced. In addition to identifying aims and objectives for learning within the theme as a whole and for pupils' personal and social development, this means identifying learning objectives particular to the arts.

The extent to which the arts can be taught successfully within a thematic curriculum was an area of particular interest for primary teachers within the project. The following accounts illustrate the different kinds of contribution the arts can make to the whole curriculum in thematic, personal and social, and artistic terms. A primary headteacher describes the arts in an integrated relationship with other areas of learning within a theme; a first school teacher describes her music teaching in terms of pupils' personal and social growth; another first school teacher describes a discrete study in the arts in terms of shared concepts between dance, visual art and music.

**Learning within a theme**

The main concern of the headteacher of this two-teacher rural primary school is that all learning experiences are integrated to give every pupil the broadest possible knowledge and understanding of the term's theme. She does use artistic and personal and social criteria in planning the curriculum but her main emphasis is on the integrating function of the theme.

A visiting teacher recently remarked that the whole process of learning here is so 'organic'. I took this as a compliment, perhaps mistakenly as the work in hand was investigation of the roots of potted seedling trees. Was this biology? The drawing of a centipede and the rush for the microscope certainly indicated that it was so, but the observational drawing crossed the threshold of a set of skills which could so easily become developed much later in a system defining 'art' as a timetabled subject. As for the verbal descriptions which evolve, are they science, leading to clearly stated discoveries, or are they more subjective, termed in the more evocative expressions where poetry writing has its roots? Both forms can be appreciated and used.

Two boys were investigating lichens and were struggling with the concept of symbiosis: 'These are separate things, the fungus and the algae, but they depend on each other and cannot live without the other one.' Similarly, the arts must be a

*The local environment can provide a rich stimulus for work in the arts.*

complementary part of a broad education: the two parts each raise the attainment of the other. So entwined are the parts in learning, division is impossible.

As part of a project on 'The River', the pupils visited a local river and went on a journey along its course to its outfall. They explored fish physiology, the lateral line, food chains, fish feeding patterns and behaviour, maps, river valleys, erosion, pollution and drainage. This extract demonstrates the integration of all learning within the theme.

We looked towards the water authority station and the course of the old river. We went on through a village and looked for the location of the local abbey and bridge. We saw the sugar beet factory and small industry. We stopped further on and walked along the towpath and trod the old railway line. We deduced that the railway platforms, station house and ruined gates were a halt that also made the ferry necessary when far more people depended on the railway than is the case today. We could also see a depression in the ground which might at one time have been a water course for access by river to the abbey. On the river bank we had time for drawing. One little group discovered perspective in the way the river 'gets wider as it comes towards you and goes away again until it is all almost nothing'.

We stopped to look at the abbey and we could see how the abbey stone had been reused in a farmhouse which is now almost completely demolished, as well as providing stone for road mending and other uses. We went on to the next village and paused long enough to watch a collection of wildfowl on the pond and make quick observations and lightning clipboard drawings. We slowed down again to see dyking and drainage work going on.

The follow-up work after the journey included maps, co-ordinates, bearings, scale, writing, history, geography, mathematics and pattern-making, clay, painting, CDT, botany, ecology, RE, dance, poetry. An exhibition of drawings of trees was borrowed and exhibited in the school to inspire visual art work. Opportunities for dance offered by the theme were also seized upon. The pupils worked with a dancer in residence, developing a dance using the dynamic and expressive qualities of the river.

This tiny rural school provides an excellent model for a whole-school curriculum being devised around a theme. The arts are fully represented within the curriculum, although not described as a discrete area. They are taught rigorously and opportunities for developing them are recognised and used.

It is important that teachers of all age groups in the primary school are able to recognise the cross-curricular potential of the arts. They need to be attuned to picking up visual, musical, poetic and kinaesthetic opportunities to promote learning in all curriculum areas: for example, to develop mathematical concepts within music and dance using the number relationships inherent within rhythm, or alternatively, in dance and visual arts, using the shared spatial relationships.

The cross-curricular approach to curriculum planning has been given renewed emphasis by the National Curriculum. Mathematics Attainment Targets 10 and 11 in particular — concerned with shape and space — give plenty of scope for work in the arts, as the National Curriculum Council's (NCC) non-statutory guidance suggests: examples are offered of work in PE and the visual arts which demonstrate the early levels of mathematical attainment, and the first three levels of Attainment Target 11 could read very appropriately as part of a primary school dance syllabus:

> Pupils should:
>
> **Level 1**  • state a position using prepositions such as: on, inside, above, under, behind, next to etc.;
> • give and understand instructions for moving along a line.
>
> **Level 2**  • understand the notion of an angle;
> • give and understand instructions for turning through right angles;
> • recognise different types of movement: straight movement (translation); turning movement (rotation); flip movement (reflection).
>
> **Level 3**  • recognise the (reflective) symmetry in a variety of shapes in two and three dimensions;
> • understand eight points of the compass; use clockwise and anti-clockwise appropriately.

*English for ages 5-11* (DES 1988b) also makes it clear how drama makes a particular contribution to the *speaking and listening* profile component. Drama provides an excellent context for developing a wide variety of spoken language and is described as:

> ...central in developing all major aspects of English in the primary school because it:
>
> • gives children the chance to practise varieties of language in different situations and to use a variety of functions of language which it is otherwise more difficult to practise: questioning, challenging, complaining etc.;
> • helps children to make sense of different situations and different points of view in role play and simulations, by allowing them to act out situations and formulate things in their own words;
> • helps children to evaluate choices or dilemmas, to develop the logic of different situations, to make decisions that can be put into practice, tested and reflected upon;

> • accustoms children to take account of audience and purpose in undertaking an activity.

The interim report of the history working group (DES 1989c) also gives a guarded endorsement of the use of drama as an aspect of pupils' historical study, which is particularly prevalent at primary level.

> Drama, role play, re-enactments, simulation and related approaches to history also have considerable potential in giving pupils insight into the behaviours of people in the past and into their motivation, reactions and relationships. By such means pupils can explore, and come to imagine, aspects of history which they have already explored in other ways. These approaches can also be the source of good, imaginative writing, and they help to bring history to life. They need to be used with care so that the historical message is not lost in the telling or play-acting. Nonetheless, these means can help to give pupils a sense of time and place.

> These different approaches to history have their own rules. As well as respecting these rules (for example, those of good dramatic practice) [pupils] need to respect also the rules of good history — above all, an uncompromising respect for evidence. If these conditions are not met, then the work could be merely 'dressing up' or 'pretending' which, however valuable or enjoyable, is not necessarily sound history.

This report also emphasises the cultural and aesthetic dimensions of historical understanding, which are reflected in the next chapter.

## Contributing to pupils' personal and social development

In addition to contributing to learning in other curriculum areas, the arts provide many opportunities for fostering personal and social development. In the next example a first school teacher encourages the personal and social development of a specific group of pupils through music teaching.

> I wanted to work with a group of less able children. When the project began, the children in the group were with the support teacher and so missed one of the two weekly music lessons. This was an ideal opportunity to work with them as a small group to compensate for the lesson they missed.

Although the teacher's main aim was to make up for the music lessons which these pupils had missed, her aims and objectives included artistic as well as personal and social criteria:

1. to encourage children to enjoy both making and listening to music;
2. to develop self-confidence in less able pupils;
3. to develop personal musical ability through active participation;
4. to develop an awareness of music;
5. to encourage children to work co-operatively as members of a group;
6. to present opportunities for non-specialist music teachers to use music as a resource in the education of the less able child.

The teacher describes the value of the project in terms of the children's personal and social development.

> The children were lacking in confidence in everything they did. In the small group they seemed to feel secure and were not afraid to express themselves orally or

musically. Their confidence grew rapidly within the group and this transferred into the normal classroom after a few weeks. They began to contribute to class discussions voluntarily.

When they were asked to accompany the hymns for the harvest service they were excited at the thought and gave up lunchtime playtimes every day for two weeks to practise. Two days before the event, however, they began to get cold feet: 'What if I make a mistake? So and so might laugh at me I might be shaking too much.' One of the girls then stated that she didn't care: she liked doing it, it made her feel important, and no one else would know even if she did make a mistake!

The group of six children who moved together into the next class in September were so enthusiastic that their new class teacher felt more confident in her own music lessons. The children asked to be allowed to play every time singing or music was mentioned and the whole class benefited. The class teacher said many times how much confidence the children were gaining and that they were encouraging her to explore new avenues in classroom music-making. She also helped the group during the preparation for the Christmas carol concert. The music group regularly accompanies the hymns for assembly and three of the girls have joined the recorder group. I intend to repeat this project next year with another small group of slow learners.

It is interesting to note how the children's enthusiasm, generated from their confidence, increased the non-specialist music teacher's confidence and gave her the courage to 'explore new avenues in classroom music-making'.

Puppetry is also a popular art form in many primary schools as it draws on a range of skills from craft, drama and theatre and yet has clear associations with children's play. The subtle role play involved in making and using puppets has been used to particular effect with some pupils with special educational needs. A teacher in a school for pupils with moderate learning difficulties devised a series of arts experiences to develop the language of a boy with language problems. Working with a puppet, the teacher monitored the development of the boy's spoken language. He began to speak in extended sentences and to instigate conversation, both remarkable achievements for this boy.

*Puppetry combines elements of craft, drama and theatre within a playful activity.*

Another example of puppetry's therapeutic potential emerged from a middle school:

The highlight of the day came from one of the Year 7 children, a girl from Bangladesh: Rezia. She expressed a wish to change the colour of her puppet's hair from gold to a colour closer to her own. The puppet she had made was dressed in a fabric that closely resembled a sari she had at home.

When her teacher talked with Rezia about her puppet she indicated that her puppet could sing, and she sang in Bengali. This was a remarkable achievement: she had not previously spoken to anyone in her mother tongue. She explained to her teacher that the song would be sung at a marriage. That afternoon she helped her friend to make a rod puppet similar to her own. The children were later to form a partnership which bolstered Rezia's confidence to such an extent that it totally changed the way she related to her friends and the rest of her class.

The teacher with responsibility for special educational needs across the school commented:

Rezia's problems were not just confined to language skills. She had great difficulty in coping with all aspects of the creative arts. On her arrival in school she had learned how to play and draw, not having experienced some of the elements of childhood taken for granted in Western culture. For her simply to make a puppet would have been a tremendous achievement but to go on to perform and sing in her mother tongue was a breakthrough. The class teacher felt that although she had been able to help her with her vocabulary skills, Rezia had not yet acquired communication skills and had therefore been grossly underachieving. The puppet had increased her confidence to such an extent that the teacher saw the true Rezia emerge.

For pupils with special educational needs the arts can provide many opportunities for success and achievement which can be denied in other areas of learning (see Chapter Seven).

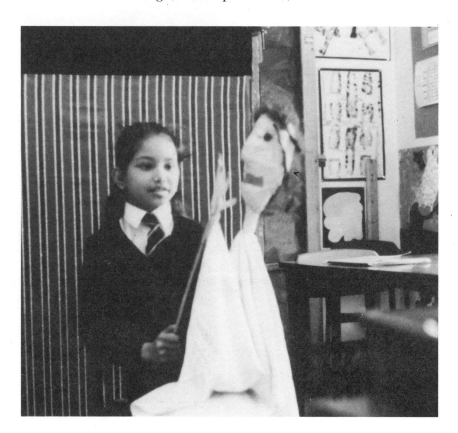

*Puppetry can prove a powerful stimulus for developing children's abilities in speaking and listening.*

**Study in the arts**

Themes can also be used in learning within and across the arts as well as across the whole curriculum. It is possible, for example, to take an artistic concept as the basis for project work in the arts. A teacher from a large first school, for example, was interested in involving dance, previously provided for separately within PE, in a project with her Year 3 pupils on *shape*. The dance work was inspired by inflatable toys and concentrated on changing shapes. The children created a gallery of living sculptures which was returned to as a recurring stimulus throughout the term (see the pictures at the bottom of p.64). At the same time a visiting secondary visual arts specialist happened to be working with the teacher's group on making pictures involving careful observation of shape, texture and colour.

In both of these experiences I had seen the children become unusually involved in the tasks they were set. This had sent me searching for possible developments. I wondered what would happen if these experiences were drawn together.

The children were particularly receptive to representing our dance shapes in visual terms. We returned to our original ideas of inflatable sculptures. Everyone was excited by the challenge of finding a suitable viewpoint, and the speed with which they needed to record what they saw. Working with white chalk on black paper gave them a variety of line and they were able to work quickly on quite a large scale. In many cases the negative image was later cut out very carefully, reversed and stuck on white paper. This produced some interesting changes in both the image and the children's response to it. The shapes which the dancers formed became more creative as they became increasingly aware of the shapes their bodies could make to an observer, and the visual artists produced a spontaneity and quality of movement which had not been previously apparent.

*Related concepts in dance and visual art can provide the stimulus for exciting work combining these two art forms.*

The following term, the teacher continued drawing together dance and visual art with her new class of Year 1 pupils. She was concerned that this might be difficult with these very young children but she continued her enquiry, developing an arts vocabulary through observation and discussion.

The children's experience of dance was limited: it was necessary to introduce them to various qualities of movement and to body shape. After some initial lessons where

we explored these elements, I returned to the gallery of sculptures. I asked half of the children to make interesting shapes which the other children looked at and talked about with me. We discussed the shapes the children were able to make and explored different viewpoints which appeared to change the shapes as we moved around them. They took turns either being the sculptures or the audience and I then asked the children to select their favourite sculpture and find a viewpoint they found interesting. I encouraged them to tell me why they had made their choice.

Dance vocabulary was beginning to emerge through the words they used to describe the shapes. One boy talked excitedly about the swirling, curling shapes created by a girl's long hair as it fell across the floor. When it was his turn to make a sculpture he tried to represent the same patterns in his own shape by using his arms and legs to twist and curl, since his hair was too short to produce the effect he had enjoyed.

The children were beginning to focus really well on the shapes it was possible to create in their dance movements, but I was still not sure how I could develop this focus in their visual art work. I decided to approach the problem from a new direction. I presented them with a visual stimulus, drawing line and patterns myself which they were to interpret through their dance.

Rather than making things easier, it didn't work at all. I had obviously made connections for which my pupils had not yet sufficient experience and which were beyond them. They were eager to try out this new idea but seemed confused about what I wanted them to do. They simply reproduced my lines and patterns as pathways across the floor and lost the expressive quality of their previous work. I had to think again.

What I was searching for was a way in which children could select and record the shapes they found exciting. This would give us a permanent visual record of their movement as a starting point. Photography came to mind as a possible answer. We used a simple lightweight 35mm camera which the children could handle. After some instruction as to how to hold a camera and use the viewfinder, we took it into the dance lesson to take photographs around the 'gallery'. The children were very careful in their selections and later when we looked at the photos they were able to tell me why they had chosen a particular shape or viewpoint.

Although the photography had been quite successful, and the children were developing their ability to show expressive and creative movement in their dance lessons, they had not yet taken it into any first-hand visual art work. We were now working on movement which would express the qualities of various percussion instruments. This was helping them to build simple dance sequences using a variety of free rhythms. I thought this might also present an opportunity for them to express the quality of both sound and movement in a visual way.

We took paper and crayons into the hall and left them around the edge to allow everyone a free space in which to move. I had chosen four instruments which would provide us with a variety of sounds. The children listened to the first instrument, a tambour, and then moved to the rhythm in a way which they felt expressed the qualities of the sound. They moved several times to the same rhythm pattern and I then asked them to go to the papers and draw a picture which would show us what type of sound and movement they had just experienced. I was amazed at how uninhibited the children were in representing such abstract qualities and wondered how I would have felt if someone had asked me to draw a sound!

The final stage was to ask for words which would describe the qualities they had felt in their movement and had tried to put into their pictures. We repeated this sequence with the other instruments: triangle, tambourine and castanets. The difference between the sounds these instruments produced was reflected in the children's movements and drawings. I brought all the elements together in a large class book

we called *Listen, Dance and Draw*. The children were as excited as I was by the progress we seemed to be making.

We tried a number of different activities with this theme. The children worked on a large scale to produce a frieze showing the kinds of movement generated when we used the shaken tambourine in a dance lesson. The children used paint and chalk to create twisting, light patterns which rise and fall. This was again done as an immediate response to the way in which they performed the dance movement. They also drew around their body shapes from the 'gallery' on large pieces of paper on the floor and the dancing figures were then cut out to produce a frieze of dancing silhouettes.

This project is an excellent example of children being educated *in* the arts. There was a theme for the work, *shape,* but on this occasion it was only used in relation to arts work, not to mathematics. This contrasts with the common practice of using a theme only to relation to work in core subjects, with arts work used only to reinforce the pupils' investigations. The teacher's main concern was to explore aesthetic concepts through different art forms. Apart from discovering concepts such as line, shape, pattern and texture, the children found them to be common to several art forms, reinforcing their understanding of them and their role within the arts.

## PLANNING FOR THE ARTS IN THEMATIC WORK

In addition to contributing to pupils' learning across the curriculum within a thematic approach and to promoting pupils' personal and social development, the arts need to be planned for as areas of study in their own right. To ensure that each of these three approaches is provided for, the following three sets of criteria are needed in curriculum planning.

**1. Thematic**  What will the children learn about the theme through the arts work?

*Useful questions to address*
- What information will this arts work contribute to pupils' understanding of the theme?
- How will the theme be explored through the arts in ways that would not be possible through other curriculum areas?

**2. Personal and social**  What will the children learn about themselves, in terms of working with others, making decisions and completing a task?

*Useful questions to address*
- Will the children listen to and take advice?
- Will the children work independently, make their own decisions and complete a task?
- Will the children work with each other, tolerate and enjoy each other's efforts?
- Will the children talk about their own work with a sense of purpose and ownership?

**3. Artistic**  What will the children learn in terms of the arts-specific skills, concepts and information learned through making and appraising?

*Useful questions to address*
- What types of arts-specific skills will be developed in this work?

- What arts-specific concepts will be taught?
- What arts-specific information will be acquired which directly affects the pupils' understanding of their arts work?
- To what extent will the pupils be making artistic judgements concerning their own and others' work?

Applying these three sets of criteria may help ensure that the arts are not used merely to service or 'decorate' thematic work. The main points to remember when embarking on a thematic project using the arts are:

1. teachers need to be committed to the development of the arts within the theme;
2. the topic has to be carefully chosen to include possibilities for arts teaching;
3. some arts teaching needs to be done outside the topic, as the arts are also specialised areas of learning in their own right.

## PLANNING FOR THE ARTS IN THEIR OWN RIGHT

One infant school devised guidelines for the arts with learning objectives and course content in each of the disciplines.

### Drama

Drawing from workshop drama outside education, we have introduced the children to a variety of body and voice activities, using many games. Children have to learn to take turns, to respect each other's voice and body space, and to explore their own voice and body possibilities. Group and circle work remain important. We use our own curriculum themes such as 'Creation', 'Darkness and Light' and 'The Elements' for stories, poetry and the children's own writing. Props are kept to a minimum although face paint and masks are used. We avoid material that is not 'gender friendly', or which gives too much attention to 'star' roles. Mixed age groups in lunchtime drama clubs are an interesting development. Through in-service workshops, everyone on the staff tackles drama. This is an area where staff support is vital and we encourage each other to take risks.

### Dance

As some of us were familiar with circle dancing, we have used this as a basis for introducing dance to all children. With material we have collected ourselves and with

*Children's dances can be based on a wide variety of cultural and historical traditions.*

help from the local circle dance teacher, we have a repertoire of dances that parents and staff enjoy as much as children. We find that both boys and girls respond to these old rhythms, mostly from Mediterranean countries, and physical co-ordination improves as we dance. Moving from the basic dances, we are adapting them and using the music creatively in festivals and religious celebrations. Instruments can be introduced as well as scarves, streamers, ribbons. Medieval music and old tunes are a good source of material, and one dance — 'The Bee Dance', using the old tune 'All in a Garden Green' — has been exported to a number of other schools and institutes.

### Art

Using our garden and the environment as a source of material for observation and drawing forms the basis of the art curriculum. Children are encouraged from the age of four to use charcoal, chalks, pastels and to mix paints as well as to explore ways of using pencils. We borrow artefacts and stuffed animals from the museum and are collecting a whole range of multicultural instruments, clothes and dolls to develop the work. Good paper and materials and attention paid to mounting are vital. We encourage free painting and a variety of pattern work, sometimes in groups, and use Celtic and Indian patterns for tracing and decoration. Templates and teacher outlines are never used. We encourage children to look at prints and photographs representing a whole range of artistic styles and cultures. The art in the school reflects both energy and precision, as did the work of a resident maskmaker who showed us how to make large structures and masks from withies [twigs] and newsprint, and left us with two large banners which decorate the hall.

### Language

In all aspects of language we try to use a variety of approaches, backed up where possible by research, to encourage children to develop their potential. Reading is encouraged through a home/school reading scheme, paired and group reading, and parental help in the classroom. Spelling is aided by use of the Letterland scheme and handwriting is given the specific physical help with co-ordination and smaller motor movements that may be necessary. We vary the types of writing from close text to letter writing, factual accounts, poetry and story writing. Drama, music and art might be used as stimuli for creative writing, together with our curriculum themes. Class books and developmental writing, using conferencing between teacher and child, encourage children to share their written work. The children are helped to explore their feelings as a part of the creative aspects of writing.

### Music

The children are encouraged to take part in creative music-making from the reception class onwards. Using themes from thematic work and musical ideas of rhythm, pitch and tempo, we ask the children to experiment, build up round patterns and later simple musical forms. We use voice, body sounds and instruments. This music is often combined with dance or drama work. Children find ways in which they can record the music they have created, and are asked to reproduce the music from their record.

Singing plays an important part in our musical activity. Each class has its own favourite songs: we encourage a core of songs that is learned by the whole school, and children and teachers make up their own to tie in with other classroom activities. We have a range of pitched and unpitched percussion instruments to encourage a wide variety of sounds and textures. Through workshops and consultation we encourage staff to gain in confidence and extend the musical experiences they share with their classes. A lunchtime music club offers further use of the instruments.

The headteacher and staff of this school have recognised the need to develop their own in-service work in the arts, complemented by outside specialists. They are all familiar with classroom drama's

educational value and use it with their own classes. The dance work is very different from 'music and movement': it uses folk dance forms with which the teachers and pupils are familiar.

Much infant and junior school art work tends to emphasise only *making* through spontaneous play-like activities. This school's visual art policy also emphasises *appraising* in the use of material from a variety of cultures and in the involvement of professional artists. The school also groups 'language' with the arts. In many schools literary skills are not directly connected to the verbal arts and can be marginalised. In this school creativity and the learning of skills are developed together.

The school has the following criteria for determining its arts provision.

- The arts must be a *daily* habit within and across the curriculum.
- The arts must take place *on site* and be relevant to everyone, not just a minority.
- The regular support of artists is needed, on site and using a planned budget.
- Performance should be secondary to process and should generally be informal, child to child, group to group, and occasionally child to parent.
- The school should have a written, planned arts policy, with a teacher responsible for overseeing its implementation.
- The arts must afford equal opportunities to boys and girls in content and organisation.
- The arts must reflect the multicultural nature of modern society, not just its cultural heritage.
- The arts should involve others in the community, particularly parents.
- The arts curriculum should have a problem-solving practical emphasis, with both collaborative and individual work.
- The child's immediate environment should be a source of inspiration and fantasy as well as a stimulus for learning.
- Children with particular artistic aptitudes should have an opportunity for further development.
- The school should have adequate resources for attractive display work, good examples of artefacts and images, quality materials and musical instruments. These should be *on site* to set early standards. Primary schools should offer the same access to other materials and artists as do secondary schools.
- There should be a network of teachers from local primary schools who meet occasionally, enabling schools to act as a resource for each other, with advisory support.
- The school should use one of its closure days for in-service work in the arts.

## RESOURCING THE ARTS

The arts need a wide range of resources: those which stimulate ideas for art-making; those used in the production and performance of work; opportunities to see the world of the arts beyond the school; and, particularly for the performing arts, time and space. Display in all the arts also needs resourcing: this is often catered for in the visual arts but neglected in the performing arts. It is relatively easy to display visual art and written work on the school walls but to display dance, music or drama requires a particular organisation of time and space. For pupils to show their work in these art forms to other classes or visitors requires a timetable change. For example, a school could reorganise an afternoon or morning for sharing the performing arts.

Material resources are redundant without knowledgeable and

experienced teachers to plan and organise the arts. Primary schools need to provide for three roles if the arts are to be adequately taught: the generalist class teacher, the teacher with specialist expertise, and the curriculum leader. These three roles indicate general areas of need in developing the arts in the primary school. In terms of staffing policies they need not be met separately: indeed, in smaller schools they may successfully be met by two or by one teacher.

## The role of the generalist

The primary classroom teacher who has little or no specialist training in the arts should nevertheless:

- have an understanding of how children can learn *in* and *through* the arts;
- be sympathetic to the arts and have a broad familiarity with the art forms;
- be confident in seeing the opportunities for arts work emerging from work in other learning areas and in encouraging creative work across a range of art forms;
- be able to recognise artistic achievement in children's work and provide due encouragement.

## The role of the specialist

The role of the specialist is to support the classroom generalist with more specific skills and knowledge in the arts. Such teachers can include:

- members of the school staff who have a specialist training in one or more of the arts and are able to support other staff and develop specialist activities: dance groups, choirs, drama clubs and so on;
- advisory teachers who visit the school, provide in-service training (INSET) for the staff and support teachers in their own classrooms;
- visiting arts teachers from secondary schools who can provide a useful link between the primary and secondary phases by preparing pupils for the increasing specialisation of the secondary school;
- artists, who bring specialist expertise to the school and introduce pupils to the idea of the artist as a professional member of the community.

## The role of the curriculum leader

This role involves taking responsibility for co-ordinating and supporting the arts throughout the school, including:

- developing curriculum guidelines for the arts;
- identifying training needs and co-ordinating in-service work;
- identifying sources of support beyond the school: other schools, regional arts associations, arts agencies, theatres, galleries, concert halls;
- being a persuasive and articulate advocate of the arts with parents and governors.

Many primary teachers acknowledge the need for specialist support to increase their confidence in teaching the arts. Three examples illustrate the kinds of support available. The first shows how an artist can support arts teaching in a primary school. If the teacher and the artist work together in partnership, they can provide a unique quality of arts education for the pupils. With the skills of the artist and the pedagogy of the teacher in combination, education *in* and *through* the arts can be developed together.

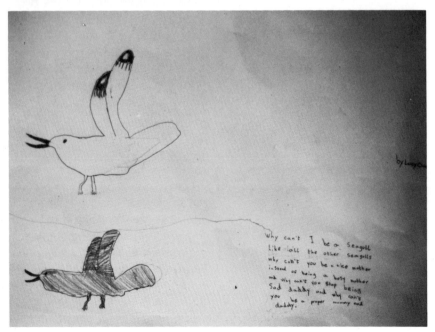

*Children should be helped to explore their feelings as part of the creative aspects of writing.*

**A poet in residence**    The deputy head of a primary school describes the school's rationale for poetry teaching, and how a professional poet contributed to it.

As soon as children come to the school, they are given the opportunity to appreciate poetry in simple forms: finger and number rhymes and traditional nursery rhymes. Poetry in the reception and middle infant classes consists of pieces which are short in length but which bring to the young child a valuable awareness of sounds and an enjoyment through listening and participation, often including body actions. All staff, from reception to Year 6, present to the children poems related to current topics.

The youngest children are encouraged to respond to poems which are read to them. They may simply discuss the content and the sounds or they may make pictorial representations. The importance of reading poems to very young children lies in the fact that poems enrich the children's own language experience and influence their written work. This may only describe the child's personal experiences and observations —a birthday party, trees in winter— but through listening to poetry and with guidance from the teacher, the child becomes aware of descriptive language and uses adjectives, similes and descriptive phrases to enhance his or her own first attempts at writing poetry.

The visits by the poet were stimulating, lively and not without surprise. His approach, which involved having a large group of more than sixty children sitting around the edge of our school hall, appeared at first to be highly unusual and not conducive to the writing of poetry to those of us who thought of it as deeply personal and intimate, something that called for small groups. The second surprise was the very structured techniques that the poet used to make the children write.

Many children produced poems full of exciting ideas expressed in highly descriptive words and imaginative phrases that they had chosen with great care. Deeply personal emotions were included in poems which dealt with the children's individual hopes and fears for the future, reminding us how young children do have the ability to confront serious subjects.

At appropriate points the poet introduced writing techniques and terminology, giving children 'tips of the trade' from the professional. Alliteration, use of simile and refrain were brought naturally into the sessions as the need arose, and the children quickly responded with examples of their own.

This example emphasises two important aspects of arts education. First, the importance for pupils of responding to other people's work, and to use it as models for their own. This seems obvious in the teaching of poetry, but for many dance, music, visual art and drama teachers it would be unusual to have *appraising* at the centre of very young children's learning. Second, the tight structures for writing poetry which the poet introduced were not the constraint that the staff originally feared. Personal feelings and responses were seen to be stimulated through the use of carefully structured techniques and poetic devices, and the deputy head noted that the poet's working methods applied...

not only to good practice in the teaching of poetry but to arts education in general. The ideas of working and reworking the medium, in this case words, of discussion and reflection, might just as easily apply to painting, where colour, shape and texture are explored. Similarly, in a piece of musical composition children might negotiate the types of sound, the speed, the volume and the form of their piece.

This residency therefore not only gave the staff a range of new teaching strategies and ideas about poetry, it also gave them the

opportunity to stand back for a short time and reflect upon the broader field of the arts and the processes and concepts they share.

## Exploring a work of literature

In the second example, a variety of specialist expertise was used in a project for a Year 6 class, including a student on teaching practice, local secondary teachers, advisory teachers and craftspeople in residence. It presents a more complex and ambitious model for arts education where several arts disciplines are developed within one theme, Homer's *Odyssey*. The headteacher introduces the school's approach to reading and language.

The school's approach is wholly based on real, first-hand experiences and on high-quality literature at all stages. There are no English exercises or commercially produced schemes of any kind. A literary continuum is perceived, which begins with picture books, rhymes, fairy tales, legend and good quality poetry and fiction and leads to classics such as *Beowulf, Hamlet, The Rime of the Ancient Mariner* and the *Odyssey*. This perception informs our whole approach to reading and literature. Children engage with literature in a range of ways with the emphasis on individual, expressive response.

The aim of the project was to explore the possibilities of a great work of literature as a source for creative and expressive response to the arts. Like the journey of Odysseus and his crew, this project always had its long-term aim but was never broken down beforehand into specific objectives. It was a journey of discovery rather than an orienteering course with a predetermined set of outcomes.

The classroom and the large practical area outside the school hall were a hive of industry. The *Odyssey* dominated the lives of the children and the other aspects of the curriculum were now looked on as a break or change from this all-consuming thing. Things like maths and science enjoyed as much time and effort but as retreats from the main event.

The children explored the poem's rich and complicated ideas through their own writing and also with the different specialist teachers, through drama, music, dance, painting and sculpture. The local secondary school's dance teacher explored a new vocabulary of movement with the children to express, through dance, the unfamiliar ideas and fantastic images of the underworld in the *Odyssey*. A student on teaching practice worked on the children's voices in drama. He had them chanting quickly, slowly, loudly and quietly the names of the characters and their own names. This was good preparation for the making of a tape which presented in choral speech form the departure of Odysseus from Kalypso. This was accompanied by work on sound effects: chopping, waves, wind, rushing water, thunder — a fine preparation for the work with a music specialist later in the project. She helped them develop original musical ideas using their voices and a range of instruments, culminating in a finished performance piece. The drama teacher examined the idea of leadership in the poem through dramatic improvisations.

A grant from the Crafts Council made it possible to bring in other professional support. A potter had the children exploring clay and talking about the Greek gods. This led to the children making their own plates, plaques, sculptures and models. A fabric worker showed them how to develop and express their ideas through the creative use of dyes, thread and fabrics. A theatre designer showed them photographs of her work, talked about large-scale model-making and

helped them to create mythical figures from chicken wire, fabric, bamboo, reeds and plaster.

At the centre of all this learning was the children's enthusiasm and delight in the *Odyssey* itself, not just with the story, but also, as the headteacher emphasises...

with its clarity, honesty and grandeur. This was essential. The *Odyssey* is not just a story. It is a finely-wrought work of art infused by the humanity and imagination of a great artist's language. We wanted the children to engage with this.

This project was unusual not only in its channelling of such rich resources into one class of pupils but in its conception. It was rooted in the assumption that a work of art can be a source of learning for the whole curriculum, and that children at primary school should have access to a wide range of arts disciplines, all introduced rigorously and as bodies of knowledge in their own right. Through the study of one of the major works of European literature, this project gave the

children insights into the ideas, values and beliefs of another time and culture.

**Exploring another culture**

Exploring another culture also provided the stimulus for term-long projects with Year 6 classes in two rural primary schools, involving work in visual arts, drama and music. The first involved exploration of Afro-Caribbean culture.

It would have been easy to adopt an isolationist perspective: 'What's the use of teaching multicultural topics to our pupils? Are they likely to encounter ethnic minorities in this part of the world? Let's stick to tadpoles and local environments.' Yet we all live in a society whose culturally diverse nature touches us all: through the newspapers and television, and when we move to a new environment.

In planning a project on African and Caribbean cultures, I was aware from the outset that to highlight differences would be to risk creating stereotypes. These would run counter to my aim of promoting empathy among the children for cultures other than their own. Equally aware of my own lack of authority on these cultures, I chose to look not at differences between cultures but at similarities and ways in which they have influenced each other.

Our approach was to look at our fundamental needs as a society and then to compare these with a selection of African societies, explored through their art and artefacts. This entailed imparting an understanding of traditional African art: that it is an integrated part of everyday life, that each object has a specific function and meaning, and may be a vital accompaniment to a specific social, religious or political event.

The aims of the project were:

- to foster empathy towards and understanding of black cultures and peoples through their arts;
- to examine African influences on the arts of other cultures, in particular cross-cultural influences on the music and visual arts of the USA and Europe.

The arts were to be used both as media through which the pupils learned new skills and as ways of initiating research into different facets of African culture. To understand a particular culture we would look at the reasoning behind its art, including the visual arts, dance, bodily adornment and music. Making and appraising African art was an integral part of this process.

The main areas of conceptual learning were organised so that the pupils gradually built up a picture of aspects of the lifestyles, customs and beliefs of certain African cultures whilst looking for correspondences in Western societies. They were tackled mainly in the following order, though with a lot of overlap:

1. African art as a functional and integrated part of society;
2. the universality of symbolism;
3. similarities between social networks in the West and in Africa;
4. the influence of African art (mainly music and artefacts) on Western art and culture;
5. how we perceive African cultures and why we perceive them thus.

There were six main phases to the project:

1. our society and its needs and the parallels between them and those of African societies;
2. a look at the Masai and Zulu cultures through the symbolism of their art, especially the concepts of leadership, government, displacement, education and health;

3. the functional and symbolic nature of art to the peoples of Africa, especially the Yoruba of Nigeria, and the differences in perceptions of art between the West and Africa;
4. the influences on Western visual art and music of African art and its accompanying symbolism;
5. the spread of African cultural influences through the slave trade and immigration;
6. the utilisation of these ideas by a practising artist.

The children were to become cultural detectives and the logical place for them to start was their own community. We looked at symbols which represented some of our needs as a society: a judge's wig or a policeman's helmet standing for law and order, for example. This part of the project was quickly in danger of swamping the rest, for the children responded with masses of information from magazines and newspapers. Their efforts were directed towards the concepts of family, religion, health, education, law and its enforcement, government and power, and entertainment.

Having looked at the interrelationships between these concepts and after producing a display of children's work highlighting our society's needs and the symbolism we associate with them, we looked for their counterparts in African cultures. Initially, we looked at television programmes on the Zulus and their displacement in and around South Africa. We followed this up through role play, with the notions of conflict and injustice introduced to promote further thought. We looked at the Masai and their traditional system of cults, with emphasis on education, age rites and the bodily adornments associated with them. This information enriched our drama as we produced costumes, facial decorations and cult masks. All were used in their correct social context, even though our two African cultures had become intertwined. The final product was a play which the children video-recorded.

A visit to a local museum to study Yoruban and Benin art from Nigeria followed. The children were given worksheets to record information on the artefacts, their attention drawn to the areas of royalty, religion and symbolic function. The next phase involved looking at the transition of such ideas and cultural trends across the oceans and the resulting blend of cultures in America, Britain and the West Indies.

A variety of people were invited to the school to impart knowledge and expertise.

A mission teacher from Kenya who had spent fifteen years in Africa described how some traditional aspects of tribal life have changed as a result of European influences. She also provided us with a superb display of African art work.

The museum's education officer, an expert on Yoruban art, gave talks which emphasised the significance of African art as a functional part of life and its symbolic importance to every member of society.

A Barbadian social worker described many aspects of life in the West Indies, including language, law, cooking and sport.

A Ghanaian woman who had lived in this country for twenty years displayed food items of African origin which are commonly available in this country, demonstrated traditional African hairstyles and dress which have influenced European thinking, and talked in her London accent about Ghana and the traditions she inherited from her parents.

A practising sculptor, trained at the Slade, who was introduced to me by the county art adviser, came to the school for a week's residency, approaching the project from the perspective of European and North American music influenced by Afro-Caribbean rhythms. He produced several large pieces in wood with four groups of children, the emphasis being on working in a traditional African style, using colour to impart rhythm.

In the weeks preceding the sculptor's visit the children had, through drama, explored

the spread of African tribal rhythms to the West via the slave trade. They had resumed adopted roles as tribal Africans, first assumed at the beginning of the project to explore feelings of displacement. Their tribe had suffered the indignities which the Zulus in and around South Africa had experienced at the hands of white settlers who desired their lands for their mineral and agricultural riches. This feeling of helplessness was revived in the second set of drama sessions when they were transported as slaves to foreign lands.

Running parallel to these sessions was a series of lessons designed to familiarise the children with the development of modern popular music. I had selected pieces of music which had easily detectable rhythmic and harmonic associations. Through listening, discussing and writing we traced the influences of African tribal rhythms up to the present day. The order we followed was: African tribal songs and chants, slave and early gospel, the blues, jazz and soul, modern rock and pop. This development was examined chronologically, although it was emphasised that several of the styles existed simultaneously and overlapped.

The children explored the deeply resonant rhythms of southern African song, the vocal harmonies common to many tribes, and the rhythmic percussion accompaniments that we detected in many of the songs. The pupils with special educational needs recorded their findings on cassette rather than in writing. To complement this work our music specialist took a series of lessons which incorporated songs using African vocal harmonies and percussion, based on the work of Hugh Masakela, Ladysmith Black Mambazo and others.

In the phase dealing with African influences on Western art the children had learned about the importance of the rhythmic sounds which accompanied the making of religious and political artefacts, and about implied rhythms in the visual art of both African tribal societies and Western artists such as Picasso and Braque. They had studied the influence of the former on the latter.

It was against this background that the sculptor entered the project. At our initial meeting I briefed him on the project, he was introduced to the children and discussed their work informally with them. When he left he had reached some conclusions about the direction his work with the children would take, which he undertook to develop and present for approval at a later date.

On the first day of the week-long residency the sculptor introduced himself and his work to the whole school in assembly and then to parents at an evening meeting. This had two important consequences: it made both staff and parents aware of the importance of using artists as a learning aid, and it led to an offer of similar help from a parent who is a practising artist.

*The sculptor's work had been influenced by artists from other societies who worked in wood, using traditional methods of carving and bright tropical colours to represent mood, rhythm and symbolism.*

The sculptor's work had been influenced by artists from other societies who worked in wood, using traditional methods of carving and bright tropical colours to represent mood, rhythm and symbolism. These influences helped determine the shape and form of the work he did with the children.

On the first afternoon he discussed his ideas with the children who were to work with him in groups of eight, each of mixed ability and sex. In the mornings he worked on his own in a corner. He was to make four icons, sculpted in concrete, each representing a form of transport associated with the period of music he had discussed with the groups. Each group was also to produce its own piece of sculpture which reflected these periods of musical history: for example, the piece one group made concerning African tribal/slave music was accompanied by the sculptor's icon, a slave ship.

The sculptor took great pains to make the work relevant to the pupils' topic. Through their sculpture the pupils further examined the theme of African rhythms and their contribution to Western music; they worked in wood collected from nearby hedgerows

(with the consent of local farmers); traditional methods of binding and joining were used, and colours which reflected the vibrancy associated with tribal art and its visual rhythms.

The works were constructed outside, where they would be subjected to the ravages of the elements, undergoing a natural transformation similar to that of African ancestor statues which are allowed to rot back into Mother Earth in a symbolic gesture of both regeneration and respect for the living. The wood carving brought together several strands of the whole project, placing firmly into context the rituals of carving and the symbolism of the artefacts.

In the mornings when the sculptor was either making his icons or preparing for the afternoon sessions he was accessible to the whole school, and many came to watch him or to question him about his work. Children from other classes became involved in other ways too. One class used the sculptures as the basis for observational drawings, another as the inspiration for a discussion about perspective. The children who made the works were continually questioned by both their peers and their parents about the symbolism and meanings of the pieces. They thoroughly enjoyed the challenge of working in different materials and on a larger scale than usual. The residency opened up many possibilities for using other materials to create what our guest described as 'linear drawings in space'.

Others who witnessed the work were impressed by the evidence of increased tolerance and understanding among the pupils toward people from different cultural backgrounds. Rather than relying upon such subjective judgements, I gave the children assessment questionnaires at different stages of the project to elicit their responses to their own work and to my teaching, and their attitudes to people of different ethnic origins.

In answer to 'What was one of the most important things you learned in this project?' one girl replied: 'The most important thing I learned about was art in Africa, because to them it means a lot, everything. It is their life and really matters. It is so much different from ours.'

More importantly perhaps, the project demonstrated that children can be given access to concepts such as religion and the law through studying the art of other cultures. Using artefacts as the basis for cultural investigation and working outwards, pupils' attention can be focused initially on the artefacts themselves with all their subtleties of tone and texture, then on the culture within which they were created. There were difficulties in this project, such as lack of space and of written material of a suitable level for the children to work from, but none proved insurmountable. The quality of the children's work amply justified the extra preparation involved.

In terms of the classification of roles introduced earlier, in this project the teacher fulfilled each of the three roles of the primary teacher: a generalist, in seeing the opportunities for arts work emerging from work in other learning areas, in encouraging creative work across a range of arts disciplines and in enlisting the support of the school's music specialist; a specialist in terms of the visual arts dimension of the project; and a curriculum leader, in identifying sources of support beyond the school.

The second project, on Morocco, had a stronger cross-curricular emphasis. The teacher's aims were:

- to help children develop the knowledge, attitudes and skills relevant to living in a multicultural society and a interdependent world;

*The children studied the influence of traditional African art on Western art forms such as Cubism.*

- to examine Moroccan culture through an art form;
- to use the children's experience in the arts to promote research, discussion, and the ability to draw comparisons and note similarities between peoples.

In formulating these aims, the teacher had been inspired by reading an early account of the previous teacher's work. Unlike him, she did not have an arts specialism, but was equally willing to learn alongside the children in extending the topic through the arts. Once again, the three teaching roles are successfully combined, and the centrepiece of the project is a residency by an artist, in this case a weaver. In this teacher's account there is, however, a greater emphasis than in the previous project on pupils' personal and social development, as reflected in the first aim. The arts are conceived more as a stimulus for and reinforcement of other kinds of learning than as areas of exploration in their own right. In other words, the emphasis is more on learning *through* than *in* the arts.

The weaver was engaged in her own study of the culture and lifestyle of the people of Morocco, spending time each year with a Berber tribe, and was able to supplement her own experience with numerous artefacts. Handling these objects and learning the craft of weaving were to comprise the children's direct experience to set alongside discussions and activities to heighten their awareness of the global and interdependent nature of our existence.

This strategy was in part a response to the view that classroom activities are relevant only if they involve things that can be held and touched. Whilst respecting this as a point of view, I cannot accept it as the only criterion for assessing what is valuable in primary education: if links are not made with things and places far outside children's present environment, they may grow up with a very distorted world view, with the mass media its main input.

The lifestyle of the Moroccan people was to be under view in a project called 'Common Threads' because we were not only to look at Moroccans' explanations of events in their lives but to identify similarities in our own lives. 'Superstition' and 'scientific logic' would be explored as the different attempts of people, using the information at their disposal, to account for the happenings in their lives.

I was very aware of how little I knew about Morocco. While gathering resources I became aware that I was not alone. The county library service loaned me three books, the sum total of my 'topic collection', and investigating the music or art of Morocco involved innumerable telephone calls and letters, all of which produced only very general information. The dearth of tangible resources concerned me because I was accustomed to keeping well ahead of the class in factual terms. Like the children, I would have to pick up on the weaver's input.

My work with the class began from where they, their parents and grandparents had been born and whether they had any relatives living abroad. This was extended to look at penfriends and foreign holidays. This information was included on a sketch map of the world. In art work the children considered the specialness of their own families and designed coats of arms, some depicting the jobs their parents did, others their hobbies.

The children then compiled in groups a list of objects in the classroom and the raw materials from which they thought they had been made. We then worked out which countries were the main producers of the raw materials and this information was added to the sketch map. It was my aim that the children should focus on their personal contact with the wider world, and see how their classroom was part of a worldwide network of producers and consumers.

*Opposite above*
*In a project centred upon a study of Picasso's painting,* Guernica, *sixth-formers explored themes from the painting using movement, drama and Spanish song. (See text on p.23.)*

*Opposite below*
*In a project inspired by an artist in residence, primary school children spent the morning exploring the relationship between movement and drawing through sketching body shapes in stillness and movement, and then the afternoon creating a huge collaborative mural of dancing figures. (See text on pp.31-2.)*

At the teachers' centre the following week a secondary visual arts specialist led a session exploring the theme of symbols through various media: printing with polystyrene blocks, cutout paper work and symmetrical pattern design, later extended into Islamic patterns. In preparation I had led a discussion on language and the problems of communicating with people who do not speak the same language as we do, leading into consideration of signs and symbols. We also talked about different alphabets, dialects and accents.

These language ideas were extended into music, with groups working on question-and-answer phrases on the xylophone, glockenspiel and chime bars. We then listened to some African drumming music and the children paired up with a drum and tambour to compose their own pieces of drumming. This highlighted the complexities of trying to create variety on a drum without using sticks, and we agreed that their compositions were very dull in comparison with those we had listened to.

Sign language was extended into drama, with two sessions conducted in virtual silence. Speech was only resorted to when communication had broken down or when clarification beyond all our signing abilities was needed. Having begun with miming games, each child endeavoured to communicate to a partner something that they wanted him or her to do. In the second session the ideas were developed in groups of three or four and, by signing, the children worked out a short story and enacted it for the rest of the class. These were set to music with groups coming in and miming at different points.

The weaver came into school and led a stimulus session on Morocco using slides, photographs and artefacts. Her input began with issues like our common human need for survival and led on to the topography and housing of Morocco. The children wanted to know why the houses had flat roofs, few windows, and so on. We kept relating back to our type of housing and its appropriateness to our landscape and climate.

The weaver talked about the Moroccan people's lifestyle, the division of labour, education, superstition, and the perception of time. The phenomenon of the 'evil eye' was raised from a question about a shepherd's cloak with an embroided eye on the back. This remained a fascinating idea for the children and, later, when we were looking at the rituals surrounding life in a Berber tribe, they seemed to have developed the empathy to identify with how people might feel at certain times.

During the weaver's next visit the children warped up small wooden cards and began their own weaving. They gradually began to try out ideas and work through them on their own. Later we used tomato boxes as simple loom frames. The warping up of these proved painstaking, but many of the children became adept at getting just the right tension on the warp threads. Some of the boys' weaving was particularly innovative. Many children went on to weave a sign or symbol relevant to them, and later I bought a metal bed frame for £6 and they warped that up! (See pictures on p.65.)

The children found strange the suggestion that some Moroccan women never left the village, that men did the shopping, that women were sometimes regarded as possessions by their husbands, that they separated into sexes in the mosques. To alleviate this sense of alienness and to heighten the children's awareness of their own assumptions about male and female occupations, I showed them six photographs of men and women engaged in various activities. For some children these were also surprising: a woman bus driver, a man operating a sewing machine, a woman doctor in a hospital, a man vacuuming, a woman at the helm of a ship and a man bathing a baby. We then filled in a chart of who did what at home. It became clear that some children had strongly-established role models.

This was followed up in drama with the children role playing, individually and then

in pairs, activities or occupations which they wouldn't expect to do on account of their sex.

The weaver then led a lesson on ceremonies, telling the children about the rituals related to the birth of a baby and all 'superstitions': the kohl around the baby's eyes, the charms around its neck, its seclusion with its mother for seven days — all to give it protection from evil spirits or djinns. It was when she told them of the bowl of milk with soot in it, left outside the door lest the much revered owl, thought to have hidden breasts, should come to suckle the baby and cause its death, that real empathy showed as a child drew a parallel with the unexplained phenomenon of cot death in our society.

Symbolism was discussed with reference to Moroccan and British marriage ceremonies and to the death ceremony. The matter-of-factness of the Moroccan death ceremony caught their attention: the immediate burial — they took a while to work out why this might be — and the businesslike way in which everyone went back to work afterwards.

I had been fortunate enough to obtain a tape-recording of some Berber wedding music, and during the next few days the children listened to it in groups. We then had a class discussion about it, which was quite difficult for me as I found the music very hard to appreciate. Their write-ups, however, showed them far more catholic in their taste: another reason for early exposure to other cultures.

On her next visit the weaver showed slides of the sheep-shearing ceremonies. We talked about how the children might record their information, and they decided on either annotated drawings or cartoon strips with writing underneath. She also spoke of some of the Moroccan beliefs about spinning, such as that wool must be left on the spindle for it to eat.

She also told the children stories from Moroccan oral culture, including one about the Hoopoe bird, whose brains are eaten because they are believed to have magical qualities. The bones are then boiled up in henna and the one that takes the dye the strongest is thought to be lucky.

I wanted to give the children the opportunity to make a large model of this bird, and through the art adviser procured the services of a secondary school art teacher. He came into the classroom and with fifteen children, masses of newspaper, wallpaper paste, brown sticky tape and a cane, created a huge living sculpture which was hung from the ceiling. (See pictures on p.65.)

The children had become fascinated with how the weaver lived when out in Morocco, so she gave an account of a typical day in her life there and this led to a fascinating conversation about food: in particular, why different peoples regard different types of meat as suitable for eating or otherwise. Contrasting values were discussed in relation to the treatment of animals: in Morocco an injured mule would be left in the sun to die, while in Britain animals are force-fed for food, which would be as obnoxious to a Moroccan as their treatment of the mule to us. We talked of laws and punishment and of Islamic values, and I extended this into a directed reading activity about Islam.

My class, in common with many primary school children, had had no experience of portrait or figure painting, so we returned to the teachers' centre with a secondary visual arts specialist and after a morning session on colour mixing and experimentation with materials, the children painted portraits of two children dressed in Moroccan clothes. They loved doing it and I found it exciting to see the characters of children whom I knew come through in real authorship of their work.

Shortly after this the class made a final visit to the teachers' centre for a day of music led by an enthusuastic collector and maker of musical instruments. During the

A project in an urban sixth-form college provided another example where attitudes to gender were challenged. Its basis was an exhibition of paintings by a woman artist, the theme of whose work was the female nude, particularly the pregnant nude. (See p.34-5.)

In one first school the children created a gallery of living sculptures which was returned to as a recurring stimulus throughout the term. (See p.44.)

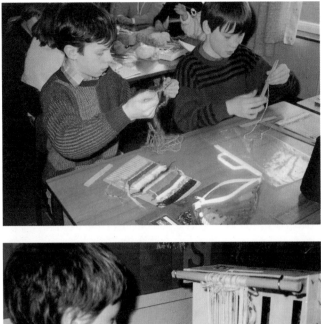

*The children warped up small wooden cards and began their own weaving. Later we used tomato boxes as simple loom frames. The warping up of these proved painstaking, but many of the children became adept at getting just the right tension on the warp threads. (See p.62.)*

*With masses of newspaper, wallpaper paste, brown sticky tape and a cane, fifteen children created a huge living sculpture which was hung from the ceiling. (See p.63.)*

morning he demonstrated an incredible variety of instruments from all over the world and captivated the children with a lively commentary (see pictures on p.68). The afternoon was spent with the children divided into groups, making music on the instruments of their choice.

In music, as in any art form, it is necessary to have time for exploration and discovery before commitment to a task. A couple of times we stopped to listen to each other and to help some of the less imaginative children or those having problems with the mechanics of playing. At the end of the afternoon a video- and sound-recording was made of each group presenting what they had created to the others.

Back at school the children constructed instruments of their own and made up rhythms on them. Dental floss can be surprisingly tuneful when attached to a glacé cherry container and a piece of hazel! Writing, drawing, art work and weaving were completed — apart from the bed loom, which was to remain in operation for the following term's work on the theme of 'textiles'. Then I decided to attempt to evaluate our journey through the term.

I compiled a set of slides depicting Western and Moroccan lifestyles — a modern fitted kitchen from a consumer magazine was juxtaposed with a more basic Moroccan equivalent, for example — and a record sheet on which to classify the children's responses into categories of observation, description, explanation and transformation, through which we would measure their ability to extend their ideas to things outside the images.

I was not testing attitudinal development by exploring latent prejudices but rather the children's ability to make connections, see common threads, between their lives and those of Moroccan people. Endeavouring to be scientific, I showed the slides to another class by way of a control group. It was an interesting experiment but did not yield any conclusive information, probably because the children were very aware of what they thought I 'wanted' from them.

These two extended accounts reinforce the previous examples in underscoring the main themes which are explored in the rest of this book.

1. the interrelationship between *making* and *appraising* in arts teaching and learning, explored in Chapter One;
2. the variety of teaching roles demanded by work in the arts, explored in Chapter Two;
3. the relationships between the different arts disciplines, explored in Chapter Four;
4. the centrality of assessment as an integral part of arts teaching, explored in Chapter Five;
5. the need for sharing of resources and expertise in the arts between the different phases of education, explored in Chapter Six;
6. the need to provide access to the arts for pupils with special educational needs, explored in Chapter Seven;
7. the roles of professional artists in the curriculum, explored in Chapter Eight;
8. the roles of the arts in promoting links with the wider community, explored in Chapter Nine.

These accounts also introduce the two principles which have permeated all the project's work, and which underpin this book: the need to provide for cultural diversity and for equal opportunities for boys and girls within the arts in the curriculum.

# SUMMARY

The primary curriculum affords many opportunities for developing arts practice, but primary teachers need to articulate aims and objectives for arts learning as for all areas of the curriculum. Many do not have sufficient arts training to articulate their aims in this way. They work intuitively but without the conceptual language to plan, describe and evaluate their work they may miss valuable opportunities for extending their pupils.

Within the thematic curriculum it is important to ensure that there are opportunities to study the arts in their own right: for learning *in* as well as *through* the arts. This involves teachers planning and evaluating work using arts-specific criteria as well as those concerned with the theme itself and with pupils' personal and social development.

Primary schools need an arts policy to ensure that the arts are well represented in relation to other areas of the curriculum, that there is a balance of work in different arts disciplines, and between *making* and *appraising*. There should be curriculum guidelines in each discipline to help teachers to sustain the teaching of the arts in their own right.

School policies for staffing in the arts are necessary to ensure that within the school or a local consortium there are:

1. generalist teachers with a willingness to introduce the arts;
2. teachers with specialist expertise in one or more art forms;
3. curriculum leaders for the arts.

---

### A checklist for evaluating the arts in the primary school

1. Does your school have a policy for the arts?
2. What range of arts disciplines is provided for within this policy?
3. How does the policy reflect the school's equal opportunities policy?
4. How are pupils with special educational needs given access to the arts?
5. To what extent are the arts developed within thematic work?
6. To what extent are the arts developed as specialist areas in their own right?
7. What opportunities do your pupils have for *appraising* as well as *making* in the arts?
8. Is there a post of responsibility for co-ordinating the school's arts programmes?
9. What kinds of in-service development in the arts in terms of specialist support do the staff in your school have: professional days, input from advisory teachers, professional artists, secondary specialists?
10. To what resources beyond the school do your staff and pupils have access?

*The class made a visit to the teachers' centre for a day of music led by an enthusiastic collector and maker of musical instruments. During the morning he demonstrated an incredible variety of instruments from all over the world and captivated the children with a lively commentary. (See p.66.)*

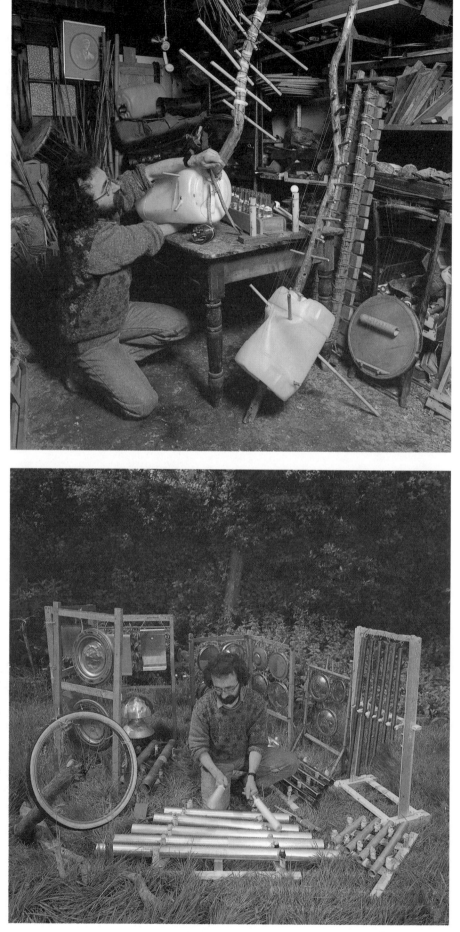

# THE ARTS IN THE SECONDARY CURRICULUM

## INTRODUCTION

In this chapter we consider the place of the arts in the secondary curriculum. We begin by identifying three issues of pressing concern for all arts teachers: the balance of provision for the arts, timetabling and the informal curriculum. Issues for curriculum planning in the formal curriculum, including timetabling, at Key Stages 3 and 4 are then explored in detail. The chapter concludes with a detailed examination of the roles of the arts in the informal curriculum of secondary schools.

## THE STATE OF THE ARTS

Primary schools meet the challenge of developing a coherent arts policy by pooling staff expertise and by drawing on specialist expertise from outside the school, including neighbouring secondary schools. In secondary schools there is no less need for teachers of the arts to collaborate with colleagues from other disciplines to develop an arts policy. Three issues merit particular consideration in developing such a policy:

**1. *The unbalanced nature of arts provision at secondary level***
This is manifested in the uneven levels of status and resources between the different arts disciplines in individual schools, but is rooted in the different histories and traditions of the arts disciplines in education. We explore these in more detail in *The Arts 5-16: A Curriculum Framework*.

**2. *The constraints of the traditional secondary timetable***
The arts do not sit easily in a day divided into single periods. These do not give pupils the time to benefit from the working methods used by the arts. A painter reminded teachers of this in the course of a two-hour workshop session with pupils: that artwork develops unpredictably and can take anything from an afternoon to a lifetime to produce.

Many secondary schools in the project experimented with different types of block timetabling in order to give pupils a more satisfactory experience of the arts. New timetabling challenges are arising from

the practice of grouping the arts together, which is discussed in more detail later in the chapter, and from the structure of the National Curriculum, which we turn to shortly.

### 3. *The roles of the formal and the informal curriculum*
Arts activities most commonly available outside the timetable are bands, orchestras and choirs, drama and dance groups and, to a lesser extent, art clubs. These activities are highly valued by most schools, but for varying reasons. Some regard them as a valuable shop window for the school, while others realise that the quality of the learning experience that pupils receive is something not available within the normal timetable. One headteacher made the following observation about a successful production.

It brought the school to life, and involved a great many students, raising again the question of the extent to which the benefits of this sort of venture could be brought into the school timetable.

We explore this issue further later in this chapter.

## THE ARTS AND THE WHOLE CURRICULUM

The varied nature of arts provision does not reflect only the distribution of specialist staff across schools. It is rooted in the different histories and traditions of the arts disciplines. In *The Arts 5-16: A Curriculum Framework* we argue that the arts share a number of common processes and principles. They can also contribute in shared ways to the teaching of major issues and common themes across the secondary curriculum.

The cross-curricular approach to teaching and planning has been given added impetus by the National Curriculum, particularly in the inclusion as a foundation subject of design and technology as an activity which goes across the curriculum, drawing on and linking with a wide range of subjects. DES (1989b para. 1.22) observes the following.

> In design and technology the fluency of pupils in the design 'language' of form, pattern, colour, texture, shape, and spatial relationships is of crucial importance. Their command of this 'language' and judgement of how to apply such considerations could clearly be developed further in art.

Such 'language' is indeed relevant across the arts as a whole. Designing as an aspect of *making* — in terms of sustaining a composition from initial stimulus to realised form and following a logical sequence in the selection and development of material — is as central to dance, drama, verbal arts and music as to the visual arts. Each of the arts can make particular contributions to delivering the four Attainment Targets for Profile Component 1 'Design and Technology':

> ### AT1 - *Identifying needs and opportunities*
> Through exploration and investigation of a range of contexts (home, school, recreation, business and industry) pupils should be able to identify and state clearly needs and opportunities for design and technological activities.

> ### AT2 - *Generating a design proposal*
> Pupils should be able to produce a realistic, appropriate and

achievable design by generating, exploring and developing design and technological ideas and by refining and detailing the design proposal they have chosen.

### AT3 - Planning and making

Working to a plan derived from their previously developed design, pupils should be able to identify, manage and use appropriate resources, including both knowledge and processes in order to make an artefact, system or environment.

*Designing is a process central to all work in the arts, not just an activity related to design and technology.*

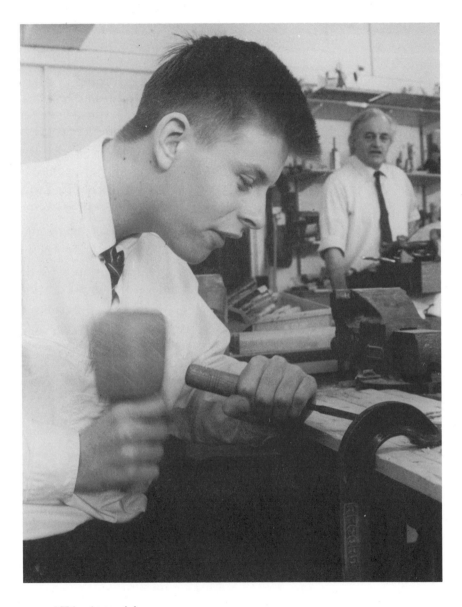

### AT4 - Appraising

Pupils should be able to develop, communicate and act constructively upon an appraisal of the processes, outcomes and effects of their own design and technological activity as well as of the outcomes and effects of the design and technological activity of others, including those from other times and cultures.

(DES 1989b)

During this century technological developments in ways of recording and altering images and sounds from the 'real' world have been increasingly important in the exchange of information and ideas.

They have also stimulated new kinds of artistic practice and helped to alter our conceptions of art itself. It is through the arts that many of the major technological advances such as developments in publishing and communications are experienced and explored. Arts teachers therefore have particular contributions to make in delivering the Attainment Target for information technology (IT).

> Pupils should be able to use IT appropriately and effectively to communicate and handle information in a variety of forms and for a variety of purposes and to design, develop and evaluate appropriate models of real or imaginary situations.

The range of possibilities for the arts in contributing to the delivery of this Attainment Target is wide: from computer graphics through video, sound-recording, synthesisers and lighting, and through links with media education. This does not mean merely skills-based courses but creative and critical engagement with a range of new media and forms. Through the arts, young people can explore many of the most fundamental aspects of technological change.

Opportunities for the arts also exist in the programmes of study and Attainment Targets of other foundation subjects. Attainment Target 14 in science, entitled *Sound and Music*, requires the following.

> Pupils should develop their knowledge and understanding of the properties, transmission and absorption of sound.

The programmes of study for the four Key Stages which support this target reflect some important elements of a 5 to 16 music curriculum.

### Key Stage 1
Children should have the opportunity to experience the range of sounds in their immediate environment and to find out about their causes and uses. They should investigate ways of making and experiencing sounds by vocalising and striking, plucking, shaking, scraping and blowing, for example, *using familiar objects and simple musical instruments from a variety of cultural traditions.* Children should explore various ways of sorting these sounds and instruments.

### Key Stage 2
Children should be made aware of the way sound is heard and that sounds, including musical notes, are made in a variety of ways, and can be pleasant or obtrusive in the environment. They should explore the changes in pitch, loudness and timbre of a sound, for example, *by changing the length, tension, thickness or material of a vibrating object,* and through ways of causing sound, for example, *use of different mallets, overblowing.*

### Key Stage 3
Through access to a range of sources of information, pupils should study the way sound is produced and can be transmitted over long distances, how the ear works, common defects of hearing, the effects of loud sounds on the ear and the control of noise and sound levels in the environment. They should have opportunities to investigate the audible range. Pupils should investigate the effect on sound of the shape and materials of the built environment, such as reverberation times and insulation rates.

### Key Stage 4
Pupils should explore sound in terms of wave motion and its

*Pupils can explore the variety of ways in which sound is made by constructing their own musical instruments.*

frequency. They should have opportunities to develop their understanding of the properties and behaviour of sound by developing a wave model, for example, *through observations of waves in springs and on water*. This should be related to pupils' experience of sounds and musical instruments, acoustic and electronic instruments and recording and synthesising. They should be given the opportunity to investigate devices such as microphones and loudspeakers which act as transducers and be introduced to the mechanisms underlying various communications systems (telephone, radio) on which a complex society depends. Pupils should investigate the characteristics and effects of vibration, including resonance, in a range of mechanical systems. They should extend this study to include some uses of electronic sound technology in, for example, *industry (cleaning and quality control), medicine (pre-natal scanning) and social contexts (musical instruments)*.

The history working group (DES 1989c) emphasises the following.

> ... the cultural and aesthetic aspects of history should be component parts of every History Study Unit.

> This is for two reasons. First, the arts in their broadest sense offer a rich and incomparable range of primary sources for the study of history. They offer not only potential evidence of an obvious kind, but also in the hands of informed and experienced teachers they contain more subtle clues about the past, for example in the symbols they employ or the questions they suggest: 'Who paid for this painting?' 'What did contemporaries see in it?' 'Why do forms of music, dance or drama change from age to age?'

> Second, history can be a vehicle for the study of the arts themselves.

It offers a broad context for this kind of work which calls for close co-operation between historians and other specialists.

### Music and dance

Music in a range of forms (religious, martial, folk, popular, classical etc.) can be an important and vivid source of evidence about the past. Music has often had important social functions beyond entertaining people, by celebrating triumphs, telling stories, displaying the prestige of patrons, and expressing deep national or social sentiments or the important concerns of individuals. It is insufficiently exploited as an historical source. Pupils can also use dance as a form of expression of historical understanding — derived for example from the study of artefacts, sculptures and paintings. History can also explain the origins of traditional dances (Morris dancing, maypole ceremonies, jigs and reels etc.) as well as later and modern dance forms.

Cross-curricular dimensions, skills and themes, also given added impetus by the National Curriculum, provide further challenges for arts teachers to explore the common contributions they can make to the whole curriculum. As much of the practice represented throughout this book illustrates, the arts can contribute significantly to the teaching of cross-curricular *dimensions* — equal opportunities in respect of gender and race, and special educational needs; cross-curricular *skills* — numeracy, literacy, graphicacy; and cross-curricular themes.

In relation to the theme of education for economic awareness, many teachers have sought to develop pupils' awareness of art as a commercial activity which involves meeting the demands of clients, as examples in Chapters Eight and Nine illustrate. Art as an aspect of *environmental awareness* is also well to the fore in activities such as the mural painting described in Chapter Nine. Reference is also made in Chapter Nine to local firms contributing in various ways to arts events in schools. Introducing pupils to the concept of art as labour is an important dimension to the increasing involvement of professional artists in the curriculum, as Chapter Eight illustrates. For pupils seeking careers in the cultural industries, learning about artists' economic affairs may prove the most relevant aspect of their careers education.

In relation to themes such as personal and social education, secondary arts teachers might draw upon the work of many primary teachers, as represented in Chapter Three, in building learning objectives in such areas into their curriculum planning. Primary thematic work also offers similar models for cross-curricular learning in the arts.

In addition to whole-curriculum planning connected with implementation of the National Curriculum, two developments have had particular influence on curriculum planning in the arts at secondary level:

1. the shifts towards the grouping of the arts together in various ways at Key Stage 3;
2. developments such as the General Certificate of Secondary Education (GCSE), Technical Vocational Education Initiative (TVEI) and Certificate of Prevocational Education (CPVE) courses which stress the importance of independent learning and cross-curricular skills in all aspects of the whole curriculum, at Key Stage 4.

These two developments are closely related in their impact, if not their origin. Both have involved teachers reviewing their teaching within their own disciplines in the wider context of the arts and the whole curriculum. We now explore each development in more detail.

## DEVELOPMENTS AT KEY STAGE 3: COMBINING THE ARTS?

There are two main reasons for the interest in combined arts. The first is that many classroom teachers have recognised the positive possibilities of combination either through personal experience of combined arts practice or through a desire to conceive pupils' learning in other than subject-specific terms. The second is that those responsible for timetabling and staffing may see combination — in the arts as in other curriculum areas — as a way of 'rationalising' resources in response to growing demands on curriculum time. Combination has certainly been a pretext for overall cutbacks in the arts in some secondary schools.

It is important that these two reasons for combining the arts should be distinguished by teachers working towards a common policy for the arts. A common arts policy need not involve team teaching or working through a common theme or topic. Some forms of combined arts teaching can be carried out by a single teacher. Secondary specialists looking for models for such practice may find them in their local primary school. There is no reason why such approaches should be abandoned at Key Stage 3. Two arts teachers observed the following.

An important issue that we felt needed consideration was the bumpy ride that many children experience from primary school arts work through to the first years of secondary school. Generally there is little co-ordination and understanding in this area apart from fairly formalised reception meetings and pupil assessments sent on to secondary schools. We were lucky enough to be able to create time to visit some local primary school to see for ourselves. It emerged that in the best primary practice the arts were recognised as valuable and resourced appropriately. Often there was provision for much cross-curricular work in the arts and other subjects. This was generally characterised by thematic work and seemed to us to create logical links which strengthened the learning taking place. It was evident that quite a gap exists between the organisation of learning at primary and secondary level that could be bridged by careful and sensitive adaptation at lower secondary level.

Developing a common arts policy may simply involve the arts having a single co-ordinator, equivalent to the curriculum leader in the primary school (see Chapter Three), responsible for organising finance, timetabling and faculty meetings and for negotiating with the school management.

Combined faculties can support curriculum planning by improving staff co-ordination. They can enable teachers of two or more disciplines to identify common source material for a particular set of lessons: for example, Year 7 might use an environmental visit paid for from departmental funds as the stimulus for separate work in art and drama. This can help pupils to explore such learning experiences more thoroughly and teachers to develop their thinking about the relationships between the disciplines, whilst providing the normal amount of time for each of them.

**Experimenting with the timetable**

Faculty structures can also facilitate changes in the timetable which enable teachers to work together more effectively. In one such change, devised by staff of an arts faculty at a large secondary school, the objective was to improve the organisation, timetabling and resourcing of the Year 7 arts curriculum without jeopardising work in the individual disciplines. The school co-ordinators argued the following.

No one could contemplate having his or her own subject dissolved into a combined pool. Each of the arts is as important as the other and needs its fair share of time. Combined arts work should be seen as an extra dimension to existing practice.

The aims of the initiative were to:

1. increase the strength of the arts by enabling them to work together rather than in isolation;
2. create a link between learning in the primary school and in the secondary school.

The staff decided to adopt a thematic approach and to adjust the timetable for the six Year 7 groups. With the headteacher's support they devised timetable changes which entailed blocking an arts timetable which had previously been organised in separate subjects. The resulting combined arts course included English, art, music and dance. It proved impossible to include dance as it was blocked with PE, but it followed the thematic approach at another point on the timetable.

Each subject also gave a small amount of its time to allow a combined arts session to be timetabled in addition to work in the discrete areas. The groups had sharing sessions in the gym at least twice a term to keep them in touch with what others were doing. Later, because of the success of the project, this gym was converted into a combined arts studio, which further enabled pupils to see and share work.

It was decided not to stay in form groups but to mix the three classes and have mixed ability groupings. An extra member of staff was provided as a floating member between the three classes and their staff. The co-ordinators gave the following description.

Effectively, four members of staff worked with three groups, giving us much room for flexibility and co-operation. Fortunately our fourth member was a specialist in dance, enabling a further discipline to be involved as well as acting as co-ordinator and team leader. Within this system:

1. the co-ordinator relayed ideas from one class to another, distributed resource material, set up displays and oversaw the links being made between arts areas;
2. the system facilitated team teaching, reduced class sizes and enabled any member of the team to approach an idea through another arts discipline;
3. half the year group could be brought together to work in the hall, using a combination of the arts in one session;
4. any member of the team could assess and record the responses of the children through video- and audio- recording or individual discussion;
5. increased motivation of specialists through close support and the introduction of fresh ideas was enabled;
6. meetings after school became an essential part of the course's development, in addition to the many informal discussions that arose quite naturally from the theme.

THE DAILY MIRROR, Friday, November 16, 1928.

HOME SECRETARY AND THE POLICE INQUIRY

£1,000 OR £2 A WEEK FOR LIFE

# Daily Mirror
THE DAILY PICTURE PAPER WITH THE LARGEST NET SALE

MORE INSURANCE CLAIMS PAID

No. 7,803 — Registered at the G.P.O. as a Newspaper — FRIDAY, NOVEMBER 16, 1928. — One Penny

## CREW OF SEVENTEEN DROWNED IN LIFEBOAT DISASTER

The overturned Rye Harbour lifeboat washed up on the foreshore at Jury's Gap, near Rye, Sussex, after it capsized yesterday. Two of the dead were found beneath her.

The crew of the Rye lifeboat launching their craft in response to a call.

Artificial respiration being attempted on one of the lifeboatmen.

In the sight of weeping women the Rye Harbour lifeboat disappeared among mountainous waves when returning from a wreck yesterday. Soon afterwards it was seen floating bottom upwards, and men were discerned struggling in the water. All the crew were drowned, and the disaster has robbed the little village of Rye Harbour of practically the whole of its fishing population. The lifeboat's aid proved to be unnecessary, for the crew of the sinking vessel had been taken off by a German ship. (See also pages 14 and 15.)

The theme for this experimental course was a local lifeboat disaster in which seventeen crew members were lost. This event was very much part of the local community's history, and it was thoroughly researched to provide the resources for exploration through dance, drama, creative writing and music (see pictures on p.125). This illustrates the potential contributions of the arts to historical study, as described above.

In retrospect it was evident that an immediate curriculum change had been achieved, but the co-ordinators devised a set of criteria which needed to be met if such a change were to become long term:

- knowledge and valued support of the arts by the school management team;
- committed staff on the teacher team, with a willingness to be resourced and take risks;
- subject specialists at work in each of the arts areas;
- a capitation allowance extra to departmental monies;
- adequate provision of time and space (three classrooms plus hall area);
- careful selection of thematic work: a community-based programme seems to offer many opportunities for learning;
- provision of a co-ordinator/floater;
- promotion of the importance of the arts within the school and the community, through combined displays, presentations, sharings, workshops, pageants and open classrooms;
- openness, communication and problem sharing.

Clear guidelines are also essential for evaluation of such a course and for assessment of pupils' work. It is worth emphasising that no pupil lost an area of subject time altogether but in fact gained through his or her involvement in a project which enhanced learning in specialist areas. As a safeguard, the co-ordinators suggested that each arts discipline should have a clearly defined statement of its area of experience available as a starting point for planning. The characteristic value of each discipline would then be established and it would be clear how and what each discipline might contribute independently and in combination.

A more radical timetabling change was implemented by a comprehensive which abandoned its whole-school timetable for an arts week. The aim of the week was to give pupils experience of a wide range of arts activities and their use in everyday life by bringing them into contact with practising artists. It was not intended to be an arts festival where pupils were concerned only with finished work but to be an opportunity for them to create their own work alongside the artists. The week involved a craft fair, exhibitions, workshops, demonstrations, readings and performances from local artists and others with a national reputation. There was an astonishing range of arts activities available for the pupils including music, dance, drama, mime, play writing, video, television study, and a large range of visual arts and crafts. Arts festivals and their implications for the regular curriculum are explored further in Chapter Nine.

## Securing staff commitment and coherence

If some form of combined arts teaching is to occur, it is vital to persuade staff that it may enrich rather than inhibit the teaching of their own discipline. Staff confidence and commitment are vital elements in successful combined arts work. A music specialist argued the following from experience of developing a Year 7 combined arts course.

The clear lesson for me is that joint courses can only work given a high level of commitment from all the staff involved. It is therefore much better to organise the content around the staff than to attempt to draw people into a preconceived plan. It is also a mistake not to involve everyone in the planning process, even if this seems frustratingly slow at times. Staff involved in the planning will have a far greater level of commitment than those to whom it is just another subject for which they have been timetabled.

This view is shared by the creative and expressive arts co-ordinator at another secondary school.

A set-up which facilitates combined arts work is essential for providing a suitable starting point for development. But it is just a first step in a delicate and complicated set of negotiations. Practical frustrations abound: the difficulty of providing block timetabling to give subjects working together sufficient flexibility; having to find enough space to accommodate dance, drama, PE and music rehearsals — often competing for space at the same time; the impossibility, in a period of high staff turnover and redeployment, of knowing which staff will be available in the terms ahead.

It may be difficult in some schools to timetable all the arts staff to work at the same time with a whole year group. Where this is achieved it can be even more difficult to respond to pupil demand, as found by staff at another school.

Both the faculty heads made the point that distributing 180 pupils among ten staff and a variety of subjects would be alleviated by the provision of 'floating' teachers available to support visits, outdoor work, small group projects and to enable staff to develop their confidence in working in other areas.

Provision of an additional member of staff as 'floater' and co-ordinator was, as we have seen, integral to the success of the 'lifeboat disaster' combined arts course described above.

There are often particular fears about the quality of work in individual disciplines produced by pupils when the arts are taught together. The framework for arts teaching proposed in Chapter One recognises that the arts make common contributions to a child's education but also emphasises that the different disciplines have unique roles to play within these.

Combined arts schemes should promote as well as extend the educational contributions of the disciplines involved. One school organised a combined arts course during Key Stage 3 as a roundabout system with each class spending a block of nine weeks with any one teacher exploring a common arts theme. The art staff ensured during each nine-week block that pupils experienced drawing from observation, use of paint and colour, group work and three-dimensional construction, whatever the theme.

**Defining terms**

Terminology has an important role in clarifying thinking in the area of combined arts. We are using 'combined arts' as the general term to cover any bringing together of teachers, classes, media or disciplines in the arts — in other words, any practice which deviates from the single teacher in his or her classroom teaching a single arts discipline. We can then use other terms to describe certain types of work more specifically.

### Multidisciplinary work

The arts teachers of a year group might decide to work from a common theme, such as the local lifeboat disaster described earlier. Teachers might continue to work with their own class in their own discipline, perhaps providing regular opportunities for themselves and their pupils to share work with other classes in order to compare how the disciplines have developed different responses to the same theme. We describe such approaches as *multidisciplinary* teaching. The lifeboat project's co-ordinators describe their experience.

To understand the context of the lifeboat story we felt it was necessary for the children to explore the idea of storm conditions by creating and recreating in the arts. Dance considered the movement qualities associated with storms at sea (swirling, rising, crashing). Art was able to capitalise on this by transferring these dynamic qualities into clay and paint work. Music was able to create the feeling of a calm sea building to a storm (using percussion, choral speaking). Creative writing employed some of the vocabulary already used and the visual images to write poems, stories and descriptions. Drama considered the effects of storms on fishermen and their boats.

Such multidisciplinary work using a common theme might prove particularly valuable for teachers in schools which operate a 'circus' system during Key Stage 3 and who feel that it is difficult to provide sufficient depth in short periods of contact with pupils. A further illustration of this approach comes from another comprehensive school, where art, drama, English and music teachers decided to work together with Year 7 classes:

Each teacher took the theme of 'Victors and Victims' as a starting point. They discussed resources and approaches together, generating an enthusiasm and a shared knowledge of content and methods which often led to alternative ways of working.

The art department decided to choose an area of study in which pupil and teacher could get to know each other by exchanging experiences. The teacher's aims were to heighten pupils' awareness of body language as a form of communication and to enable pupils to use this awareness in making pictures which would include figures. The pupils' own figures provided the starting point for the work, and one pupil was asked to sit in a slumped position. The rest of the class then shared possible emotional interpretations of this posture, from which the idea of bullying emerged. Each member of the group then took turns to adopt an unusual walk which the others described. An appropriate adverb was chosen by each pupil and they joined with a partner to enact their words in mime to the others, 'freezing' at the crucial moment, while the others made lively yet adequate lightning sketches on paper. Everyone had the opportunity to enact victor and victim roles in order to experience bullying from both viewpoints. The next stage involved making cardboard jointed figures based on each person's body proportions which were used as templates in the creation of a final victor/victim picture.

A novel, *The Eighteenth Emergency* by Betsy Byars, was the starting point for work within the English department. The book is about the problem a boy faces with the school bully once he has antagonised him by writing his name on a poster of Neanderthal man. The subject is approached in a humorous way accessible to twelve-year-olds and creates a climate of affection as well as concern within which the topic of bullying can be raised and discussed more directly. The class looked at poems concerning bullying and discussion of these, especially concerning what motivates bullies, led on to writing from the standpoint of both victor and victim. From

there, a look at a more serious play, *Coins Against the Wall*, led on to discussion about what sort of behaviour can contribute to being bullied and how the problem can be confronted and dealt with positively. This led to the preparation of tape-recorded questions to teachers, parents and pupils about their encounters with bullying and how they dealt with it.

*Child on Top of a Greenhouse* by Theodore Roethke provided the starting point for work in drama. The poem poses a number of questions concerning a boy and his circumstances, which were then investigated through various approaches. These included the teacher assuming a role, such as a journalist interviewing people connected with the boy, or pupils assuming roles, such as the boy at different stages in his history. Another approach involved 'hot-seating' pupils in role to enable them to tell their story or, similarly, setting up a pair of pupils to interview each other about their role. Flashback situations were created by pupils in small group enactments. These events were recorded in written form, drawings and storyboards, or shown to the rest of the group in their original form.

For the presentation of ideas, the music teacher focused on forms ranging from the more traditional creative/graphic score to beat-box raps and folk-style anti-war songs. Stimulation material came from both classical and pop music, which were apparently equally popular with pupils. They were encouraged to choose freely from a wide range of instruments and to work in small groups to create their own pieces. Group compositions even included poems with sound effects. The creative process enabled pupils to explore their own ideas about the themes of victors and victims encountered in other lessons.

On reflection, the team felt that the project had succeeded in many ways, not least in the quality of response from pupils. However, in some respects, it left teachers unsatisfied and raised an unanswered question: how much more could be achieved if space was created on the timetable for teachers to work together in the classroom?

### Interdisciplinary work

With some reorganisation of the timetable, these teachers might have fulfilled their wish to share classes and to look at ways in which disciplines might work together. This might involve one discipline informing work in another, although without fundamentally altering the structure or aims of the second discipline. In the next example two teachers from an inner-city comprehensive moved towards such an *interdisciplinary* approach through experimenting with ways in which they could collaborate within the constraints of the timetable to explore links between dance and drama. Both teachers were specialists in their disciplines. They had worked together previously on school productions but as their teaching of a Year 9 group was blocked together they decided to collaborate on a more systematic basis.

The first experiment was simply to use the work achieved in a block of drama lessons as a stimulus for the following block of dance lessons. The theme was the way in which a dominant culture can mistreat a small group. Here the drama teacher describes the results of this first phase.

When I was invited to watch the resulting dance I was extremely impressed with the feeling quality of the work. The class was not only symbolically representing those rejected people in another art form but was also, it appeared to me, dancing 'in role'. Anyone witnessing the dance could see from their faces and their belief in the expressive rightness of the movement that they were experiencing rather than just performing their dance. It didn't really matter what we called this work. One art form

had been a stimulus for another. The class had experienced something in two different disciplines. It worked for us and, most importantly, it worked for those pupils at that particular time. Important barriers had been broken.

In the next school year the teachers repeated the experiment with two Year 8 groups, creating two dances and two dramas sharing the same themes but this time bringing all the pupils together to share, in performance, the final results. The pupils were enabled to understand the differences and similarities in the interpretive powers of dance and drama but it was not an entirely satisfactory process. The dance was created to be performed; the drama was not. The value of the drama work was therefore not as easily presentable. This dilemma inspired the teachers to adopt an approach which would break new ground for both of them. This approach is described in the next section.

Interdisciplinary collaboration of this sort is possible with other curriculum areas. A visual art department might collaborate with the geography department on a project about the local environment by teaching drawing skills. This would be beneficial to the geography department and, if successful, would help to improve drawing within the school.

In other cases there might be a greater degree of negotiation over the outcome of such a collaboration. Attempts to link a piece of writing to a piece of music, for example, might require adjustments to the form and understanding of both pieces. This process of interaction would be unlikely, however, to challenge the cultural or structural differences between writing and making music. It might enable pupils to understand ways of linking work in the two disciplines while reinforcing their awareness of the differences between them.

Such links might take any number of forms. If we think in terms of pairs of disciplines we can imagine joint projects in video and dance, drama and visual art, music and dance, and so on. The vital factor is that the relationship is intended to be *reciprocal.* An interdisciplinary project involving dance and visual arts specialists, for example, is only likely to be satisfactory to both parties if the work produced is informed by both disciplines.

The environment in which drama work, from improvisation to production, takes place can be central to its success, and an interdisciplinary course combining drama with art and design might identify environmental design as a unifying component, for example. Such a reciprocal approach would be altogether different from the familiar story of art teachers having to design, often under duress, sets and publicity for the school production.

### Integrated work
Multidisciplinary and interdisciplinary work occurs within the framework of a curriculum organised around separate disciplines, and is usually taught by teachers with expertise in different disciplines. 'Integration' implies a more radical change.

There is a tendency to describe all activities involving more than one arts discipline as 'integrated'. Such general use of the term makes it difficult to distinguish between the variety of practices within the combined arts field. It is also inappropriate in most cases. Just as the term 'integration' implies 'making whole', so 'integrated arts' suggests

*A project involving two art forms, such as dance and visual art, can be described as interdisciplinary if the work produced is informed by both disciplines, as in this project inspired by the Italian Futurist Giacamo Balla.*

*Integrated arts practice involves the development of different forms of expression and communication.*

the fusing of different disciplines to develop different forms of expression and communication.

Examples of genuinely integrated arts practice are more commonly found in societies where the familiar Western/European distinctions between arts disciplines are not made, and in some contemporary Western arts practice which has developed new ways of working in unfamiliar media. Sometimes this has occurred when artists trained in one medium have moved into another to extend their usual field of enquiry.

The two teachers in the 'interdisciplinary' example were determined to explore an integrated approach and decided that team teaching two Year 8 classes together for a series of whole-morning sessions might produce interesting results. Both agreed to participate fully in the sessions if they were not leading them.

We entered into the joint project as an experiment. We regarded it as a learning experience for ourselves as it was a new situation for both of us. We had an initially highly structured start, really for our own personal safety, but were both prepared to keep the activities fluid and be prepared for changes of direction in the lesson. We agreed that if either of us became uninspired the other would step in to help.

Neither of us felt that we had to perform in front of the other. We understood that in our own classrooms we were both capable teachers. We knew that if things went wrong it would be our joint responsibility and that any failure in this experiment would not prejudice our high regard for each other's work.

We felt we needed a strong context for the work and devised a story-line that was a cross between *1984, Animal Farm*, and *Brave New World*.

During the first morning the pupils became individuals who had survived an unnamed disaster which had destroyed all communities. A stranger told them about a safe and comparatively luxurious Citadel which had been created by a Big Brother archetype called Friend Jones. They were persuaded to come and look around the Citadel and join the community. Through role play the frightened isolates were persuaded to enter the Citadel, meet new people and explore the environment. Extracts from the evolving story were shared using frozen pictures and in-role questioning.

With the dance teacher the new recruits to the community learned a fitness programme which had the dual role of a ritual in praise of Friend Jones, whose large picture was now projected onto the back wall. They also developed a ritualistic chant 'in honour of Jones'.

The plan for the second morning was that the pupils, after their ritual workout, were to swear allegiance to Jones and symbolically hand over their personal possessions to start a new life working in the Citadel. The teachers planned 'work' dances and the pupils could choose their area of work from the following ideas: power house, sustenance, construction, maintenance, assembly, essential needs, removals and installations.

At this point the distinctions between dance and drama began to blur.

To my surprise there was a distinct change in the work. I had expected that they would all use the dance mode. After all, the dance teacher was leading at this point. Purely by association I thought that the pupils would automatically all accept that they were required to dance. The class started to use a mixture of forms, however.

They appeared no longer to see discipline boundaries. Some groups adopted a drama form; some were largely mimetic in quality; some were pure dance but the majority showed synthesis. They moved between forms. They mixed concrete action, spoken language and dance.

The narrative continued to evolve over three mornings and the two teachers continued to experiment with in-role team teaching and letting the pupils evolve their own presentation modes. In his summary the drama teacher made the following conclusion.

As teachers we learned a great deal from working together. I'm sure that as two subject-specialists we broke many barriers and eased our initial reservations about working with each other. I learned that team teaching between two colleagues who are prepared to take risks and accept that new practices will be different but no less valuable for our pupils can be a very productive way of working for the pupils and exciting for us.

In this case the key to the integration was the team teaching. This need not always be the case. It is possible for teachers working on their own to explore ways in which two or more disciplines can be integrated: models can be derived from professional arts practice, as we suggest later. For teachers the excitement of such work lies in the unpredictability of pupils' responses: pupils rarely share their teachers' preconceptions as to what is or is not possible in the relationships between art forms.

## Providing in-service training for teachers

Few teachers have substantial experience of combined arts practice. A head of creative and performing arts gave this argument for relevant in-service training (INSET) to prepare arts teachers for new ways of working.

To run the school's creative and performing arts (CPA) programme a certain amount of INSET is required. Teachers who are specialists and who are being asked to teach against a rather broader background than hitherto require some time and support to adjust to the different demands and challenges. Teachers need to see in some detail their colleagues' work. They also need to appreciate what it is to be a pupil in the CPA programme and to see, first hand, where areas overlap and commonalities occur: not with a view to rooting them out but to building on them.

The aim of INSET in CPA is not to turn art teachers into drama teachers or music teachers into art teachers but to give staff a greater understanding of the whole area of the arts. With greater insight staff can enhance their teaching in their own specialist areas. The aim of CPA is not to teach a new subject called 'combined arts' but to teach art, drama, music — dance is taught within PE — in an enlightened and exciting way, recognising that the areas have much to give each other.

In CPA INSET takes several forms:
• teachers team teach on combined projects;
• teachers adopt the role of pupil in each other's groups;
• teachers observe each other's lessons;
• time is provided for staff to meet and to plan future work;
• teachers undertake the training of other teachers where the need arises.

The involvement of artists in residence with expertise in combined arts practice can complement such in-service work, as can teachers endeavouring to become more aware of the history of such work in the arts. Within the Western/European tradition, schools of artists

such as the Futurists, Dadaists, Surrealists and the Bauhaus have worked across a range of media, the latter group's work including crafts, design, architecture, painting, print-making, ballet, typography, pantomime and literature. Many visual artists have been involved in major collaborations with the performing arts; dance companies have devised collaborations with visual artists, musicians and writers; and musicians have developed distinctive forms of music-theatre.

A major characteristic of much contemporary Western arts practice is the move away from the separateness of painting, literature, dance, music or theatre towards new forms which are often underpinned by an issue, theme or theory rather than by medium or tradition. The aims of arts teachers are different in important ways from those of practising artists, but there are also strong links between them, and arts teachers should take account of developments in arts practice outside schools in planning courses. It is anomalous that 'art' should be a unifying concept for much work across disciplines in the arts world but not for most work in schools.

It is important not to assume or promote a wholesale move to combined arts teaching. The fact that more of it is happening is reason enough to report and contribute to its development. The essential point is that curriculum development in this area should stem from a considered policy for the arts, tailored to meet the needs and resources of the school.

## DEVELOPMENTS AT KEY STAGE 4: MODULAR COURSES?

Innovative work across disciplines has often been inhibited by the pressures of public examinations and been largely confined to Key Stage 3. The recent developments in secondary examination courses have had important effects on the thinking of arts teachers, however. GCSE, TVEI and CPVE have helped to create a climate for teaching and learning in which the arts have been more able to flourish in Key Stage 4.

Such courses promote independent and active learning and — TVEI and CPVE in particular — stress the acquisition of cross-curricular learning and the use of resources beyond the school. They all advocate the value of the working process and of acknowledging work in progress through carefully monitored coursework. The courses offer opportunities for teachers to reappraise their practice and design courses where pupils and teachers together break down traditional subject barriers.

Developments in GCSE, TVEI and CPVE have in particular accelerated the growth of the modular curriculum. A module may last for one term or a set number of weeks. It is possible to organise modules which cut across the usual timetable, and this can be particularly appropriate for the arts. Where, for example, schools have abandoned the normal timetable in favour of an arts week, this might be developed into a module or seen as a unit within a module. Similarly, if a student attends a summer school or evening course this experience might be validated as a module or unit.

Modular courses have developed partly in response to the congestion of subjects in the secondary curriculum. Modular courses can enable

pupils to spend a specific period of time studying an area to which, within an option system, they might be reluctant to devote a longer period. This may be particularly important in the arts, where pressure of time has always made it difficult for pupils to follow all the courses which interest them. Within a modular arts programme it should be more possible to ensure that pupils continue to experience a broad range of arts disciplines.

Some teachers regard modular courses as particularly suited to learning in the arts because arts teaching tends to be based around particular projects such as the completion of a musical composition, a play, a dance, a portfolio or exhibition rather than on a linear course design.

There are problems with modular arts courses, however. A modular programme may not allow pupils to develop their work in depth. For example, the development of technical skills is incremental and requires regular and committed practice. Ideally modules should be progressive and incremental, with the technical aspects becoming increasingly challenging.

The problem of superficial learning in relation to arts 'circuses' or 'roundabouts', where pupils may move from eight weeks of fabric printing to eight weeks of drama with no clear link between them, may also apply to some modular courses. For this reason it is essential that modular arts programmes make clear the links between separate modules; this may require new ways of organising and teaching the arts which explore the relationships between them.

A compulsory *foundation module* which establishes for pupils the basis for the work is therefore essential, to be followed by an opportunity for personal choice, with three or four options to choose from. This could be followed by a *core module* which all pupils follow, then another opportunity for choice and finally a *unifying module* which pulls the course together and re-establishes the connections introduced in the foundation module. This could be a production, anthology, video or exhibition.

A common organising device for modular courses is to use a theme, but sometimes thematic work can provide a superficial coherence which papers over the fragmentation of modules in separate disciplines. It may be more useful to look at the learning experiences which the children are engaged in across the arts, as staff at one urban comprehensive found. Their arts course was designed for Key Stage 3 with the intention of 'building upwards' into Key Stage 4.

When looking for an appropriate course structure we considered various established approaches including a topic approach ('The Seasons', 'Supernatural'), a historical approach ('The Victorians', 'Impressionists') and an approach based on the school show.

Each of these approaches was appealing for different reasons. The advantage of the 'topic' approach was that it followed on logically from primary school work. As a means to structure a major part of our secondary school curriculum it seemed to lack cohesion, however. Few topics are just as stimulating for visual arts, music and drama. Pupils can become bored doing 'Winter' in three subject areas for any length of time and, depending on the topic, an enormous amount of knowledge might be needed by all staff to maintain interest in the topic.

The historical approach was rejected partly on the opposite grounds: that it is actually too academic for many of our students. Events in arts history rarely coincide to any great extent. The school show approach — mounting big productions — was also looked at. This model was, we thought, what inspired the senior management team and, while it is easy to see the advantages, we rejected it on the grounds that it tended to produce mainly theatre. Music and art tend to 'service' the drama. It is also difficult to involve everyone fully, and rehearsing is a partial form of arts education.

The course structure we have chosen focuses on a sequential modular approach, with each child going through a set of experiences that build up into the course. The two themes of the course are:

1. the arts and the individual (approaches and processes in the making of the arts);
2. the role of the arts in societies and communities.

The six module titles are:

1. the arts involve exploring things (using media and materials);
2. the arts involve atmosphere, feelings and moods (using media to create artistic gestures);
3. the arts involve organising things (form and shape);
4. the arts involve imitation and imagination (working with styles);
5. the arts say something about societies and communities (the arts give people identities);
6. the arts can convey messages about ideas and issues (the arts and the mass media).

Within this overall structure we expect there to be elements of all the other approaches outlined above: for example, we expect to be using themes like 'The Supernatural' in the 'Feelings, Moods and Atmosphere' module. The school show approach will be in evidence whenever we tackle the 'Organising Things' module, either in producing a puppet show or a video or a piece of street theatre. The 'Historical' will emerge whilst we are doing the 'Societies and Communities' module, when we will study in some detail the arts of one society in order to place a sense of personal perspective in the students' work. This approach will also give us the flexibility to do multidisciplinary and interdisciplinary work. It will also create the climate for some genuinely integrated work.

The conceptual framework described in Chapter One could also be used as the basis for planning such a course. *Making* and *appraising* across the arts may provide a more satisfactory basis for course design, with particular modules stressing the different processes involved within these two ways of working, such as exploring, forming, performing, presenting, responding and evaluating.

Another basis for modular course design might be the elements of learning, with modules designed in terms of concepts, skills, values and attitudes, and information. This might provide an exciting challenge for arts teachers as they would need to analyse their own and each other's practice for common characteristics.

There are many examples of modular arts courses, some called 'expressive', some 'creative' and some 'performing' arts. They look at what the arts can offer collectively to students, and to which cross-curricular and 'life' skills the arts can provide access. All are organised on a modular basis and emphasise self-directed learning, a natural outcome of which is the use of resources beyond the school. Students are encouraged to visit and conduct research at arts centres, galleries, museums and theatres and to create their own arts projects which link

the school and the community. Many theatre and dance companies, orchestras, galleries and arts centres now have education officers which make these liaisons increasingly easy and appropriate.

## THE ARTS AND THE INFORMAL CURRICULUM

The use of resources beyond the school and — as we argue in more detail in Chapter Nine — the staging of arts festivals and community events provide many excellent opportunities for involving parents and the local community in the curriculum, but they all depend to a greater or lesser extent on teachers' commitment to extra-curricular work.

Many local education authorities (LEAs) also support extra-curricular facilities which bring together committed pupils from different schools: music centres providing access to instrumental tuition, bands, ensembles and orchestras; 'special ability' dance classes and youth dance companies; drama and youth theatre groups. These may also be used to showcase the authority's achievements, although they do provide valuable experience for all concerned and, for a small proportion of those involved, unique prevocational training. They offer wonderful opportunities, but generally only for those pupils who were already motivated and committed to the arts when they attended the audition.

Teachers in schools which have a wide range of lunchtime and after-school activities in the arts face a dilemma which can only be resolved through schools taking a more flexible view of the whole curriculum, as argued by a music teacher.

These activities are not always outside the timetable by design. Normally the opportunity to run them during school hours does not present itself. They have also never been officially recognised or evaluated. There is no shortage of people who encourage them but no LEA has a stated policy for resourcing them.

Performing arts activities may often be extra to the timetable but they are not separable from the curriculum. 'Clubs' (often used as a blanket term) provide particularly interested or motivated pupils with the opportunity to develop their individual potential. This is a central function of any curriculum. HMI (DES 1985) makes such a distinction between timetable and curriculum.

> A school's curriculum consists of all those activities designed or encouraged within its organisational framework to promote the intellectual, personal, social and physical development of its pupils. It includes not only the formal programme of lessons, but also the 'informal' programme of so-called extra-curricular activities.

In calculating 1265 directed hours, headteachers have generally refrained from allocating some of them for, say, producing a school play. A headteacher may 'reasonably direct' a school play to be produced, but few would wish to do so. If directed hours were set aside for such activities, what duties would they replace? Should such activities remain voluntary? Or do we play a complex game where heads expect them but pretend they do not, and teachers see them as part of their job but insist they have volunteered? Those seeking a teaching career in the performing arts frequently achieve promotion on the strength of their 'extra-curricular' work, a common feature of job descriptions and interviews. If such work is considered part of their job this should be clearly stated, in order to give it the recognition and resources needed.

We would begin to develop a policy for the informal curriculum by addressing three questions.

1. What are the responsibilities of arts teachers for the informal curriculum?
2. Are pupils entitled to have access to an informal curriculum?
3. What resources are needed  for such a curriculum?

In response we could pay teachers for running 'extra' activities. We could break the stranglehold of the timetable by giving staff time off in lieu. We could offer special posts to co-ordinate the informal curriculum within a community of schools. LEAs could set aside capitation for the development of the informal curriculum in each school. If such ideas sound fanciful it is worth remembering that many community schools run twilight youth classes along these lines, and some teachers already have part responsibility to a school and part to community education.

Such ideas have already taken root in some schools, as this final account, by the principal of a sixth-form college where the arts are flourishing, shows.

If the sixth-form curriculum is thought of only in terms of examination work then the performing arts at the college are small beer indeed. In September 1987 the numbers of students taking A level courses in music and theatre studies were 25 and 26 respectively, or about two per cent of the examined curriculum.

Fifty per cent of students' time is not spent in A level classes, however, and it is here that the performing arts have a significant presence. There are many students who have an interest in or aptitude for the arts but do not take arts A levels because their proposed careers seem to require other subjects or because their third-form options ruled them out. These are the students who involve themselves in 'optional arts', and it is to their needs that arts staff give a great deal of attention.

There are five full-time staff (eight per cent of total) and one technician in the performing arts departments. Such numbers can be justified only if there is an extensive programme of non-examination activities. The difficulty from a management point of view was that so much of this provision necessarily took place outside the timetable at midday or in the evenings and had traditionally been regarded as extra-curricular. It was provided on an *ad hoc* basis and could not be considered part of a teacher's normal timetable.

Against this background some staff agreed to operate a flexitime system for themselves and, to a certain extent, for students. Activities such as choir, orchestra, guest concerts, visiting theatre groups, drama workshops, play rehearsals, lectures and video sessions take place during an extended eighty-five minute midday break. The time involved in running these activities is considered part of contact time. Students have enough time to have lunch and to take part in an activity which contributes to the non-examination part of their individual learning programme. Students' participation is assessed and included in their reports and references.

Evening activities such as theatre trips and extra rehearsals have not yet been incorporated into this scheme because of their sporadic nature. There is however a willingness to provide some tangible acknowledgement that staff engaged in such activities are working and should not be expected to do them over and above the rest of their work.

Often much of the stress in organising voluntary activities such as theatre trips lies in the arrangements of booking by phone, providing transport and collecting money. Teachers' days are not suited to such work. We have transferred these arrangements to secretarial staff at the college reception desk who have constant access to a telephone and are centrally placed to receive payments from students. Since they

handle a large number of such activities they are in a strong position to negotiate competitive prices with coach firms and can also bid for group reductions and special rates. The use of the college credit card also eliminates a great deal of tiresome postal confirmation.

Amongst 820 students there will always be a number who are enthusiastic supporters of arts activities. Others may need encouragement to try something new and much will depend on the ability of staff to make early contact with new students. Students and teachers in the high schools are asked to indicate areas of special interest on the application form and college arts teachers are provided by admissions staff with lists of information so that planned activities can be aimed at a specific audience. Arts activities are publicised in the college bulletin and the central fund is used to subsidise tickets to bring their price within reach of most students. In cases of hardship staff can appeal, on behalf of students, to a special governors' fund reserved for this purpose.

Most of the students have come from eight contributory high schools. If the range of arts activities provided in the college was on the same scale as a typical high school the opportunities in some areas would be reduced by a factor of eight. A few years ago, for example, twenty-three students auditioned for the role of Sally Bowles in *Cabaret*. Many had presumably whetted their appetites for acting in high school plays and would certainly be capable of playing such a part. Twenty-two of them found that their opportunities were now severely limited.

As each high school has approximately three contributory primaries, a pyramid structure of 24-8-1 presents a picture of reducing opportunities for children so that the enthusiastic participants in the primary school are gradually whittled down to the confident and talented few in the sixth form.

Such considerations have convinced staff that their provision of arts options must be on a far larger scale than that in a single high school. The appointment of a full-time producer in residence was a recognition that a great deal of staff time would be needed if our aim was to be fulfilled. Changes in personnel have hampered evaluation of the new structure but it is clear that students are being provided with a wide range of opportunities in acting, music-making and associated areas. Most students who wish to do so are now able to participate whatever their ability level.

The arts staff are in no doubt as to the value of what they do outside the examined curriculum. They reject the term 'extra-curricular' and argue that for many students optional arts activities are essential ways of learning and self-realisation. The role of management is crucial in supporting this view and there are certain practical steps which can be taken to raise the status of arts activities.

1. Funding should be provided on a realistic basis, recognising the amount of student time involved and the connection between quality and expenditure.
2. The time involved should be recognised as an integral part of the individual workloads of students and staff.
3. Necessary release for students from other classes for arts activities should be on the same basis as that for field trips, lectures etc.
4. Students' involvement should be assessed and given the same status as that accorded to their 'academic' achievement.

## SUMMARY

The arts in secondary schools present a very varied picture, both in terms of representation and status within the curriculum and of staffing and resources. The curriculum changes which have brought the arts together as a group with shared interests are linked to the

evolution of initiatives such as GCSE, TVEI and CPVE as well as the National Curriculum, which has created new opportunities for the arts to contribute to other areas of the curriculum.

All these changes have impelled teachers to review their classroom practice, both in terms of finding common ground between the arts and of investigating the cross-curricular learning which the arts promote. This has produced a renewed interest in redefining the place of the arts in schools and given teachers the opportunity to rethink their teaching in close communication with colleagues from other disciplines.

The modular structure of many of these new courses has advantages and disadvantages for the arts, but again has provided the opportunity for teachers to reappraise their teaching. The emphasis on active and self-directed learning, and on the use of resources beyond the school, is entirely appropriate for arts learning and presents considerable scope for innovation.

### A checklist for evaluating the arts in the secondary school

1. Are the arts considered a generic area of your school's curriculum?
2. What opportunities does your timetable offer for arts staff to meet and plan work together?
3. How does your school's arts policy reflect its equal opportunities policy?
4. If drama is taught within English and dance within PE, are there opportunities for these teachers to meet with other arts staff?
5. If your school operates an arts 'circus' in Key Stage 3, how do you ensure cohesion and continuity in pupils' learning?
6. In what other ways does the school timetable affect the development of the arts?
7. What innovative ways of blocking the timetable for the arts might be possible in your school?
8. To what extent does your school's arts provision rely on the informal curriculum?
9. How is extra-curricular teaching valued in your school?
10. Have you explored themes across the whole curriculum in your arts work?
11. What are the opportunities for combined arts work in your school? Is this work interdisciplinary, multidisciplinary or integrated?
12. Have the arts staff received any INSET for combined arts work or for arts across the curriculum?
13. Do you have a member of staff responsible for co-ordinating arts programmes?

# PROGRESSION, ATTAINMENT AND ASSESSMENT

## INTRODUCTION

Pupils' progress in the arts, and the assessment of attainment, are inextricably linked. Both demand that teachers are able to describe what pupils are intended to learn and the outcomes. In Chapter Five of *The Arts 5-16: A Curriculum Framework* we consider the *principles* of assessment in the arts; in this chapter our concern is with the *processes* and *criteria* of this assessment.

The chapter opens with a discussion of how pupils' learning in the arts progresses, then considers what counts as evidence of attainment and what criteria we can use in describing it. A cross-curricular approach is described which enables teachers to see how attainment in the arts can be evident across the curriculum.

The next section looks at roles and methods of assessment. Changes in assessment procedures resulting from the GCSE and the ways in which these have benefited arts teaching are discussed. Examples are given of new approaches to the assessment of pupils' achievement. The chapter concludes with a checklist for evaluating assessment policies in the arts.

## PROGRESSION

This extract from a teacher's account of a graphic artist's work in four schools introduces some key issues of progression. The teachers had decided that a useful way of looking at pupils' development in the arts was to consider the ways in which different age groups tackled the same material. The approach was to introduce a common factor which would enable them to reflect on their pupils' responses and on their own practice. The artist worked with different age groups on a piece of work called *The Story of a Letter*, outlining stages in the life of one of the letters of the alphabet, and then focusing on one frame, which was reproduced in a variety of media.

Although the artist's role within the classroom differed slightly according to how the teacher perceived the needs of the class, in most cases he gave the pupils the same

*The artist gave the pupils the same clear framework within which they could develop their own ideas.*

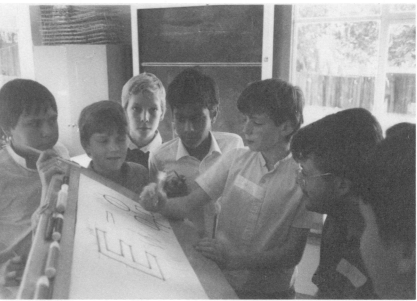

*The seven-year-olds drew quickly and had lots of ideas. Some sense of proportion could be noticed, as could more organisation and control.*

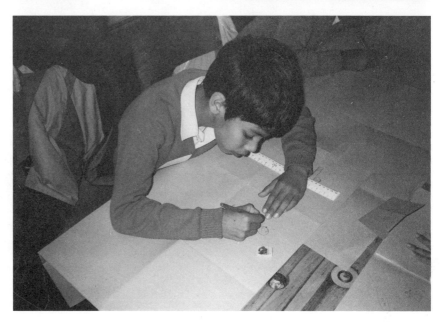

clear framework within which they could develop their own ideas, prompted them by use of questions and suggestions, and gave pupils of all ages a completely free choice as to which media they could use in stage two of the work. Teachers themselves saw the possibility of a range of follow-up work, from dance to making stories on tape or computer, developing writing skills, or three-dimensional work in pottery, textiles or cookery.

The youngest pupils had some difficulty in translating their ideas to paper: it took a lot of explaining from different adults in the classroom for them to feel confident in the task. Their experience of pre-school education ranged from nursery or playgroup to none. In some respects the whole idea was a little too abstract and some pupils had physical difficulty controlling the pencil. The stories were not always coherent and the pictures were cluttered with important objects from the pupils' own lives: the letter itself was not isolated clearly. The most able pupils, however, drew shapes which were clearly defined, using light and dark tones, and were observant. Although some letters seemed to be suspended in space and there was an overall lack of characterisation, the enjoyment of the task was clearly conveyed in the cartoon figures which were drawn, as the picture below illustrates.

The seven-year-olds drew quickly and had lots of ideas. Some sense of proportion could be noticed, as could more organisation and control. Able pupils used detail and

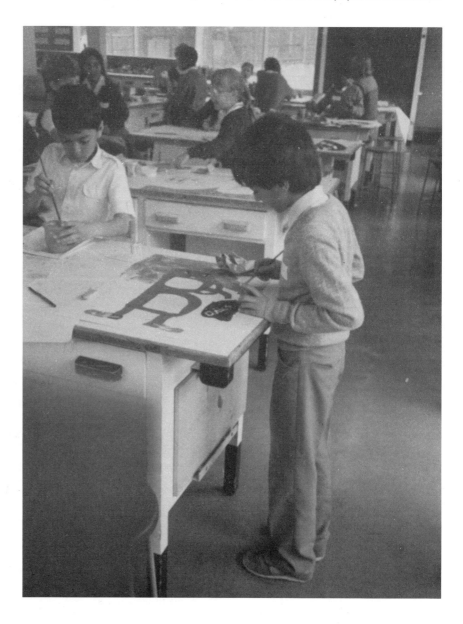

drew more carefully, although hand control was still not well developed and the background not completed. Lively, busy backgrounds were still a feature of this work.

Twelve-year-olds, by contrast, were more self-conscious when approaching the task, but their pictures used the whole of the paper and an ability to experiment with texture to gain different effects was noticeable. The able pupils' work showed strength and vitality, and a purposeful selection of objects within the frame. Colour was handled more consistently and continuously to gain a striking impact, although it was not subtle, lacking shading control.

The oldest pupils acted on teacher advice to make clear dramatic statements visible. Colour was used in a more sophisticated way and there was a more obvious control over the final effect. The work was meticulously created and the choice of different media was for particular, integral reasons. It was clear that teaching children techniques is important in their development. Even the older children did not naturally know how to organise their composition or use colour to reinforce their ideas: they needed teacher guidance. All pupils, of whatever age, took great pleasure in their work.

This extract opens up the issues of progression in several ways. The content of this project was useable to some extent for all ages. For the very young pupils it was rather too abstract, but with plenty of teacher support the children achieved limited results. The seven-year-olds had few problems with it conceptually and were full of ideas. They did not have the range of skills and understanding of the media to explore them fully. Children aged twelve and over were able to explore those ideas more fully through the media and it was the oldest children who used the media in a controlled and skilful way to convey their ideas.

In describing the responses of children with different capabilities to a particular stimulus, this teacher echoes the construction of *statements of attainment* (DES 1989a) — describing what pupils know, understand and can do at different stages *(levels),* of their work within particular areas of the curriculum *(attainment targets)* — which are a cornerstone of the National Curriculum. The statements of attainment for Levels 1, 2 and 3 of Attainment Target 3, Writing, within English at Key Stage 1, for example, describe pupils' learning progression in similar terms.

At Level 1, pupils should be able to:

• use pictures, symbols or isolated letters, words or phrases to communicate meaning.

At Level 2, pupils should be able to:

• produce, independently, pieces of writing using complete sentences, some of them demarcated with capital letters and full stops or question marks;
• structure sequences of real or imagined events coherently in chronological accounts;
• write stories showing an understanding of the rudiments of story structure by establishing an opening, characters, and one or more events;
• produce simple, coherent non-chronological writing.

At Level 3, pupils should be able to:

• produce, independently, pieces of writing using complete sentences, mainly demarcated with capital letters and full stops or question marks;

- shape chronological writing, beginning to use a wider range of sentence connectives than 'and' and 'then';
- write more complex stories with detail beyond simple events and with a defined ending;
- produce a range of types of non-chronological writing;
- begin to revise and redraft in discussion with the teacher, other adults, or other children in the class, paying attention to meaning and clarity as well as checking for matters such as correct and consistent use of tenses and pronouns.

What can this tell us about progression in the arts? It is evident from research in various disciplines that to describe development in arts learning as predictably sequential is inappropriate. The pattern of pupils' progress depends on previous experience and understanding of the arts. For some pupils the concept of 'the arts' as presented in school is alien, for either social or cultural reasons; for others, they are a source of inspiration and motivation. For such reasons it is difficult to describe age-related stages of progression in all aspects of the arts.

There are aspects of learning in the development of technical skills which can be described in a linear fashion, but these are not all necessarily related to age. Dance technique, instrumental music teaching and the training of the voice for speaking and singing rely on incremental 'training', as muscular co-ordination has to be built in a carefully planned sequence. But this is only one aspect of arts education. Developing creativity, imagination, aesthetic understanding and the application of technical skill are much more complex issues.

An appropriate model for progression in the arts is the spiral curriculum. In this conception certain fundamental concepts and ideas are introduced with young children in a simple way and are returned to repeatedly during their school career, each time developed and elaborated according to the pupils' increasing technical and perceptual competence. The underlying themes and issues of arts education may remain relatively constant through school life but the teaching strategies, conceptual language and technical challenges become increasingly more complex and sophisticated.

In composition, for example, in whatever discipline, pupils may be developing their understanding of the relationship between the parts and the artistic whole. With young children this might simply involve recognising the relationship between two parts, in terms of contrast, similarity etc. With older pupils this might involve the subtle and complex arrangement of the parts of the whole which communicates precisely the artist's intention.

Another example is the resolution or conclusion of a piece of work. For young children this might simply be a matter of knowing when to stop: where to put the full stop, when to put down the brush or hold a finishing position. For older pupils it might mean establishing the climax or denouement of a composition: resolving tensions and ideas within the work or surprising and contradicting what went before. In terms of critical work, very young pupils might simply describe the content of their own work whereas older pupils will describe their work in relation to the work of others and make informed and discerning judgements about it.

*Young pupils' first activities in the arts are playful, exploratory and often show a very loose relationship between intentions and effects.*

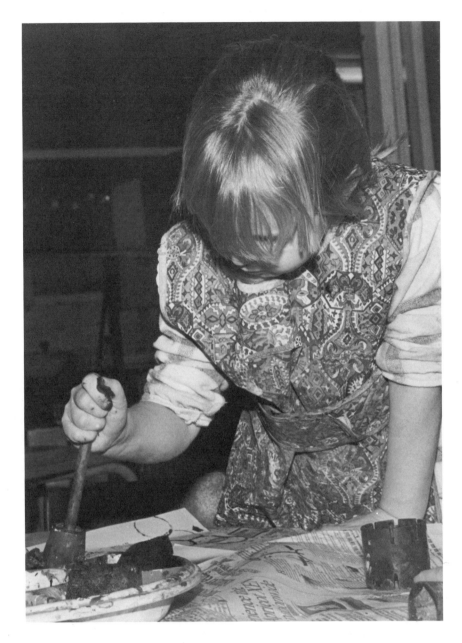

### Principles of progression

#### Complexity
Fundamental concepts and ideas can be introduced in simple and concrete ways to very young children and be returned to in increasingly more complex and abstract ways as pupils gain in experience.

#### Control
Young pupils' first activities in the arts are playful, exploratory and often show a very loose relationship between intentions and effects. The forms are often simple and accidental. At some stages the pupils' work may be derivative and clichéd. Creative and technical development involve acquiring increasing control of the media of expression and, as a result, in the composition of appropriate forms. These two areas of control are directly related. It is through a progression from accidental effects to technical facility in the media that pupils move from inarticulate or derivative forms of expression to autonomous, purposeful and sophisticated work of their own.

#### Depth
Young people have different aptitudes and interests in the arts.

During Key Stages 1 and 2 it is important that they should have creative and critical experiences in a wide range of artistic forms and media. During these years most pupils will begin to show preferences and capabilities in different disciplines. During Key Stage 3 they will begin to identify the areas for specialisation in Key Stage 4. Specialisation at this stage is necessary to acquire the depth of understanding and expertise on which articulate and fulfilling work in the arts depends, and towards which all pupils should be progressing.

### Independence

As they begin to work in the arts, young pupils depend heavily on the teacher not only for practical help and instruction but for their conceptions of the purposes of artistic activity, and for ideas and forms for actual work. As they progress they should be increasingly capable of originating their ideas for work and of making and carrying out decisions about the forms it should take. Their critical understanding should take account of the views of others but they should be increasingly capable of forming their own judgements of work and of giving reasons and criteria to support them.

## ATTAINMENT

**Evidence and criteria of attainment**

### Making

Evidence of attainment in *making* can be seen and heard in any productive outcomes of pupils' work, as it emerges and in its final form. As work progresses it is possible to describe and assess pupils' capacity to experiment, select, develop and organise ideas — all essential processes within *making* — through looking at the evidence. Evidence can also be found in conversation with the pupils as they explain their work and in their documentation of the *making* process. This documentation could be in diary form, a video or in a portfolio of preparatory and finished work.

One infant school's arts policy includes a useful list of different sorts of evidence which guides the teachers' assessment of the pupils' art-making. The list demonstrates the breadth of the arts experience required for young children in order to prepare the foundations for *making* and *appraising* and for future specialisation in individual disciplines.

> We should look at the child's response to the stimuli and then ask the following questions.
>
> - Is it well thought out?
> - Is the medium appropriate?
> - Is there evidence of first and second drafts?
> - Is there evidence of building on, and practice of skill?
> - Is there evidence of time being taken to reach a satisfactory conclusion, and willingness to sustain effort?
> - Is a folio of children's art, poetry etc. kept and discussed with the child and, later, parents?
> - Is there evidence of confidence and development?

This list would also be an appropriate general list for the assessment of older pupils' work. It takes into account the value of the processes of art-making as well as the finished product and although it does

emphasise *making* rather than *appraising*— appropriately enough in the assessment of very young children's work — this list also indicates that the ground for *appraising* is being prepared, with the reference to the discussion the teacher will have with the pupil about the work in the folio.

If a related portfolio is not available, leaving the only available evidence of *making* as a completed solo composition in dance or music, or a painting, poem, or play, then the following criteria could be used in its description and consequent assessment. The pupil's work:

* shows a personal response to a stimulus;
* demonstrates the understanding of certain concepts of form;
* demonstrates the pupil's understanding of the medium and appropriately communicates his or her artistic intention.

If the evidence includes a portfolio of preparatory work or a diary of the *making* process, including pupils' self-assessment, then the criteria for satisfactory attainment and consequent assessment in this creative area might also include the following. The pupil's work:

* demonstrates that the pupil has sustained the composition from initial stimulus to realised form;
* demonstrates that the pupil has taken advice and used ideas which have been introduced by the teacher or a critical friend;
* demonstrates a logical sequence in the selection and development of the material.

If the work was a group collaboration then a different set of criteria could be included, relating to social skills used in the process of *making*. For example the pupil is able to:

* co-operate and contribute within the group;
* make decisions, take the initiative and follow a leader;
* tolerate and sympathise with different points of view in discussion.

Evidence of *technical attainment* exists in the presentation of work. It includes manipulative skills and the appropriate application of those skills in performance or composition. Three examples from different disciplines illustrate this.

1. *Example criteria for technical attainment in dance*

The pupil can:

* demonstrate control in body management, both in stillness and in action;
* co-ordinate isolated body parts and combinations of movement which involve the whole body;
* show a range of movement dynamics in terms of speed, energy, continuity and plasticity;
* shape and orientate the body in space through changes in shape, level, direction and pathway;
* use dance technique in the performance of dances, accurately communicating the artistic intention of the choreographer.

2. *Example criteria for technical attainment in the visual arts*

The pupil can:

* select and control media and materials in a systematic and disciplined way;

- demonstrate a range and sensitivity of mark-making;
- observe and record accurately;
- demonstrate, in composition, understanding of visual elements, e.g. line, tone, colour, pattern, texture, shape, form, space;
- synthesise ideas into materials, techniques and processes.

3. *Example criteria for technical attainment in music*

The pupil can:

- control the instrument or voice in terms of fluency, accuracy and sensitivity;
- express style and mood;
- demonstrate understanding of timing and rhythm;
- demonstrate tonal variety and use of dynamics;
- communicate the shaping of the music through awareness of phrasing, climax, tension and relaxation.

### Appraising

Evidence of attainment in *appraising* can be seen, heard and assessed through the statements which pupils make either in writing or in discussion, and in applied form in practical work. The statements, in response to their own or others' work, can be critical or contextual. Pupils' own practical work will demonstrate where they have used and applied the understanding gained in the appraisal of others' work. References will be evident to different cultural traditions or to forms, styles and devices used by artists.

In the case of media and film studies, and in any critical work in Key Stage 4 and above, many of the criteria for technical attainment are in *appraising*. Typical criteria for GCSE media studies are that the pupil should be able to:

- describe the content of media texts while recognising the differences between major media forms;
- recognise and communicate an awareness of aspects of mode of address and genre;
- produce written and practical work which demonstrates knowledge and understanding of media representation; media production, industries and institutions; media audiences and identities.

For film studies typical criteria are that the pupil should be able to:

- demonstrate a knowledge of the terms of film production in general and at key historical moments;
- demonstrate an understanding of the major theories of film production and reception;
- demonstrate the ability to 'read' films in specific textual detail as cultural products.

### Cultural fairness

The National Criteria for GCSE called for all subjects to be 'free of political, ethnic, gender and other forms of bias'. The cultural and linguistic diversity of pupils should also be taken into account in the formulation of syllabuses and examination questions. One drama teacher explored the extent to which her criteria for assessment were appropriate for the Asian pupils in her classes.

I began more and more to suspect that there was a gap in my teaching. The girls did not draw on their own experience and culture when improvising. I found the problem

difficult to address, partly because their enjoyment was obvious. However, I began to be aware of a lack of authenticity or integrity in their work: the enthusiasm and co-operation was all very well, but what effect on their assessment would my judgement of shallowness and lack of persuasion have?

At this time I was struggling with the idea that drama was universal, that it transcended cultures, that it was about people. I think now that I had found a way to avoid the real issue. Eighty per cent of my pupils were Asian, and that had to be recognised. Once I had acknowledged the challenge, I found it easier to examine and develop my practice. To do this, I referred to two of the more important aims of drama teaching:

1. to develop the pupils' self-confidence and ability to express themselves and their individuality;

2. to increase confidence in speaking, to develop language and oracy skills.

How could my pupils, for most of whom English is a second language, have equal opportunity of success in assessment when fluency in the English language is examined? And if an aim of drama was to develop confidence in self-expression and a sense of identity, then the individual culture and experience must be recognised and drawn upon.

This teacher, who had already begun to use the pupils' home languages in the classroom, then began a series of experiments in her teaching to consider the effect of pupils using their mother tongues on their achievement in drama. The class was a group of Year 9 girls, mostly of Asian origin, with a variety of languages.

After initial reticence the project took off with the help of a teacher from the language support service. Teacher and pupils gained in confidence and expanded the content, relevance and quality of the drama work. The following is an extract from the teacher's conclusions.

Drama has the capacity to create and develop skills which are not solely dependent upon language — the use of spatial elements (movement, ordering, timing), group interaction and negotiating skills — and these areas can be assessed by observation. But confidence and assurance in verbal expression appeared to lead to more successful acquisition of these other elements in the process.

I am conscious that I am not equipped to provide the bilingual support in my own teaching to which my pupils are entitled. The implications for assessment are disturbing.

This study began as an enquiry into assessment procedures in drama with Asian girls and turned into a study of language and the problems of a monolingual, monocultural curriculum. If the curriculum is culturally 'fair' and relevant, fair assessment will follow. Current procedures are not giving Asian pupils equal opportunity to succeed in their own terms or anyone else's. Until I can more adequately reflect and make provision for the linguistic and cultural diversity in the classroom, I cannot pretend to be operating fair assessment procedures or be doing anything other than paying lip service to the requirements of the GCSE General Criteria.

## Attainment across the curriculum

The arts can be taught across the curriculum, as well as in discrete disciplines. If evidence of knowledge and understanding in the arts can be found in other curriculum areas, and vice versa, then alternative possibilities for course organisation and assessment could be developed.

### At primary level

In the primary classroom the arts are often used across the curriculum. Evidence of conceptual understanding will show in a variety of areas: spatial concepts may be evident in mathematics, three-dimensional art work and dance; evidence of drawing skills can be produced in most aspects of the primary curriculum; the ability to describe and evaluate objects and artefacts according to aesthetic criteria can be noted in environmental studies and design and technology.

In the following example a nursery pupil shows his grasp of concepts required for printing as he observes his own footprints.

After a wet playtime the children trooped through on the wooden floor, leaving a variety of muddy footmarks. Jack said to me: 'We're printing on the clean floor, look, with our shoes.' Other conversations occurred as coats were hung up and children came to sit down on the carpet, but Jack was trying to trace his steps and match the pattern on the soles of his shoes with a set of footprints on the floor. I joined him and the nursery nurse took my storytime so that I could follow this up. I said: 'All the prints are the same, Jack.' He said no, they weren't and that when you did any prints you could see what made the print. He spent a long time looking at all the muddle of prints on the floor, and then went home.

On the following afternoon, I had ready ten colours of paint and I asked a group of friends, including Jack, to come and print a picture. They were to choose something which could be used to print a shape and something on which to print and then begin. Jack immediately began choosing.

Attainment in core subjects is also observable and measurable within the context of learning in the arts. Much learning in music, for example, requires mathematical understanding. In the following example the children had been listening to Indonesian gamelan music and looking at paintings inspired by it. Now they were making their own gamelan and meeting a mathematical problem.

Following the discussion and looking at the pictures of gamelan music, the children decided that the instruments most resembling the Javanese gamelan in sound were xylophones, glockenspiels, bells, 'soft' drums, stringed instruments, voices and flutes. The local church had kindly lent us an octave of handbells for the project. The children thought they so closely resembled the sound of the gamelan that they wanted to include them in their music. We listened again to the music. It was pointed out that the Javanese system involved the use of five- and seven-tone scales and that we had eight bell notes, and much as we liked them, how were we to incorporate them?

'Let's use four then four.'
'What about two then six?'
'Seven add one — they'll do — they make eight.'
'No, three and five.'

Eventually five tones were selected, because this would incorporate the Javanese five-tone scale, and even though seven tones and one tone would incorporate the seven-tone scale it would only leave us one note which wouldn't make a good sequence, unless it were used as ostinato.

'Anyway it's our gamelan, it doesn't need to be t'same, does it? Why couldn't we borrow some more bells?' one child queried.

We finally decided upon the five and three tones, as another child had suggested that we could still play seven tones on the xylophone or glockenspiel.

No one came up with the idea of rejecting the three tones and just using five bells and seven notes on the xylophone or 'glock': they were so keen to use the bells.

### At secondary level

With the teaching of cross-curricular themes, new ways of looking across the curriculum will emerge at secondary level. For example, arts attainment might be observable in any course — science, social studies, PE, language, home economics — either in terms of the presentation of a project or coursework, or in the preparation of an event for a particular group. Similarly, design and technology attainment could be observed and described in all arts activities.

Many modular courses for pupils in Year 10 and Year 11 already make use of this cross-curricular approach. A dance or drama course, for example, may share a course module on stage lighting with a science course and pupils from both courses would work together.

Drama and media education are already well prepared for this approach as they have strong cross-curricular traditions. It is possible to assess pupils' historical, literary or sociological understanding within either of these curriculum areas, or vice versa.

### Attainment across the arts

It is possible to make links across the arts. Musical attainment is easily observed within a dance lesson. The understanding of rhythms, musical structures and time signatures are evident at all Key Stages; simultaneously, the dance attainment is observable, using different criteria for observation, such as physical co-ordination, spatial awareness, movement memory and the rhythmical understanding essential to both music and dance.

In one TVEI performing arts course there is a range of modules across the arts including both traditional and new art forms such as television studies. One module, 'Dance and Music Appreciation', aims to give pupils knowledge and understanding of the relationship between dance and music in a given period of history: for example, Stravinsky's contribution to the Diaghilev era, or social dance forms and popular music of postwar Britain.

Several courses designed during the project crossed the arts in various ways, and used criteria similar to those given above. Here is a typical example set of assessment objectives from an expressive arts GCSE syllabus.

> The assessment will indicate the extent to which the students can demonstrate:
>
> - understanding of, and correct use of, the forms, styles, technical devices, and basic vocabulary appropriate to the areas of study;
> - practical and technical skills through the creation of original works/compositions;
> - ability to prepare, select, research, and arrange source materials;
> - ability to sustain ideas from conception to realisation;
> - ability to make a contribution to group development and realisation of ideas;
> - ability to assess and evaluate their own work and performance;
> - ability to assess and evaluate the work and performance of others;
> - awareness that common elements exist between the various areas of study;
> - ability to communicate effectively.

Other cross-arts syllabuses had less arts-specific objectives, such as the ability to:

- investigate
- experiment
- record
- present

or:

- research
- express
- evaluate

Although these syllabuses use different terms to describe assessment objectives, there is obvious similarity in the required outcomes. All require evidence of preparatory work and the understanding of the working process: notebooks, diaries, video- or audio-recordings; evidence of completed work either in performance, exhibition, concert or presentation; written and spoken accounts, commentaries and critiques.

## ASSESSMENT

**Roles of assessment**

### *Facilitating progress and attainment*
Teachers need constantly to make judgements about pupils' work in order to identify existing levels of development and to plan future work. Assessment in this sense should be *formative*. Teachers also need to make overall assessments of pupils' achievements at the end of a course or period of study. Assessment should also be *summative*.

### *Facilitating curriculum continuity*
Easing the transition between the different phases of school life was a major concern within the project. Continuity requires that there is an agreed set of expectations for pupils' achievement in the arts and that this achievement is recorded and information conveyed to teachers as the pupils move on. This is a principal role of assessment.

### *Improving co-ordination between disciplines*
The arts promote developments which may influence work in other areas of the curriculum: skills of drawing and observation may feed into work in science and mathematics; the verbal and social skills developed in drama may feed into all areas of the curriculum. Equally, what is learnt elsewhere may affect performance and attainment in the arts. A policy for assessment in the arts should be an integral part of an assessment policy for the school as a whole to enable arts teachers to relate their work with pupils to work in other subjects, and for other teachers to take similar account of work in the arts.

### *Meeting the needs of accountability*
Many groups and individuals need information about pupils' progress and attainment in all areas of the curriculum. These include the pupils themselves, their parents, other teachers, future employers and, where relevant, institutions of higher and further education.

**Approaches to assessment**

### *Negotiation*
Methods of assessment in the arts need to be appropriate to the styles and methods of teaching and learning in the arts. In arts lessons pupils and teachers work in collaboration, often in an open-ended and unpredictable way. The pupils' autonomy is encouraged and developed. Analytical thinking and self-evaluation are promoted through discussion of their own and others' work. This collaborative

relationship can be extended into assessment. It is important that the criteria for the success of any arts work are explicit. Pupils and teachers should negotiate agreement on these, particularly where there is room for a variety of response.

The teacher is constantly making formative judgements about pupils' performance. These can be discussed with the pupils. This negotiation can affect the planning and development of the course content and the teacher's strategies. In this way teaching and learning can be enhanced by assessment and not hindered.

A drama teacher from a comprehensive school describes how his style of teaching changed and developed through analysing ways in which he assessed his pupils' achievement. He explored new tactics in his teaching practice by giving a difficult group of Year 9 pupils more power in the selection of the content of their drama lessons. He used processes of negotiation which were new for him and the pupils and which gave the pupils much more responsibility in assessing their own achievement.

This extract illustrates the benefits of integrating assessment into classroom teaching. It also points to two useful techniques to aid assessment: audio-tape and photographs.

Negotiating with the class in this way has allowed me to step to one side as a teacher. By handing most of the decision-making over to the pupils, I was able to observe selected individuals more closely, instead of having to maintain an overview of them as a whole body. My judgement about the quality of the work and individual contributions to it was consequently more detailed and better focused. The pressure on me to 'orchestrate' the proceedings was reduced: because I had a less firm lesson plan to adhere to, I could observe, and follow, the mood and changes of direction as they occurred, rather than having to adjust them. By giving greater responsibility — the students call it 'freedom' — to the class, I had freed myself to concentrate on those aspects of the lessons that I most valued, and considered most important to assess....

I was able to gain a far more informed and detailed view of individual pupils during the lessons. There was enough time and space for me to absorb valuable information which might previously have gone unnoticed, or hardly registered. I gained an insight into their preferences, responses and attitudes. A reciprocal channel of exchange opened up between us. This was facilitated by observation, and by discursive exchanges in class. The analysis of photographs and studying of transcripts after the event was an invaluable help. It may be considered time-consuming and expensive to record and photograph every lesson but an organised and precise use of this equipment makes a profitable exercise in terms of the significant information it yields. The unexpected comment, the quiet contribution from a 'weak' pupil is recalled and available for analysis: all the 'lost' moments which occur in the whirl and action of a busy lesson are retrieved.

### Self-assessment

Developing pupil autonomy is an important function of arts teaching. It is important that the pupils' judgements about their own work are taken into account. This next example points to a way of building pupils' confidence and autonomy. A teacher worked with a group of pupils on creating a 'poetry climate' and looked at the implications for assessment.

I would first need to decide how best to evaluate what was happening in this 'poetry climate' I was hoping to create in my classroom. There were a number of factors I had to consider, not the least of them being the problem of objectivity in a situation where personal feeling and response were the areas of activity being evaluated. A valid criterion, I felt, was how the pupils saw *themselves* fulfilling the aims they set themselves, in writing, understanding and responding; so that was to be one strand in the assessment. To this end I asked for volunteers to keep diaries in which they would record their assessments of the lessons and their work. I would also tape-record them talking in small groups about their work with me. In turn, I too was to keep a diary, in which I would record my own evaluation of and thoughts about the sessions — the second strand of my assessment.

This illustrates how assessment can directly support teaching. By building in a system of self-assessment, the pupils' thoughts and feelings are valued by the teacher and their self-confidence encouraged. The system of self-assessment feeds directly into the pupils' critical skills, which are essential to *making* and *appraising*. The action of assessment is also described in the variety of ways in which the teacher is collecting evidence: her own and the pupils' diaries, and the audio tape-recordings of group discussion.

### *Profiling*
Many arts teachers argue that the most satisfactory way of reporting assessment in the arts is through a system of profiling. This allows descriptive statements rather than marks or grades.

A primary teacher who had been exploring ways of assessing pupils' creativity in visual art makes the case for profiling.

Having investigated aspects of creativity more closely than before, I feel I have a deeper understanding of each child. I could say, for instance, that X is an accurate and detailed artist in pencil and collage work, that he makes realistic models and colours well. He loves to draw imaginary battle scenes, and is heavily influenced by the space fantasy he watches on television and reads about. He plans his pictures carefully and logically, and includes highly technical machines and exotic monsters, though his representation of domestic pets is less accurate. He has a good vocabulary and can communicate his ideas clearly and fluently, at some length.

These are, obviously, descriptive phrases, which nevertheless, because of the detail, will contribute to any assessment I make. I *can* say more about X: about his responses to particular stimuli, the areas in which his confidence is greatest, and how this affects not only his work but his working method. I have a reasonable understanding of his intentions, and so can judge whether the choices he makes are appropriate or not. I can say something about his use of space, what features of a picture or story most attract him, and about his ability to think in visual terms.

The difficulty lies in conveying the increased, if never complete, depth of my knowledge and understanding in a way that is meaningful to me, the parents, other teachers and, most importantly, in a way that is both fair and respectful of what is not explicit. Grading a child B+ or A−, even trying to express these ideas in not more than twelve words, is insufficient. One very important result of my study was to reinforce my own confidence in the value of the work done: a confidence that should help me to communicate more effectively, and one that is supported by more specific and detailed concepts. When making an assessment, I can refer to what I know of the child, and also to what I know of the influences and conditions that bear on how the particular child works.

This knowledge should become part of the child's permanent record, if it is to be of

any use. I feel that a more detailed system of profiling, with opportunities to comment on all aspects of the curriculum, is the only way to record and communicate the important details which illuminate the understanding of each child.

### Records of achievement

There has been considerable development in records of achievement (RoA) schemes and many teachers have experimented with the statements it is possible to make about pupils' attainment. Computerised 'statement banks' have been set up to facilitate profiling. In some cases a system of unit accreditation has been developed. If pupils fulfil the requirements of a unit they receive an accredited statement with no grade or marks recorded. These credits are then collected in the pupil's RoA.

With the publication of the TGAT report (DES 1987), the idea of profiling became further endorsed and teachers across the arts disciplines have been working to define their own profile components. Several groups have attempted to articulate profile components for the arts as a generic area of the curriculum.

Having looked at many teachers' attempts at developing RoAs for arts subjects, one sees a clear pattern. Language may differ but all include:

- the technical skills of production;
- experimenting with and developing material;
- the knowledge and understanding of the concepts of the media and artistic form;
- the ability to sustain an idea from inception through to realised artistic form;
- the understanding and appreciation of the work of professional artists;
- the context — social/historical/cultural — of work produced;
- the personal qualities and value education which success in the arts requires and instils;
- the ability to contribute to group activity.

The value of pupils' self-assessment has already been referred to in this chapter and this is an important aspect of RoAs. The 1989 report of the records of achievement national steering committee (DES 1989d) pointed to the need for teachers 'to provide frequent and supportive opportunities for pupils to gain experience in self-assessment'.

The key factors cited were:

> the availability of clear and intelligible criteria which are related to the work in progress; the willingness, ability and confidence of pupils to be constructively self-critical; and teachers' willingness to consider and act on pupils' views.

The report also pointed to the need for planned discussion to be seen as a regular aspect of teachers' assessment practice: not to set aside extra time but to incorporate one-to-one discussion into normal class activities for the assessment of subject-specific achievement.

This is particularly important in the arts. There are no universal definitions as to what is, or is not, art, and no absolute definitions of what is 'good' and 'bad' art. It is essential that pupils are able to distance themselves from their immediate personal and emotional response, and to form a reasoned judgement based on sound

argument. In this way the pupil will be learning to distinguish between personal preference and a judgement made according to agreed criteria. Such learning demands that the teacher is prepared to give discussion, as a whole class and in one-to-one conversation, a key place in course-work and in assessment procedures.

## SUMMARY

In any teaching it is essential that teachers and pupils know how pupils' progression and attainment are assessed. In arts learning fundamental skills and concepts are repeated, elaborated and developed as pupils become familiar with them and ready to take on new levels of sophistication. Attainment can be described in terms of *making* and *appraising*. Evidence is to be found in the artefacts pupils make and their responses to their own and others' work.

Evidence of attainment in the arts will also be apparent in other curriculum areas. It is possible that different sets of attainment targets can be met within one carefully prepared project, either across the arts or across the whole curriculum.

---

### A checklist for assessment in the arts

1. Do you assess your pupils' progress in all their arts activities?
2. What do you use as evidence of that progress?
3. What criteria do you use when assessing that evidence?
4. Do these criteria reflect your teaching aims and objectives? If not, in what ways are they different?
5. Are your assessment procedures free of political, ethnic, gender and other forms of bias?
6. Do you have particular expectations regarding your pupils' attainment in the arts according to age?
7. Do you assess your pupils' attainment in both *making* and *appraising*?
8. How do you incorporate pupil self-assessment in your overall assessment?
9. What range of methods of assessment do you use?
10. To what extent do you integrate your assessment procedures into your classroom teaching?
11. How do you act upon the results of your assessment?
12. How do you assess group work? What criteria do you use?
13. To what extent do you use formative and summative assessment?
14. How do you report your assessment to parents and discuss it with them? Do they see pupils' arts work?
15. To what extent is attainment in the arts valued in your school?
16. Do you discuss pupils' attainment in the arts with other staff?

# CONTINUITY 5-16: LIAISON AND TRANSITION

## INTRODUCTION

Progression, attainment and assessment cannot be provided for within curriculum planning unless learning in the arts is planned as a continuous process from 5 to 16. This cannot be achieved unless teachers are aware of the previous work their pupils have completed, the types of work on which they will embark in the next phase of their education, and the relevance of their current work to both. In this chapter we discuss the need for continuity in arts education within and across phases of education, and describe a range of pratical strategies for achieving this.

## THE NEED FOR CONTINUITY

In practice, arts education tends to be fragmented and discontinuous. In primary schools record-keeping does not always include pupils' arts experiences, and those records that are kept in the arts do not always accompany pupils to secondary school. This does not help to develop primary teachers' ability to plan learning in the arts in a progressive sequence.

In secondary schools specialist arts teachers are generally more able than their primary counterparts to look 'vertically' — to recognise what tasks are appropriate to particular ages and levels of ability within particular disciplines. However, they are less able to look 'horizontally' at the range of learning experiences available to pupils across the arts during a particular year, or across schools in the same area. Secondary specialists are often unaware of what is being learned in other arts disciplines. Valuable overlap, unnecessary repetition or confusing contradiction can all go unnoticed.

Liaison and continuity was an area of great concern in the Arts in Schools project. Many development groups explored ways of improving co-ordination between different phases of schooling and thereby planning more coherent programmes of study for pupils from 5 to 16. The main concern was the transition between primary and secondary schooling. Regular development group meetings enabled primary

and secondary teachers to compare practice and priorities in terms of aims, content and methods. Practical projects were designed to ease the transition for the pupils, for the teachers to learn more about each other's practice and about the pupils' development. These projects fell into two main categories:

1. Crossing phases:
projects which enabled pupils of different ages to work together and to learn from each other directly;

2. Sharing expertise:
projects where pupils stayed in their usual grouping or school base and another factor, such as an artist, performance or exhibition, was introduced across the age range. This enabled the teachers to compare the different age groups' responses to a common stimulus.

## CROSSING PHASES

In the first type the most common model was for groups of schools — usually the local comprehensive and its partner primaries – to plan a collaborative event or festival. Teachers and pupils in the individual schools all prepared some work and came together on an appointed day, usually in the comprehensive, to share it.

Two projects demonstrate imaginative attempts to create purposeful one-off events of this type. In one project pupils from neighbouring primary schools were invited to the high school to participate in a day of arts workshops on the theme of 'monsters'. This workshop-based day avoided the anxiety of pupils preparing a formal performance, so often the defining feature of such collaborations.

The high school offered a creative studies course in the lower school and the 'adventure day' shared the aims and methods of that course: team-taught, topic-based, and combining the disciplines of art, music, drama and English. It grew out of the staff's awareness of the difficulties experienced by pupils during the transition from primary to secondary school. It aimed to strengthen the links between the two phases and to provide opportunities for learning the basic skills of music, drama, art and movement studies.

The secondary teachers agreed afterwards that:

- they had underestimated the abilities of the primary school pupils;
- the chosen theme was neither sufficiently abstract nor sophisticated for the children;
- they had missed many opportunities within each activity by not using the expertise of the primary teachers.

Events of this type show their value not in the short but the longer term, as ways of enabling arts teachers from different phases of education to compare approaches to teaching and learning.

On another comparatively formal occasion, more than a hundred children from primary, secondary and special schools came together to perform a full orchestral piece with an orchestra. This had involved the children practising their special pieces for many weeks but the final performance offered the unique experience for children with a wide range of ages and abilities of playing in an orchestra with professional musicians.

There was much discussion amongst the teachers about the educational value of the concert and the discipline and concentration needed for rehearsing and performing with a professional conductor. It did however represent a valuable opportunity to compare the attainments of the different age groups. In a single event it was possible to hear simple and complex variations on the same theme, and also the wide range of technical proficiency from beginners to skilled professionals. It was also possible to observe the ways in which different age and ability groups contributed to the overall performance in terms of understanding and co-operating with the conductor and supporting each other.

Other schemes of this first type involved pupils from different phases working together in more sustained ways. These projects offered teachers an opportunity to consider more thoroughly the differences between the age groups and the way the children could learn from each other.

In one project, Year 10 GCSE students wrote stories for junior pupils as part of their English course.

Stage 1 of our plans involved secondary pupils writing stories for junior children. Although our main aim was to strengthen links between project schools we also had objectives which were specific to the verbal arts:

1. to engage secondary pupils in a project that involved them in writing for an audience;
2. to evaluate how this kind of work might develop the writing skills of the older pupils;
3. to encourage the junior pupils to think creatively in an interview.

The junior children were interviewed on a one-to-one basis, to enable the primary pupils to decide on the content of their story themselves. The secondary pupils had to prepare the questions and after the interviews spent time in their own school writing and illustrating the final story. As part of their preparation they studied the format and content of children's books.

The interviews were thought by all to have been a success. Some of the teachers wondered if fourteen-year-olds and eight-year-olds would feel happy talking to each other but this presented no significant tension at all. There was the occasional difficulty over the meaning of a word: the word 'hero' turned out to have a different meaning for interviewee and interviewer, with the younger child thinking a hero was a person who did lots of fighting. An older pupil used the word 'tragedy', which was completely unfamiliar to the child being interviewed. When these difficulties occurred the older pupils quickly found alternative words. In some cases the younger children, letting their imaginations run freely, gave too many details. The task of putting all their requests into a single, coherent story seemed daunting and we looked forward to seeing how well the writers coped with this.

We had decided that once the story books had been completed we would invite the primary pupils to visit the high school for the final session. Some of the younger pupils seemed less 'safe' at first, but once they were with the same high school pupil and looking at their stories this nervousness mostly disappeared.

During this session the stories were read to and by the juniors. This was followed by some discussion of the books. The head of English felt the stories were very suitable as GCSE coursework, along with the questionnaires and first drafts. This meant the books could not be given away, which disappointed many of the younger children. Merely writing out the stories again was no solution to this problem as many were painstakingly illustrated. Making a second copy would have been a major undertaking.

It became clear during this session that some of the books were suitable for reading to young children while others were suitable to be read by them. Sometimes this was due to the writers misjudging the reading ability of their audiences; others had made a conscious decision to construct the story one way or the other. Children's books do of course fall into these two categories and along with an investigation of existing books we realised that more detailed research could have been undertaken into the abilities of individual children. We could have spent more of the first session hearing the children read.

The teachers agreed that for all children this project had significant implications for oral work. It was a worthwhile experience for them to talk with children of a different age. It was an opportunity for the younger children to think creatively, while it required the older students to be more analytical about communicating in a simple and precise way.

The most significant observation concerned pupil motivation. Senior pupils often ask why they have to do a certain task. Even when they do not they may inwardly fail to see the meaning and relevance of certain tasks. Frequently the reason given for creative writing at this age is the need to complete examination coursework. The only audience for their work is likely to be their examiner/moderator and teacher.

Giving students a particular audience was a source of inspiration for them. They had formed a contract with a younger child to produce a story. They were concerned that this child should be pleased with the results. There was a specific purpose to the work.

The secondary teachers were impressed with the commitment their pupils brought to these stories. Some went to great trouble, trying out their stories on younger brothers and sisters, asking parents for their opinions, comparing their work with their peers', giving support and seeking advice.

These evaluative comments reflect the personal and social gains, but in relation to the verbal arts they show that by providing a real audience pupils are enabled to shape their writing to communicate not only the appropriate ideas but also in the appropriate style. The pupils were engaged in one of the essential processes of arts education, that of shaping or forming material for communication to specific audiences.

It would clearly be possible to rehearse the arguments of the previous chapter by comparing this teacher's description of her pupils' attainments with the statements of attainment for particular targets in English at Key Stage 4. In this case the activity described also echoes elements of the relevant programmes of study in English. This serves to illustrate the many areas of overlap between English and the arts within the National Curriculum — and the fact that many classroom activities include elements of both, whatever title is adopted for timetabling purposes.

## SHARING EXPERTISE

The second type of strategy did not necessarily involve pupils working with different age groups but, rather, experiencing a new context for learning within normal groupings. One development group invited different artists to work across the age range through Key Stages 1-3 and compared the results.

One of the residencies, by a puppeteer in a first school, involved integrating puppet-making into class topics. Each year group's puppets demonstrated a different level of conceptual and technical understanding. The sequence of development was obvious when looking at the final exhibition of the school's puppets.

As the puppeteer moved up the age range we studied progression in skills, imagination, concentration and collaboration. Reception class children were content to copy the basic idea, using a paper plate, and to make it their own by decoration. The skills of drawing, cutting and gluing were an essential part of the creative process. Although copying the basic puppet, the varied expressions drawn by Year 1 children gave their work some individuality. Year 2's witches' faces differed mainly due to elaborate eyes complete with eyebrows, eyelashes and pupils looking sideways. Year 3 had moved away from the basic suggested puppets, expressing marked individual differences so that no two finished models were alike. These children, adapting and experimenting with materials, were prepared to discard ideas that hadn't worked and begin again.

Signs of group collaboration became apparent as we moved up the age range. The youngest children worked entirely on their own, seeking help from an adult when they needed it. After the visit some children in Year 1 made a puppet theatre together, and Years 2 and 3 completed group projects. More subtle signs of collaboration emerged when Year 3 pupils asked a friend to hold a nose in an exact spot while it was sellotaped in place. As skills and confidence increased, concentration and a willingness to tackle problems became evident.

Another development group used a dance animateur working with different age groups across the project schools. The culmination of her work was a sharing in one of the primary schools where children and teachers presented the dances they had been working on. The children from the different groups were each other's audiences, extending their learning into *appraising*. They were taught how to watch dance, as the animateur explained what had been the theme and working process with each group and what the audience should look for. This allowed pupils and teachers to be more critical. This was useful not only for the children but as INSET for the teachers, enabling them to observe different levels of experience and understanding.

In another project sixth-form students from a tertiary college became teachers in primary schools for one afternoon a week for a year. The head of art at the tertiary college describes the aims of the project:

1. to promote observational drawing and its uses across the primary curriculum;
2. to establish an educational link between primary and tertiary education, using arts students as the providers of specialist expertise;
3. to enable the students to promulgate and defend their own ideas in a professional environment and to sample education from a teacher's viewpoint;
4. to give the resident teacher the confidence to undertake such work after the project had ended.

There were many valuable outcomes of this project, including the prevocational training for the student and the INSET for the resident teachers. Perhaps most importantly, it questioned the teachers' expectations of their pupils' capabilities.

Throughout the project work was produced in a variety of media which was technically beyond that expected of ten-year-olds. One of the questions which needed to be asked was whether we set too low a standard, when with the right degree of instruction and support ten-year-olds can produce work usually expected of fifteen- and sixteen-year-olds.

Is it that we set too low a standard or that we do not have enough specialist art-trained staff to develop potential and construct work schemes with clear-cut aims and objectives? On the other hand, is it educationally acceptable for ten-year-olds to produce work to the standard of sixteen-year-olds? Although the end result might demonstrate a high degree of technical competence, how relevant is it to their individual development? Is the end product superficial? Is the skill element minimal and is the approach heavily teacher directed?

Such transferring of expertise is not only valuable for pupils in meeting new people and experiencing new teaching approaches. As this example suggests, it can also provide valuable INSET for teachers themselves, giving them an opportunity to reflect on their own pupils' development in different situations and to re-evaluate their own teaching in the context of a continuous process of arts education.

## Teacher exchanges

One of the most productive strategies for liaison between phases is teachers visiting each other's schools: changing places for an afternoon, observing each other's practice, teaching a different age group or simply using the opportunity for formal or informal exchange of information regarding pupils' attainments in particular areas of the arts in the curriculum.

Secondary arts specialists can make an important contribution to the work of primary schools by enhancing children's arts experience and providing INSET for teachers. They represent a resource primary teachers can draw on in any part of the country, with or without funding.

One secondary English teacher organised a regular teaching exchange with a primary school in order to learn about the development of early writing skills. In the process he concluded that secondary pupils often deny their primary experience by apparently not being able to remember what they did. They become confused by the differences in teaching styles and undervalue their early school experience.

I had gone into the school initially to talk to teachers about children's writing, starting in a reception class and working my way up to Year 6 in an attempt to learn more about the development of writing skills. In the event what I found most interesting was that children were being asked to do things which my Year 7 pupils had denied doing: they claimed to have done nothing but rhyming poetry in primary school, when all I could see on the walls was free verse.

This teacher organised an exchange with the head of another primary school and recorded her observations about working in a comprehensive school.

She was intrigued that her ex-pupils considered that playing had now stopped and work must begin. She reported that the class were reluctant to talk, preferring to get on with 'what sir has told us to do'. This was especially interesting in the light of pupils' previous 'inability' to remember what they had covered at primary school.

Our school has now set up a curriculum review and the question of the assimilation of Year 7 is to be discussed. If schools are serious about liaison then time must be set aside for regular visits, to the extent of having a teacher responsible for organising them.

## Liaison between school and further education

Education should be planned as a continuous process beyond as well as up to the age of 16. Liaison is therefore also essential between schools and further and higher education. One development group devised a modular GCSE arts course with the intention that modules could be transferred between schools, sixth-form colleges and colleges of FE. In this way a pupil might be able to continue a course, using an accreditation scheme as they transferred to different institutions.

Ideally, credits could be granted for extra-curricular courses such as summer schools or courses within other arts organisations. This opens up another area: that of the continuity between learning in the formal and informal curricula. Modular courses often use resources beyond the school. Liaison with arts agencies and community arts programmes should therefore be part of the way secondary arts teachers conceive their responsibilities.

## Liaison between school and teacher training

One arts-based response to the widely acknowledged need to break down barriers between schools and initial teacher training saw PGCE students given an opportunity to link their course with the secondary school curriculum via a course in community theatre (one of the module options in the neighbouring comprehensive's TVEI pilot project). The project is introduced by a lecturer from the college of higher education.

It is the perennial complaint of students on Postgraduate Certificate of Education (PGCE) courses that they are not taught how to cope with classroom control problems: that they spend the first few weeks of their course considering educational aims, lesson planning and theories of learning, only to find on their first teaching practice that most of their creative effort is taken up with classroom control strategies.

As part of our 'Care and Control Conference', a week-long examination of issues and strategies related to classroom control and pastoral care, we devised the 'Acting Up' project, involving the re-enactment by pupils from the neighbouring comprehensive of scenes dealing with classroom control which they have improvised with their drama teachers over a period of weeks. Members of the audience of student

teachers are invited to discuss the motives and behaviour of the characters with the actors, the pupils. This leads into general discussions about classroom behaviour and pupils' attitudes to teachers.

'Acting Up' grew out of the idea of using case studies to examine classroom problems. In planning discussions within the PGCE team it was suggested that it might have more impact if we could act the cases out. A personal contact enabled the interests of the PGCE course and of the drama group at the comprehensive to coincide. The first attempt at the project involved three drama groups: a TVEI community theatre group, a Year 11 option group and a Year 12 group. Ideas for the plays were written and put forward by a member of the PGCE team but the action and dialogue were largely improvised. The three groups performed three times in rotation to groups of about thirty students. The scenes tended to portray quite dramatic or extraordinary classroom events such as confrontations and fights.

The second version, by contrast, featured scenes based on more subtle and realistic themes. This time the plays were all improvised by the pupils without any pre-written material and the role of the teacher was prescribed by the pupils. In this way we were tapping into the pupils' experience and perception of what constitutes a 'bad' teacher.

The teacher's Year 12 group had her playing the role of a tired and underprepared teacher whose casual and neglectful attitude engendered chaos and disrespect in the pupils. One Year 10 group's teacher was the classic newcomer determined to crack down hard on the pupils and 'show them who is boss', haughtily and imperiously. Order was maintained for a while but eventually resentment generated by the teacher's unjust behaviour led to confrontation and disorder. Another Year 10 group's teacher was taken to the cleaners by her class.

> My group's work focused on the dangers of being 'too nice'. To do this the pupils assumed roles as pupils in a class of their own age, and advised me as the teacher how to 'get it wrong'. The role play was developed by the pupils stepping out of role and taking responsibility for the content and structure of the scene, then stepping back into role to check the appropriateness of our material. The finished product was rehearsed and polished, in the sense of refining the shape and hence the focus of the drama, with an appropriate beginning and ending. These scenes were re-enacted in front of the PGCE students. The pupils then divided into pairs and joined groups of students to discuss 'the performance' and talk about their perceptions of teacher practice.

> The scenes were then re-enacted with the PGCE students in a position to 'freeze' the drama at any point and suggest alternative strategies that could be employed in order to keep control of the situation. The pupils agreed to react as they would do were the teacher acting in this way. There were two dramatic 'pulls' at this point: one was the pupils' desire to preserve the shape of their play in such a way that the proposed changes would not alter their storyline, whereas the students' intentions were significantly to change the direction in which the drama was going; the other was that the pupils were pitting themselves against the teacher so that they continued to fail, whereas the students' aim in suggesting new strategies was to make the teacher successful. The pupils found it difficult to step in and out of role because they had lost both artistic and 'real' control.

Our aims in relation to the students' learning were:

• to raise their confidence by enabling them to see that pupils who engage in disruptive behaviour are nevertheless recognisably human underneath;
• to demystify stereotypical disruptive behaviour and reveal it as a game which

pupils play for amusement;

- to enhance their ability to cope with difficult classes by enabling them to learn the rules of the game from the experts, the pupils;
- to show them good teachers working with potentially difficult pupils in a productive and creative way;
- to help them develop a view of teaching as a form of role play which can be self-consciously analysed, reflected upon and altered.

In relation to the pupils' learning, it was agreed that four aspects of the project were of particular importance:

- they were framed as experts on classroom control and responded accordingly: other staff observing the preparatory lessons were astounded at their level of commitment and involvement;
- they had significant roles within the drama and therefore significant power;
- being in role put them in a protected situation and enabled them to re-examine their positions as pupils relating to teachers;
- they worked within theatrical conventions and took responsibility for shaping, focusing, creating tension, building to a climax, selecting an appropriate finishing point and choosing language: in other words, they were working within drama as an arts process.

Examining classroom control in the college meant engaging students with a representation of reality rather than with reality directly. The case study approach was commonly used as a way of representing reality for the purposes of college-based discussions and it had many advantages. It was easy to manage, accessible and seemed to be authentic. We also felt that it lacked impact on an emotional level. Simulations and role play by the students had been tried, but tended to lack any authentic content. Students might play what they believed to be typical pupil roles but the behaviour they portrayed tended to reflect their own stereotypes rather than authentic pupil behaviour.

The purpose of the pupils' enactments was to make the case studies 'live', so as to increase their impact. A member of the PGCE team who is a part-time novelist wrote scenarios for the pupils to work on for the first version, but on the second occasion we decided to go for improvisation from scratch. We felt that without pre-written scenarios the drama would represent more authentically the behaviour the pupils actually engage in. We wanted to tap into the pupils' intimate knowledge of the subject matter. To suggest that we could imitate everyday classroom situations would be an oversimplification, however. We were using a compressed timescale, and the language was in reality carefully selected and shaped in order to create the illusion of unrehearsed classroom dialogue. Many would regard teaching itself as role play, however: a game in which both sides know the rules and play out certain roles. In this sense, we were using role play to examine role play.

Most students commented that the experience provided good insight into the pupils' perspective. The students appear to have become more aware both of the real sense of injustice some pupils have, and the extent of their playful wickedness: their determination to unseat an unsteady teacher for the amusement value. For some students a more subtle message came through. The 'wind-up' game pupils play was not just for laughs but an instinctive attempt to force the establishment of a symbiotic power relationship. The pupils gave the impression that they were looking for some sort of security and were only satisfied when they had evoked firm and caring responses from teachers who knew how to play the game.

Not all students found the experience positive. A few found it disturbing and discouraging: a display of bad behaviour without any hope of a remedy. These students did not perceive the display of excellent drama work which was the result of weeks of hard work on the part of both pupils and staff. They appeared not to notice that these pupils who knew all about rowdiness and riot had in fact spend the day 'working'. They were able to go in and out of role whenever their teacher demanded it. They had shouldered enormous responsibility and clearly had very productive relationships with their teachers.

The message of this project goes far beyond that which particular students might learn about classroom control strategies. If its aims were confined to practical tips for new teachers we would be open to the accusation of promoting a narrow, behaviourist view of pupil-teacher relationships. A major part of this project is the exploration which takes place in the small group discussions between pupils and students which follow each performance. Through these discussions each side of the 'great divide' may come to understand the motives and feelings of the other.

## Co-ordination between formal and informal provision

If arts education is to be a planned and co-ordinated process up to and beyond the age of sixteen, effective co-ordination is needed between the opportunities provided within and beyond the formal timetable. This is also essential in enabling schools to develop their wider community roles, as we discuss in Chapter Nine.

One dance teacher's response to this need for co-ordination between the formal and informal dance curricular was to develop her curriculum dance by offering extra-curricular activities such as dance clubs and school performances, and by using a community dance programme.

Dance in the curriculum is enhanced through club work. It develops a different rapport and relationship between pupil and teacher and enables pupils to develop their personal commitment and dedication to the subject.

The community programme is an added bonus, providing further experiences and opportunities, particularly the senior youth group, which caters not only for present

*Dance clubs enable pupils to develop their personal commitment and dedication to the subject.*

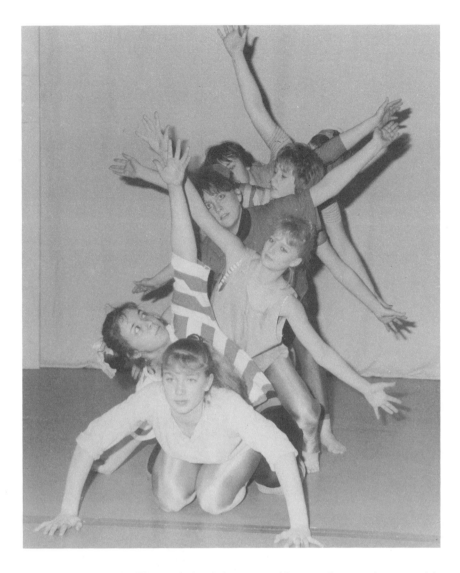

but also for past pupils. The youth dance theatre provides more intense choreographic and performing experience, both in local venues and on tour. This complements pupils' schoolwork, especially those involved in examinations.

Many pupils continue in the group when they have left school. For many it is simply a way to pursue their hobby while others use the company as a stepping stone before going on to college to do a specialised dance course. Others have found employment on the community dance programme and used the youth group experience in conjunction with the [then] Manpower Services scheme. The youth group plays an important part in the links between school and community and life after school.

## SUMMARY

Arts provision in schools is often fragmented and prevents teachers from viewing arts education as a continuous process. In particular, there is often little communication between teachers in primary and secondary schools.

Some projects designed to remedy such fragmentation focus on personal and social outcomes, with pupils of different ages coming together on a shared venture. Others examine pupils' learning across the age range. A common strategy is to introduce an artist, exhibition or performance and to explore the different age groups' responses.

All such initiatives provide valuable INSET for teachers. Some teachers from different phases change places for a series of lessons, opening up debate concerning teachers' expectations of pupils and whether or not there are recognisable patterns of development in the arts. A valuable outcome of these exchanges is the increased understanding teachers then show for each other's methods.

Continuity and co-ordination between curricular and extra-curricular learning and the development of closer links between the curriculum and prevocational and vocational study are also crucial in strengthening links between the school and the arts world.

## A checklist for facilitating curriculum continuity

1. Are you aware of what pupils have learned in the arts before they came to you? If so, is this through reports or by direct experience of the work itself?
2. Do you know how well they are progressing in other areas of the curriculum?
3. Do you know what arts experiences your pupils will have access to in the next phase of their education?
4. Do you explain to your pupils the relationship your work has to their previous experience in the arts and to the work they may do in the future?
5. To what extent are your pupils aware of how work in the arts relates to other areas of the curriculum?
6. Do your pupils see models of work from older pupils so that they can visualise where their work may be leading?
7. Do your pupils ever have the experience of working with older or younger pupils?
8. Do you ever get the opportunity to observe another age group — either in your own school or in another phase of schooling?
9. Do you ever work with a different age group of children?
10. Do you keep records of what your pupils are achieving in the arts and if so, do you share these with the pupils' next teacher?
11. Do you ever meet with other staff to discuss pupils' progress in the arts?
12. Can you plot a route through school for pupils who want a vocational course and career in the arts? As a primary school teacher, do you know what courses are available in your local secondary school? As a secondary school teacher, can your school offer the appropriate examination opportunities for pupils who wish to pursue a career in the arts?

# MEETING SPECIAL NEEDS

## INTRODUCTION

Many teachers are aware of the value of learning experiences in the arts for pupils with special needs. The arts offer pupils with learning difficulties in particular areas of the curriculum new media through which to express themselves. This can be vital in raising such pupils' self-esteem. Yet many schools give the arts low priority in planning educational provision for pupils with special educational needs. In this chapter we identify what the arts have to offer such pupils and how schools can build these benefits into their curriculum planning.

**Nichola's story**     A primary teacher describes how work in the arts helped raise the motivation and self-esteem of one of his pupils.

Nichola is an immature child, physically, socially, intellectually and emotionally. She is very frail, is small for her age (ten), is very thin and pale, has only one lung and has a heart problem. She has missed a great deal of school through illness. She does however have a very strong will and this often resulted in confrontations with the teacher if she decided that she did not want to undertake a particular activity.

Nichola would often use the excuse that she could not do something before even attempting it: she expected to fail. If she did undertake a task and then came across a problem, she would lose all interest in it and become withdrawn, refusing to respond to any attempt to communicate with her. She had great difficulty in mixing with other children.

Nichola seemed to require one-to-one attention from the teacher if she was to achieve anything. She did receive five hours per week of individual tuition from a peripatetic special needs teacher which, although very important in improving her basic numeracy and literacy, resulted in her being out of the classroom a great deal and may have increased her alienation from the other children.

Nichola's stubbornness was most apparent in physical education. Although she got cold very easily, and therefore could have problems with outdoor games, there was no reason why she could not take part in indoor activities such as gymnastics, games or dance. Nichola tried to avoid any form of physical activity however, using 'instructions' from her mother or forgotten PE kit as an excuse.

When I began teaching the class I started to include drama as a regular part of the timetable. Since this took place in the school hall, required movement and had an

element of working in front of others about it, Nichola placed it in the same category as games and gymnastics and at first refused to involve herself to any great extent.

Other children were loath to work with her since she either insisted on her own ideas being used exclusively or became sullen and ignored the rest of her group. Consequently I usually had to work with her myself. Only once did she work well in a pair with another child. This was when the object of the exercise was to try to outstare each other. She found that her strong will and determination were what was required and she gained great satisfaction from being unbeatable at this activity. The other children seemed to sense the level of importance that Nichola attached to this success and many of them attempted to outstare her at playtime. Fortunately they all failed!

Nichola began to realise that she was able to undertake activities in drama on an equal footing as the rest of the class and started to enjoy the work. This enjoyment began to make her view other physical activities with a more open mind. She became very keen to show what she could do, enjoying the pleasure of repeated success. She found that her ideas were no less valid than anybody else's and began to gain the confidence to perform in front of others, pleased with the praise that she received and secure in the knowledge she would not be doing it 'incorrectly'.

She particularly enjoyed movement work and recently she asked if she could join a dance/drama club that I run once a week after school. At first she preferred to sit at the side and watch, but eventually she began thinking out her own simple sequences of movements to fit in with the work we were doing and began to join in with the others as a member of a group.

This change of attitude towards physical activity has spilled over into other areas of the curriculum. Nichola is now more prepared to contribute orally in the classroom and to socialise with other children. She now approaches any task with a more open mind, no longer assuming that she is going to fail at it.

I do not think that any one factor alone is responsible for the change in Nichola; perhaps her attitudes have changed on their own. Or it may be that individual tuition has been a major factor. I do believe that work in drama has helped her confidence since it highlighted her successes, rather than making her more aware of her failures. To children like Nichola the possibility of failure is always there. A curricular area where personal engagement is the main criterion for success, rather than correctness of response, is important for building confidence.

Nichola still has problems; she probably always will have. At least she has started to believe in herself, and her own ability to succeed.

## DEFINING SPECIAL EDUCATIONAL NEEDS

Nichola's learning difficulties do not place her in a particular category of pupils: rather, they illustrate kinds of difficulties experienced by many pupils in mainstream schools at different points in their careers. It was the Warnock Report (HMSO 1978) that rejected for all time the practice of categorising particular groups of pupils in terms of different handicaps, in favour of trying to understand their individual learning needs and planning educational provision to meet these. It challenged the idea that there are two types of children, handicapped and non-handicapped, the former needing special education, the latter ordinary education, and it defined special provision as:

> any form of additional help wherever it is provided, and whenever it is provided, from birth to maturity, to overcome educational difficulty.

The theme for one experimental combined arts course in a secondary school (see pp. 76-78) was a local lifeboat disaster.

Children requiring special provision were no longer to be conceived as a homogeneous group, but rather:

> the planning of services for children and young people should be based on the assumption that about one in six children at any one time and one in five children at some time during their school careers will require some form of special educational provision.

The 1981 Education Act identified children with special educational needs in the following way:

> a child has special educational needs if he or she has a learning difficulty which calls for special educational provision to be made. A child has a learning difficulty if he or she:
>
> (a) has significantly greater difficulty in learning than the majority of children of his or her age, or
> (b) has a disability which either prevents or hinders him or her from making use of educational facilities of a kind generally provided in schools.

Although all children's precise learning difficulties differ, there are four broad aspects of special educational need: physical disability, sensory impairment, learning difficulties, and emotional and behavioural difficulties. These may be combined in a variety of ways. They do not correspond to particular groups of pupils. The whole spirit of the 1981 Act was to get away from the notion of starting with the handicap and shaping the curriculum around it, in favour of starting with curricular goals and developing strategies to make these goals and objectives attainable by pupils with difficulties of access.

This philosophy was carried forward into the 1988 Education Reform Act, under which all pupils share the same statutory entitlement to a broad and balanced curriculum, including access to the National Curriculum. The principle of access informs each of the three main ways of adapting the National Curriculum to meet individual needs. Modifications and disapplications within the statutory orders for particular groups of pupils are used sparingly; statements of special educational needs specify how the National Curriculum is to apply to the individual pupil; and temporary exemptions are granted to headteachers for only a limited time, following extensive consultations.

## DIFFERENTIATION IN CURRICULUM PLANNING

A great variety of learning difficulties exist within the twenty per cent of the school population, educated in either mainstream or special schools, identified as having special educational needs: from the severely mentally or physically impaired to those, like Nichola, requiring remedial help within the mainstream. All these children are entitled to access to a broad and balanced curriculum. This means that schools must uphold the broad aims of education for all children whilst providing for differing abilities and characteristics.

Differentiation, the process of designing appropriate learning programmes and organisational structures to meet pupils' individual learning needs, involves keeping pupils' progress under constant review through monitoring and evaluation, and adapting individual

learning programmes in the light of what is learned, in the arts as in all areas of the curriculum.

The challenge of educating pupils with special educational needs in and through the arts is the same as that of meeting the individual needs of *all* pupils in their learning experiences in the arts. The key theme is to ensure equal access for all pupils. What is the general role of the arts in the education of pupils with special educational needs?

**The role of the arts**

Some schools consider only a very narrow area of the curriculum when identifying children's special needs. Children are categorised at a very early age as 'able' or 'less able' on the basis of their achievement in limited areas of the curriculum, frequently reading and mathematics. An assumption is made that attainment in these 'core' areas indicates overall educational potential.

A primary teacher describes the system for identifying and monitoring pupils with learning difficulties which operated in her school.

Children with special educational needs were identified by an internal screening process. Each class teacher completed annually an information sheet issued by the headteacher requiring test results and comments about each child. Once all sheets were completed the head discussed individual children with the school's special education advisory support teacher. Children would be referred to appropriate agencies such as the educational psychologist. Those requiring detailed screening were followed up immediately and special teaching programmes and regular monitoring would be implemented. Only limited time was available for these children.

The internal monitoring sheet helped to maintain a consistent record of events. Every term there would be, in consultation with the class teacher, a written review. The system of communication was fast and efficient between teaching staff, headteacher and other outside agencies such as speech therapists, school doctor and psychologists.

At all times there was concern as to whether sufficient, and in some cases appropriate, individual teaching programmes were provided. School-based individual teaching was only available for the most difficult or serious cases and with limited time allocation. In such circumstances the main concern for the majority of the staff was to improve the reading, writing and mathematics areas of the child's performance. Teacher awareness of the beneficial effect that the arts could bring to these children was limited.

This school's practice is typical of many others. Yet repeated failure in 'core' learning areas like reading, writing and mathematics can demolish children's self-esteem and alienate them from the educational process. For all children, but especially those identified as having special educational needs, the enhancement of self-esteem is a priority and requires the inclusion in the curriculum of experiences which offer different kinds of access to success.

The importance of the arts for such pupils is that they promote a broader conception of educational ability, and a wider range of media and forms of perception and communication. They not only offer ways of meeting pupils' special educational needs but of revising the general view of ability on which the identification of special educational needs may be based. The value of the arts in the education of pupils with special educational needs is not to compensate for abilities that children and young people don't have, but to identify and develop the abilities they *do* have.

*One development group based a combined arts project on the work of the Indian artist, Rabindranath Tagore. An Indian dancer, who interpreted the poems of Tagore through dance, worked with each of the schools. (See p.156.)*

*Particular artistic challenges are involved in designing and painting murals. Unlike a painting which can be moved, a mural has a particular environmental context. It must fit in with the buildings around it. (See p.185.)*

Teachers in special schools and units tend to lack confidence and expertise in the arts: arts teachers in mainstream schools tend to lack confidence and expertise in meeting special educational needs. Consequently, the arts do not figure as prominently as they might in special education, and arts teachers do not take the role they might in helping ordinary schools to fulfil special needs policies.

Four general roles of the arts in meeting special educational needs may be identified:

### 1. *Individual needs*
The arts are concerned with individual qualities, abilities and perceptions. This intrinsic attention to the individual can help to break the mould of the broad categories which can hamper the education of children with special educational needs.

### 2. *Expression and communication*
The mainstream curriculum is intended for able-bodied pupils. Average performance relies on average speech, visual, hearing and writing skills. Pupils of average (or above) intelligence with sensory, motor or emotional problems can have substantial difficulties in demonstrating and developing their abilities. The arts provide a wide variety of new opportunities in different media to communicate and to succeed.

### 3. *Social education*
The problems of children with special educational needs can be compounded by their actual or perceived isolation from others. The arts provide invaluable opportunities for working and achievement with other children and adults.

### 4. *Raising confidence*
Children with special educational needs can be caught in a recurrent cycle of low achievement and falling self-esteem. By providing new goals and avenues for achievement, the arts can help to give them necessary experiences of success. These experiences can raise their self-confidence and enrich their attitudes to themselves and to other people.

The arts also offer more specific opportunities for learning and individual development which can have enhanced value for pupils with special educational needs:

- they explore feelings and ideas which are not necessarily in the cognitive/intellectual domain and which use the senses in refined and sophisticated ways e.g. listening, seeing, kinaesthetic awareness, touch;
- they require individual, creative responses and teaching which offers pupils differential treatment in terms of strategy, content and assessment;
- they require teaching which is non-judgemental: work has to be assessed in terms of each pupil's efforts and ideas as well as their interpretation of a particular task;
- they give each pupil access to success, as there is no built-in right/ wrong element in the art-making process: they consequently create the opportunity for the development of self-esteem and self-confidence.

# LEARNING IN AND THROUGH THE ARTS

Many teachers describe remarkable gains when children with learning difficulties are enabled to participate in arts activities which offer them access to new media. Such gains are generally described in terms of emotional, motivational and social development. Important as these gains are, this tendency to emphasise the 'instrumental' functions of the arts — to regard them primarily as a context for generalising learning in 'core' curriculum areas — is a function of teachers in special education lacking confidence and expertise in the arts.

Teachers in special education are particularly likely to describe the benefits of the arts in terms of their contribution to learning in other curriculum areas. They share with many primary teachers an integrated view of learning, seeing the curriculum not as divided into discrete subject areas but devised and programmed according to the needs of the pupils. In general, they engage pupils in the arts in order to foster other more generalised skills and not from a particular view of the aims of arts education. A teacher of pupils with severe learning difficulties characterises this approach.

The curriculum for such children should focus on the acquisition of clearly ordered skills and concepts, often to be acquired in highly structured situations.

Children with learning difficulties also have particular problems in generalising this learning, hence the importance of providing opportunities for practising and applying skills. The arts enable this to happen in a context the children recognise and find motivating. Children often feel less pressurised in these situations and are consequently more receptive to learning.

Arts activities can be structured to afford a valuable opportunity for cross-curricular learning of skills, concepts and factual knowledge. In a motivating and meaningful context, pupils will find both a need and a reason to use their resources and skills, particularly language and self-help skills.

In a drama lesson, for example, children might work in role as lost explorers, experiencing through drama the problem of how to ask for help. This would give them the opportunity to practise an important skill at one step removed, emotionally protected from failure through the role. Learning through the arts in such ways, pupils may discover an inner resourcefulness for generalising and applying learning in the real world.

As this teacher describes, the arts can facilitate progress in personal and social development and encourage pupils to apply skills gained in other curriculum areas in an arts context.

The arts are also important in their own right, as part of all pupils' educational entitlement. All children are entitled to engage in the arts for the intrinsic rewards they bring, as the following example from a severe learning difficulties context illustrates.

The arts can be used to promote motivation and purpose in severely disadvantaged children. Severely handicapped children undergoing programmes of physiotherapy, for example, have to spend considerable amounts of time in positions which inevitably restrict their interaction with classmates and teachers.

A bucket filled with paint, with a small hole in the bottom, is suspended from the ceiling. The children, dotted around the room in their physiotherapy positions, push

*All the children carried out scale drawings of their own ideas, source material for which included drawings from life (a dog, plants and leaves), from books and from photographs taken of dogs in the park and at the club. (See p.186.)*

the bucket and paint drips from the hole, making a design on the paper spread on the floor between them. Creating this effect as a group not only motivates the children to be involved in an aesthetic engagement, it helps to develop physical control, and makes a shared experience of what was previously individualistic.

Here physiotherapy adds another dimension to the argument, but the important point is that even if these children's abilities to control the application of the paint are very limited — compared with, say, children who might draw with their feet or apply paint with their palms or with a head-set — they are still able to relate at a basic level to the patterns they have created, to be involved in an 'aesthetic engagement'.

Similarly, Nichola's teacher noted earlier that she, already showing many signs of learning and gaining socially from movement sessions...

began to think out her own simple sequences of movements.

Nichola had not only learned through an arts activity to co-operate with others; she had also learned to engage in the process of art-making itself.

A further illustration comes from a research project with a small group of Year 6 pupils with language difficulties; their class teacher felt they would benefit from working with the intimacy of a small withdrawal group. The aims of the project were:

- to demonstrate how children with language learning difficulties can develop their spoken and written language through first-hand experience, using natural forms as starting points for small group talk;
- to demonstrate how such children, when given access to more mature art forms such as poetry, will eventually absorb the richness of the textual language and make it their own.

The group met once a week over a period of three terms, in the course of which natural objects — plums and chrysanthemums — were used to stimulate talk and develop written responses. The teacher who organised the project concluded that:

This small-scale research has shown that before children with language learning difficulties can gain access to more mature forms of language, it is necessary for the teacher to reawaken their sense of touch, vision, hearing, scenting and tasting in a tangible way.

Initially, writing from such children can seem limited. Even though they can often talk with confidence and vitality, they have difficulty committing the same experience to paper. It is important that they are given access to the most richly-laden language available so that they gradually form a confident and sensitive awareness of words. To this end, poetry should be seen as an integral part of their curriculum.

Notice how an emphasis on self-esteem and social skills (learning *through* the arts) goes hand-in-hand with the recognition of language as a creative medium and the importance of poetry (learning *in* the arts), even with pupils lacking basic language skills. The child's curricular entitlement remains constant; it is the way the teacher introduces and structures the activity to provide wider access that varies with the learning capabilities of the pupils.

In this final example from a day school for children aged 4 to 19 with severe learning difficulties, including some with minimal and multiple physical handicaps, learning in and through the arts are once more seen as complementary. The general roles of the arts in meeting special educational needs introduced above are well illustrated, as are the more specific opportunities for learning and individual development which the arts promote.

The arts play an important role in the school curriculum. It is our policy to encourage creative work in and appreciation of different art forms as well as using the arts to underpin our curriculum. Although the school is small we have a lively and talented staff who recognise the opportunity the arts offer in teaching concepts which would be inaccessible to the child with severe learning difficulties using a clinical behavioural approach: for example, those of history and geography.

We regularly enliven our teaching of the arts by inviting arts specialists into school to take workshops and also by involving pupils in arts activities in mainstream schools when opportunities present themselves. We believe it is important for all children to have the opportunity to 'star' and, to this end, we produce concerts and shows to which families are invited. When we undertake a performing arts project, the 'happening' is not something to be observed; it is an experience to be shared. We do, however, select parts which we put into a performance for parents.

Although all the children have severe learning difficulties, there remains a vast range of needs and abilities to be catered for. There is also a wide age range of pupils and therefore age-appropriate activities and behaviours must be considered. In a project on China, for example, older pupils were encouraged to seek out magazines or newspaper articles about China, to find books at home and ask parents about China and to relate items of news heard on TV. These were all collected together in a class scrapbook. Pupils were asked to bring to school Chinese items for our school display. The response was good, producing an attractive array of china cups and saucers, pictures, dolls, parasols and jade figures. These activities developed language and communications skills and offered opportunities to reinforce number, shape, colour, reading and writing skills.

The China project brought the pupils into a partnership with a freelance theatre designer, members of the county youth theatre and trainees from the local theatre training workshops. The school hall was transformed into an ancient Chinese village and the pupils were given the opportunity to act in role the lives of different inhabitants of that village: builders, potters, farmers and weavers. The hall was then transformed into the emperor's court to enable the village folk to contrast their lives with a very different behaviour and protocol. Four arts areas of the curriculum were explored through the project: drama, dance, stories, music; art — costume, make-up, masks; art and craft — pottery, group display work; cookery — using a wok and eating with chopsticks.

Within group teaching situations such as those involved in this project, all individual children are learning at their own rate and it is the responsibility of the teacher, through formative assessment and observation of a child's performance, to decide what is the next step to be learned. Within a group activity such as making papier mâché masks, one child might be expected only to exercise the necessary motor skills and co-ordination to tear up the newspaper into small pieces and place them in a bowl. The teacher would then physically help the child to create a mask so that he or she would have a lovely end product. At the other end of the continuum of ability, another child would be expected to make the papier mâché and create a mask with only verbal encouragement from the teacher. It is important that all children are given the opportunity to achieve success. Nothing motivates like success!

In this way individual objectives are set for each child working within a group. Successful achievement of objectives is recorded in each child's personal file. Our school curriculum is contained within our checklists which cover each area of development. Our school arts checklist is still being developed: the development of a checklist by school staff is very time-consuming.

Many things that happen to children in the course of arts activities are not measurable in an objective recording system, but so many things are observable: the look of concentration and wonderment on a child's face when he or she becomes engrossed in a story when usually he or she can't sit still for two minutes; the responses of children when they have adopted a role and will actually respond in it, forgetting that usually they are reluctant to talk or even to lift their heads because of shyness; the comments passed by the children in a music session that indicate their interest and understanding of the experience they are sharing.

The local radio station presented a feature on the China project, and two of the pupils were interviewed. Both were eighteen-year-old boys and they were able to answer the questions posed by the interviewer and give a comprehensive account of what they had experienced. It was clear that they had enjoyed the drama, music, stories and painting, but they had also acquired concepts and factual knowledge about China. I know that whenever they see China featured on TV they will be able to make more sense of what they see and hear because of the baseline they now possess.

We also made a video of the project, a useful method of recording children's responses that gives the opportunity to observe progress when reviewed at a later date compared with present performances.

## CLASSROOM SUPPORT STRATEGIES

The other notable feature of the language development project described earlier was its model of support learning in small groups withdrawn from the classroom.

It was felt that a small intimate group of no more than four children would help generate confidence in the pupils. They would be encouraged to feel relaxed and unthreatened, thus allowing them to admit uncertainty in their learning experience without being intimidated.

How viable is this model of support teaching in the arts within the regular curriculum? What other steps can schools take to organise arts teaching to the best advantage of the pupils with special educational needs in their care?

Assuming that the school is acting within the framework of the 1981 Education Act and naming a teacher responsible for children requiring special provision, and that this teacher has access to some in-service training in the arts, how best can this resource be deployed?

Two main strategies are generally employed: the withdrawal of individual class members for small group tuition, and classroom support for individual children in the context of normal teaching programmes. A special needs postholder and arts specialist working in a primary school made this comment.

In order to assess learning needs, one has to observe children in their ordinary working situation. Small groups with more teacher contact can expose children's stengths and weaknesses quite quickly, but these may not be the same strengths

and weaknesses that they exhibit in the classroom. For example, a slight loss of hearing may not be apparent in a small group. It is therefore essential that the support teacher sees children in their own working environment. Children are then unaware that special attention is being paid to them.

There are some common problems that have to be addressed in introducing classroom support.

### 1. *How do we organise the timetable?*
Support within a classroom should be for a proportion of every working day, for a long enough period for the observer to understand the dynamics of that particular class. This allocated time need not be the same every day; it is beneficial to see the children work on as many different activities as possible, and at varying times of the day. The first week of observation may in fact be of limited value in that the presence of a second teacher may alter the dynamics of a classroom and create some anxieties until everyone is at ease with the situation.

### 2. *Whom do we support: the child, or the teacher as well?*
The question of who to support depends on the way the support teacher relates to the class and the class teacher. It is the support teacher's job not only to support the child but to support the teacher, and to show that by working together within the normal classroom the children can be supported and teachers can become more confident and skilled in dealing with children with special educational needs.

### 3. *How do we deal with reluctance on the part of the staff to accept another teacher in the classroom?*
There are teachers who feel very threatened by the presence of another teacher, and they have to alter their classroom organisation to cater for this arrangement. To such teachers I have made it clear that my services are at their disposal if required, but that no extra withdrawal support can be available if they choose not to accept classroom support.

There are some very strongly expressed arguments against having a floating teacher available for classroom support, not least being that smaller class numbers might solve the problem of many children with learning difficulties. This assumes that every teacher has the skill and experience to make effective provision for children with special needs.

I am not advocating that withdrawal support is never appropriate; on the contrary, withdrawal support for some children is essential. However, until the teacher who is offering the support programme really understands the normal classroom situation in which the child is not achieving, appropriate provision cannot be made.

A final argument against withdrawal which can be added to this teacher's observations is that it so often happens at the expense of arts sessions, deemed more dispensable than work in 'core' areas. Children who have difficulties in communicating through writing need opportunities to do so through other media. Yet it is often these same children who are denied arts sessions in order to have more exposure to those areas, like handwriting, where they are already experiencing constant failure.

The primary teacher who ran lunchtime music sessions for children who were with the support teacher while their peers were having a music lesson and so missed one of the two weekly sessions (as described in Chapter Two) was at once confirming this trend and demonstrating a commitment to music education for all which cannot be taken for granted in the average school.

## INTEGRATING PUPILS

The 1981 Education Act states that 'as far as possible all pupils... should be educated in mainstream schools'.

Progress in implementing this principle has been slow. The proportion of the school population educated in special schools and units has remained fairly constant. The Act did however raise the profile of schemes of integration, designed to bring together pupils from mainstream and special settings temporarily for shared learning activities. What benefits may be gained from such schemes, what factors make for their success, and what roles can the arts play within them?

**The need for resources and co-ordination**

The curriculum and organisation of the primary school are generally more adaptable to the needs of integration. Younger children are also more likely to accept, or fail to notice, differences in their peers. At secondary level the curriculum and organisation of the school are less adaptable. Complicated timetabling presents organisational difficulties, and the emphasis on public examinations can result in a reluctance on the part of teachers to experiment with integration projects.

In order for a programme of integration to be successful it is essential that teachers in both special and mainstream schools are committed to it and appreciate the mutual benefits. Many mainstream teachers are reluctant to become involved in such programmes, either because they do not understand the nature and implications of the special school children's difficulties or because they feel ill-equipped to deal with them. The segregation of special school children limits the mainstream teachers' contact with them, reinforcing the idea that they require 'treatment' by specialists in a separate institution.

Integration is a two-way process which can be of as much value to mainstream school children as to those in special schools. The arts have central roles to play in integration programmes, as the following example shows.

A class teacher from a large inner-city primary school ('Priory') met a member of staff from a school for children with severe learning difficulties ('Broomfield') who wanted to raise the status of the arts within the school and make the arts more representative of the diverse cultural backgrounds of its pupils.

With the two schools being on opposite sides of the city, the integration project presented obvious difficulties. It was decided by two link teachers that children from Broomfield could be bussed to Priory once a week for joint drama sessions.

The Broomfield staff had expressed interest in celebrating Diwali at their school, which had not been tried in drama form before. Two problems presented themselves to me.

1. In what form should the drama be presented to both sets of children, given their range of physical and mental abilities?
2. What goals could encompass this very wide range of ability?

During an Arts in Schools conference looking at the use of the arts with children with special needs, I witnessed a performance by a two-person theatre group who presented a programme specially devised for the mentally handicapped. The

discussion which followed their performance highlighted the importance of visual clarity and economy of presentation in work with children with special educational needs, as well as high standards of production. The show presented a simple, uncluttered environment, with 'clean' lines, restrained use of bright primary colours and immaculate costumes. Visual stimuli were accumulative, with simple attention-holding themes — for example, the gradual opening of a series of boxes of ascending size — rather than complex 'plots'.

The performers had attempted to build a 'plot' for the play from a series of cardboard boxes set on the stage, so that even if children's minds wandered during the drama, they could soon pick up the action by joining in at the next box. I decided that our play could be built in the same way. Each cardboard box placed on the stage area would contain a prop or a bit of costume, related to Diwali. This would gradually build up a simple picture of the costumes, food and story behind this festival.

It took six sessions to build our play and establish what we thought was an astonishing working relationship between the children. Priory children learned quickly how to talk and react to the sometimes unusual behaviour of the Broomfield children, who soon began to respond, copy and interact with Priory children. The piece of drama was presented at both schools, and also at a local resource centre during Diwali.

What did the children gain from the six sessions?

- An ability to work as a team, in which every member became responsible for each other.
- On Priory children's side grew a gradual recognition and understanding of the other children's difficulties. With familiarity grew a disregard for disabilities, as all the children just naturally worked around them.
- There was a build up of self-image in both sets of children. Priory children obviously felt responsible for Broomfield children and also for the smooth running of the presentation. Their role had changed from followers to leaders. Broomfield children took quite seriously their parts in the play, and delivered their lines and actions in classic style. Their expressions told us everything as the applause spelt pure pleasure on their faces!
- Broomfield children had learned to work within fairly disciplined guidelines, because of the eventual presentation of the play to an audience.

Integration projects like this need careful planning and resourcing, including appropriate training for teaching and auxiliary staff and timetabled release for essential liaison. Projects cannot rely on the goodwill of those participating.

## Developing social awareness

Properly resourced, integration programmes can make a vital contribution to the development of all children's social awareness. The education system as a whole needs to reflect the character of the society for which it seeks to prepare children. Since our society is culturally diverse, the curriculum should reflect such diversity, whether the range of different cultural backgrounds is actually represented in the classroom or not. A similar approach is needed in education for special needs. Awareness of disability needs to be extended even where no disability is represented.

As we have seen, the arts have the same functions for those with special educational needs as for all other pupils. They are one of the ways in which pupils with special educational needs can contribute to and participate in the social culture. Disability groups have begun to see the arts as a major way of asserting a distinctive cultural identity. Just

as arts teachers aim to reflect the multicultural dimension of the whole curriculum, so they should seek ways of reflecting disability culture.

## The need to adapt teaching styles

The drama project was one of a series of arts collaborations between Priory and Broomfield which illustrated the need to adapt teaching styles to the needs of children with different learning difficulties. The Priory class teacher describes work in weaving and lace-making led by two of her colleagues.

Jane had made prior visits to Broomfield and realised in looking at what the children were doing that they would not be capable of weaving in the normal way, with normal-sized equipment. She had to devise some way of adapting a strong weaving frame to their capabilities, and in order to produce reasonably quick results. She approached a bicycle shop and obtained lots of old wheels, which she cleaned up until they looked in a reasonable condition, before adapting them as weaving frames. She used all kinds of materials to weave, ranging from tinsel wool to tape. It was a very simple weaving process but one which most of the Broomfield children could manage. Most of them managed to produce something in a morning: something that they, and not the teacher, had done, successfully and with enjoyment.

Helen decided to attempt lace-making, which most of us thought impossible because of the intricate use of bobbins and pins. She obviously had to modify her equipment, so she made large lace pillows which were more than normally weighted at the bottom, together with large bobbins and huge map pins instead of the tiny straight pins that one would normally use. She left the equipment at Broomfield, also making some polystyrene pillows for the children to practise on.

Such resourcefulness and willingness to break activities down into simple component parts meant that both staff and pupils at Broomfield were given access to work in new media. A further illustration of this was provided by a small-scale project in which pupils from a school for children with moderate learning difficulties had the opportunity to develop skills in claywork in the art department at an adjacent mainstream comprehensive, as the head of art describes.

Five pupils visited on four occasions, during which they each produced a piece of claywork. They were given some idea of what to do, such as a funny animal or a character figure. The starting point was kept deliberately open to allow them to make a 'personal' statement. Each was asked to work out some ideas and then develop these in clay, with me occasionally intervening with suggestions for how to make a basic shape, how to join pieces of clay together, and ideas for decoration. At the end of the exercise the children appeared to be a little more perceptive, thinking a little more constructively, and speaking to me a little more coherently.

The teacher's impressions at the end of the children's visits were as follows.

1. Generally pupils were reluctant to experiment and wanted to develop the first idea that they came up with, as if the first smell of success was not going to elude them: grab hold of it and don't let go!
2. The group lacked self-confidence and needed constant reassurance. Without exception all members of the group were asking questions like: 'Is this right? What colour shall I paint this?'
3. There was a tendency to rush through the work, as if they wanted ideas to 'materialise' before they disappeared.

My brief contact with these children made me much more aware of the amount of

help, supervision and reassurance that children with special educational needs require and it increased my awareness of the needs of such pupils in my mainstream classes.

In the following term, nine more pupils visited the art department. This time the task was to produce a pot using the techniques of coiling.

I began by showing them some examples of successful pieces of pottery produced by some of our pupils. I explained that the pots were the result of a lot of time and effort and that they must not expect to produce something of this quality in a couple of hours. They were impressed by the quality of the work and appeared to accept my caution. We talked about ideas for the work. They appeared to be very interested when I explained that the starting points for these pots had been observations of natural forms: poppy heads, rose hips. We compared these forms with the finished pots. I explained the importance of having some idea of the kind of shape you were trying to achieve before beginning to make it.

*The arts offer pupils with learning difficulties in particular areas of the curriculum new media through which to express themselves.*

They were beginning to get restless now, so we started drawing shapes on paper: round, fat, long, thin. I asked them for ten different shapes; most only managed a few. Again they were soon getting restless. From the previous visits I had learnt the importance of not spending too much time on one aspect of the work but constantly varying the exercises (chat five minutes, draw five minutes, clay five minutes, chat five minutes, and so on).

After drawing we looked at their contributions and I asked them to choose the one that they felt they would most like to make into a pot. The shapes tended to be very ordinary, not departing very much from the traditional jug or vase. We then looked at some more unusual shapes produced by contemporary studio potters. I suggested that some might like to take more time drawing, but most were content to choose the best of their already drawn shapes and attempt to develop it in clay.

I then demonstrated how to make coils and join them together to make pots. Initially they all watched with interest but again they soon indicated that they were getting bored and wanted to have a go with the clay. We all had a go at making coils. I explained that we were not going to start the pots yet but were just getting practice at making coils. Everyone started with great concentration and with varying degrees of success.

The next period was characterised by the usual 'Is this OK? Am I doing this all right?' Some of the pupils were clearly getting quite frustrated at their inability to master the technique of making coils. We considered briefly the fact that most people find a new technique difficult at first but by practising they become more proficient.

Again there was a lot of indecision about which shape to develop. Their teacher and I deliberately avoided directing them too much, explaining that it was their ideas we were interested in and that they must decide for themselves. They could not seem to understand that they were doing the work for themselves and not for me.

As the pots grew, the confidence of some of the more successful pupils also grew. Most of the pupils discovered that the smaller, neater shapes worked best. Those who at first tended towards larger, more ambitious shapes soon found that the pots would collapse under their own weight. They did not have the skill or experience to make them work.

Many were content to produce shapes that supported themselves and looked reasonably like a vase or a fish. They felt that we were being over-critical when we started to look at the quality of the shapes. They didn't seem to have the patience required to aim for a really improved degree of finish in the work.

Generally, the children found the exercise challenging but not particularly enjoyable as the finished products were not as good as they had thought they would be.

Perhaps the most important factor here was that never before had this group of children been asked to work on a single piece of arts work for such a length of time. It would have been unrealistic to expect more from their first sustained involvement in art-making.

It is indeed often claimed that children with learning difficulties lack concentration and require a curriculum which is always presented in short sessions. Yet such children *are* able to engage in special work if it is of interest and if it provides fulfilment, two factors frequently absent from actual planned programmes. But before children are prepared to commit themselves to exploration and experimentation they need the experience and security of previous success. They also need to know that the notion of correct or (more importantly) incorrect responses doesn't apply: this is a central aspect of teaching and learning in the arts.

Some teachers are reluctant to work in the arts with pupils with learning difficulties because they are wary of the more informal classroom organisation which they entail. The potential for disaster seems all the greater with maladjusted or disturbed children. A class teacher from a special unit — catering for children with social, behavioural and emotional difficulties referred from primary schools

in the surrounding area — describes the problems and opportunities for arts teaching presented by the nature of such children's difficulties. In doing so she recapitulates many of the key elements of arts education for pupils with special educational needs which have underpinned this chapter.

One of the main difficulties for the teacher is in maintaining control whilst allowing freedom of self-expression. The children tend to become very over-excited and movement and noise levels can become intolerable. This is particularly true of drama, movement and music lessons.

Lessons which include brief, highly structured activities interspersed with discussion sessions or calming activities have proved successful. There are times, however, when children must be given more freedom and opportunities for self-expression. Often a lesson which I have considered to be a disaster, because it appeared chaotic and unacceptably noisy and disorganised, has proved to be a success as far as the children are concerned, resulting in enthusiastic discussions and follow-up work.

Some children's lack of confidence may create a barrier to their participation in arts activities. It is important that this problem is approached sympathetically since mishandling of the situation could result in a greater lack of confidence. No children are forced to participate in a particular arts activity but they are encouraged to observe or contribute in some other way: with display, for example. It is hoped that by attending and observing a movement or music lesson, for example, the child can at least develop an appreciation of the art form and may eventually be persuaded to participate. Sometimes children's behaviour may become so disruptive and distracting, however, that they must be removed to allow others to continue.

We try to provide the children with a wide variety of arts activities in the hope that they can at least find one area that they enjoy and in which they can succeed. Some activities such as painting and simple music improvisation may occur spontaneously within the classroom; others are planned activities. We also try to teach the children simple techniques (particularly in art and craft) which are sure to produce attractive results. Often a great deal of teacher input is necessary to achieve this.

The presentation of children's work can greatly influence the extent to which they feel it is of value. This is particularly true of art and craft work and we always try to display work attractively. It can also be true in music, movement and drama work and we encourage children to watch and appreciate each other's work.

Display is also important in influencing other people's perceptions of the unit and the children in it. It is important that the classroom should look at least as attractive as others in the school to minimise the 'special' image of the unit. In all areas of the arts we try to develop children's skills by building on existing strengths and by offering a great deal of support, encouragement and praise.

*We try to provide the children with a wide variety of arts activities in the hope that they can at least find one area that they enjoy and in which they can succeed.*

## SUMMARY

All schools need to recognise the importance of the arts in meeting the special educational needs of their pupils. Their arts policies should address:

- *recognition* of the individual needs of children identified as having special educational needs;
- *adaptation* of the curriculum and of teaching methods to ensure equal learning opportunities;
- *co-ordination* of relevant areas of expertise in the arts and special education to provide these opportunities.

The main strategies for implementing such policies are:

- facilitating contact between teachers and pupils across special and mainstream education;
- staff development for arts teachers in meeting special educational needs;
- staff development for teachers in special schools and units in teaching the arts.

---

### Checklist for evaluating arts provision for pupils with special educational needs

1. Are all staff aware of their responsibility to ensure that all pupils have access to a broad and balanced curriculum, including the arts?
2. How are children's learning difficulties identified within the school? Is work in the arts considered as well as the core areas? What mechanism is used to record children's progress?
3. What additional provision is made for identified children? Does it include work in the arts as well as in core curriculum areas? Does it take place in the classroom or in withdrawal groups? If the latter, does it occur at the expense of the arts?
4. Has the school a postholder with responsibility for co-ordinating school policies for meeting pupils' special educational needs? How is this responsibility discharged with regard to the arts?
5. Are children with special educational needs educated *in* as well as *through* the arts?
6. Have opportunities for linking up with local special schools and units through arts activities been explored? If so, are staff released for essential liaison work? Are the aims and objectives of such collaborations clearly understood by staff in both schools? In what ways does the regular curriculum reflect such collaborations?
7. Does the school seek to develop in all children an awareness of disabled people in society and of their responsibilities to them?
8. In what ways does the arts teaching facilitate access for all children? Are teaching programmes and styles appropriate to different abilities and attention spans? Can essential materials be used by all pupils? Is all children's work accorded equal value in presentations and displays?

# ARTISTS AND SCHOOLS

## INTRODUCTION

The general rapprochement between the arts and education sectors has provided many opportunities for schools to extend the range of their arts provision. Many schools in the project initiated schemes involving collaboration with professional artists; many artists and arts administrators took the opportunities provided by the project to develop their links with schools. This chapter draws on the project's wide-ranging experience of working with artists within a wide variety of disciplines — through school-based workshops and residencies and visits to galleries and arts venues — to explore the impact of such collaborations on teachers, artists and pupils.

Teachers and artists are often unsure what benefits will accrue from such schemes. They also need guidance on the practical organisation of curriculum initiatives of this kind. This chapter therefore considers in turn the different roles fulfilled by artists working in education; and the practical implications of such roles.

## WORKING WITH ARTISTS — WHY?

Collaborations between teachers, artists and pupils should provide complementary benefits for each group. In this first example a secondary teacher describes the experience of working with professional artists and why she values this work as an important aspect of her arts curriculum. Her description introduces many of the important issues and debates.

There is tremendous value in employing professional artists to work in schools. Pupils discover, first hand, a variety of approaches to the arts; they learn, perhaps for the first time, that the word 'artist' applies to a very broadly defined group of people; they are given the opportunity to experience the complexity and richness of art-making and to work with people working for their living in areas outside the familiar scope of industry and commerce. Through this contact pupils come to realise that people's lives are enriched by exposure to and experience of the arts.

Collaboration with professional artists must be a two-way process. The artist and the

pupil have a lot to give each other. The artist may find delight in the refreshing wonder of students and stimulation in their often acute observations, enabling them to take away lasting impressions and influences from the pupils. Pupils often find value in meeting professional artists above that of curiosity: they are genuinely keen to find out more about the artists they meet and to have their own opinions valued and sought.

It is true that many of the activities that take place involving pupils and artists are not outside the scope of teachers. Many teachers are professionals within the arts as well as education. Why then do we not rely on the skills and talents of teachers alone? The role that teachers adopt, however enlightened and progressive, often precludes the approach and response generated by visiting artists. Teachers are locked into a timetable structure from which it is difficult to escape given normal pupil/teacher ratios and their inability to rely on free time. The pressures to which teachers are subjected often rule out taking on or sharing another role in addition to their major role as teachers. Teachers working as professional artists in their own and other schools is however an area worth exploring in greater depth, not instead of non-teaching professional artists but in addition to their input.

In addition to enriching pupils' experience in the arts, professional artists fulfil a staff development role. Staff as well as pupils can be introduced to new areas of arts experience and understanding. To ensure that maximum benefit is derived, it is important for discussion to take place between the artist and staff of the school prior to the visit. At our school the most successful visits have been made by artists who are known to the staff or who have some idea of what the pupils have been doing in their arts course. Follow-up work, discussion and reference to the work of the artist are important aspects: often, the benefit and impact of a visit only become apparent at a later date.

At our school we aim for all pupils to come into contact with professional artists on a number of occasions throughout their school career. This is important because the size of the group involved on any one occasion should not preclude conversation and inquiry. It is all too easy to render a visit valueless by overwhelming the artist while attempting to involve as many pupils as possible. Visiting artists are usually not teachers and are unused to coping with large numbers of pupils. Ideally, the artist and the member of staff involved should become co-workers. In no sense are such visits regarded as 'jam' or extra to the diet we give our pupils. They are integral to the whole programme of experience we offer.

A printmaker reflecting on a residency in another secondary school, which involved helping pupils to give artistic form to their responses to an exhibition of work by another artist, characterises the artist's perspective on working in schools.

The project was one of the most successful and exciting that I've ever done in school. All of my skills as an artist were used, not just my ability to make prints. What I liked about it was that I wasn't just coming into the school to do some print making. I was engaged in the work in total: using the exhibition, making the drawings, building up pupils' visual information and ideas — it was search and investigation, not just technique.

Coming into schools as an artist, I hope that in some way I am expanding pupils' contact with the world of art. In meeting me they are meeting someone who is engaged with art all the time, my main purpose of being, a serious occupation. I hope some of that serious application will rub off on them.

I came away feeling that it was very worthwhile because I knew that the work would be continued and expanded by the teachers. That is really the main purpose of

projects like this, for me anyway: not that I come into a school and do some exciting things with a few pupils but that I work with the teachers as well so that they can learn from me and pass on that knowledge to many more pupils.

A pupil involved in the same project confirmed its value to his own development in both *making* and *appraising*, in acquiring from the printmaker new working methods and techniques with which to give shape to his own responses to the exhibition.

When I first saw the exhibition I wasn't impressed, because I thought that the drawings were supposed to be finished pictures — they were framed and put in an exhibition like finished pictures. When we were told that the small drawings were just his way of working out ideas, kinds of experiments, then I looked at them differently. I liked the big pictures in the exhibition, they were impressive, I think they made me want to do a large piece for my still life. I wanted to work bigger and bolder.

Looking at the work of an artist and learning from it was good, it made me realise what he was doing and how good he was. It's given me a wider view of art, in looking closely at how an artist works.

We learnt a style of drawing and a new technique of printing but we didn't just copy the artist's style. It was good that we did something different of our own even though it was connected to the type of thing he did.

It's good to see how an artist tries things out and changes them before making a picture. When I did my first drawings of the still life I tried out a number of different styles, like he did. I think I came to know the objects better by doing that.

I think that I'd like to see more exhibitions and try other techniques. I won't be satisfied with just painting and drawing from now on, I'll want to do other things.

The teacher also derived ideas for future work from the project.

Since the project I have experimented with the technique beyond what we learnt from the printmaker. The pupils too have explored more adventurous methods. They know as much about it as I do. What is important is not that I should know more than them, but that we all have the confidence to use the medium when the need arises. Because I am confident about teaching it, I am now able to offer screen printing as an option to Year 10 groups, and hope it will become an established part of the course.

Working with artists is, as this and many other examples in previous chapters illustrate, a unique way of providing teachers with specialist support and INSET. It is also fundamentally important in developing the relationship between *making* and *appraising*. By coming to know professional artists' work at first hand, pupils can come to understand the roles and functions of the arts and artists in society and the part which they, themselves, can play as artists or as consumers of the arts.

## Formulating aims and objectives

It is essential for arts teachers to develop their own rationale for working with artists. Two sets of aims formulated by teachers illustrate this. The first is from an inner-city primary school, within a Muslim community, where a textile artist became resident with the following aims:

1. to encourage parents to come into school to work with the children;
2. to introduce a new art form to the children;
3. to allow the children the experience of working with a professional artist;

4. by working with fabrics, to make art more relevant to the children: many of our mothers were skilled in the art of needlework, but work with fabrics was rather neglected in the school.

The second set of aims is from a multi-ethnic secondary school where an English teacher set up a residency with a local Asian story writer:

1. to enable departments to work together in a school rather than a departmental project;
2. to publish a book reflecting the college community, containing plays, stories, poems, illustrations, writing in community languages and information about the community — for use by the college as a future resource;
3. to contact partner primary schools and involve pupils coming to the school the following year, thereby increasing continuity in the transfer between primary and secondary education;
4. to invite anyone who had been or was involved with the college to contribute: ex-pupils, adult education service, evening classes, teaching and non-teaching staff, parents and governors;
5. to make pupils more critical of their own writing, slowing down the process and constantly reassessing and re-editing their work;
6. to increase the pupils' self-esteem: that the school had appointed a professional writer was evidence that their thoughts and writing were of worth, something to be proud of;
7. to give pupils more responsibility: they would choose when to see the writer and gain permission to miss the relevant lessons.

## The roles of the artist in education

Such carefully thought out aims give a clear indication of the intended roles of the artists in these schools. As the following examples show, artists in education can fulfil a wide range of roles: introducing new art forms and ways of working to the school; bringing arts disciplines and departments together; using cross-curricular themes; broadening the cultural basis of the arts curriculum; providing INSET for teachers.

### Introducing new art forms
In this first example of a freelance mask and theatre artist introducing a new art form to primary and secondary schools, all the above roles are also evident in varying degrees.

To be given 'time out' from a primary and secondary school timetable to work with a small group of 9-13 year-olds on a project of your own devising — this is surely every teacher's dream. My involvement in the Arts in Schools project placed me in just such a position, working on a twelve-day, combined arts project with teachers and pupils. 'Mask and Myth' was built on the programme of mask and drama work which I had been developing locally in the professional theatre and in community arts.

Masks are a powerful and compelling focus for all kinds of creativity. Few other media have such potential for bringing together so many art forms: music, dance, drama, mime, art and literature. Masks also have broader cross-curricular potential because they are essentially cross-cultural, touching upon the social, spiritual and psychological lives of many peoples.

The children in the project were helped to explore the mask images of the Canadian Indians, and to appreciate the complexities of their visual symbolism and spiritual meanings. Canadian Indian masks intertwine man and animal, the natural and the supernatural, in a staggering array of forms and structures. Faces appear on top of each other, merged together, and even within each other. Like poetry, the meanings

are there to be peeled away, layer by layer. Showing them to children is a wonderful experience because they never hide their surprise at discovering image within image, as sun turns to moon or hawk to fish. Once the imagination is captured, the mask can also be used as a first-hand introduction to a fast disappearing way of life, its social and political structures and its historical legacy.

Having seen the masks, the children took up the challenge of designing and making their own, related to a particular Indian myth which I had adapted and dramatised. We made ravens, hawks, eagles, killer whales and even the white man's rat. Using a paper-sculpture technique, the youngsters transformed two-dimensional pieces of card into three-dimensional structures by cutting, shaping and assembling — endeavouring to unite form and function. Our declared aim was to make our masks 'as strong as cedar, as colourful as nature'.

During one session we were visited by a primary maths evaluator, who commented on the mathematical concepts which were being explored and the amount of

mathematical talk being generated. The youngsters were discussing whether alterations to the spatial dimensions of the structure would affect its strength and weight, whether eyes could be made by manipulating spheres into cones, and whether mouths were concave or convex.

A major aim of the whole curriculum is to encourage children to accept new ways of relating to each other, and to counter prejudices based on age, gender and ethnicity. It was my intention to manage the group so that they all worked together with someone they did not know, girls with boys and younger children with older ones. For some of the children this came as quite a shock, especially those who had been chosen to take part in the project because they were either desperately shy or considered to be 'outsiders'. Their diaries recorded some of their fears and anxieties at being asked to change habits. Comments such as 'I don't mind working with the boys, but I'm worried that they might not want to work with me' revealed deep divisions. Knowing how difficult it is to sustain this mixing up of relationships, it was very gratifying to see new friendships being formed, especially those across the primary and secondary school divide.

The dance and drama work which followed the mask-making was again based on a Canadian Indian myth, centred on a destitute child who, despite many tribulations, wins the respect of the Raven Gods and is rewarded with a mask which brings power and prosperity. The children showed great sympathy for the child in the story. We discussed at length what decisions they would have taken in the same situation. We were not simply playing at being Indians. We took on board social and psychological complexities, discussed colonialism and racism, considered what it means to win the respect of others, discussed parent and child relationships and tried to reflect all this in the imagery of our own movements and gestures.

As our ideas took shape I began to realise how close the relationship was between the physical dance sessions and the practical mask-making. Instead of cutting out card along lines to make circles, rectangles and cones, I was now asking the children to move along these same lines in space. Instead of building up card they were using their bodies to construct pair and group structures. We discussed how the characters and creatures we were playing really did move. Clichés had to be discarded and imaginations engaged in mutual awareness before finalising our gestures and moves. We had to think and work as a group, picking up signals and trusting each other. This process was essential to the power and conviction of the final product.

I was also aware of a basic contradiction in my way of working. Although I was encouraging the sharing of ideas, I was also manipulating the children to balance the parts between the sexes and across the age range. I could not accept their choices when all the boys wanted to be gods and birds of prey, and all the girls wanted to be frogs! My diary recorded some of the tensions which arose. There was one session when I felt a resistance to my way of working. Their movements had lost meaning — everything had become small and self-conscious again. I said my piece and, at first, was gratified to see how quiet and shamefaced they all looked, until gradually brave voices piped up and started to put me right on one or two things. Hadn't I ignored their requests to change certain things? Hadn't I forgotten that someone had specifically asked me to play an instrument? They were quite right, and I had to apologise. This was an extremely valuable moment because, from then on, they spoke to me more openly and shared ideas more profitably. Gradually they started to take over the decision-making and the best ideas in movement and dance came from them.

Apart from the quality of the working sessions, there were many other elements to the project. I put up an exhibition of masks on permanent display, covering the techniques of mask-making and showing the various functions of masks in different cultures. This proved to be an invaluable visual stimulus and was a source of

information for teachers to follow up in mask projects of their own. A large number of local teachers participated in three INSET sessions, and it was extremely gratifying to see the imaginative results of the mask-making lessons which the teachers had taken with their own classes, and how enthusiastically their pupils wrote about their experiences of working in this 'new' medium.

Some of the pupils commented:

The mask-making made an impression on me because it was the best art project I had ever done. I also enjoyed the play, because our masks were put to a use instead of just put in a cupboard at school and forgotten about.

At the beginning of the project I felt quite left out because I've never really been involved in something like 'Mask and Myth', with making all the masks and planning out a play. But in the end it was great fun, because we learned to co-operate with different people of different ages.

We got along with [the artist] right from the start, not as a teacher but on more of a one-to-one basis.

### Introducing new methods of working
As well as introducing unfamiliar art forms and techniques, some artists introduce new methods of working within familiar media. In this next example a textiles teacher describes the new collaborative methods which a textile artist introduced to her pupils.

The project produced a set of wallhangings which were both visually exciting and technically well executed. The pupils involved had benefited not only by learning a new skill and becoming proficient enough to go on to develop their own work but by working as a co-operative group on one piece of work. Although pupils had worked on group projects in textiles before, the end result had always been a composite piece made up from several elements worked on by individual pupils. This time the wallhangings were produced by the pupils all working on one piece of fabric and guiding its development through the printing process.

During each lesson pupils would either print an image of their own design on the cloth or would extend or fill in a shape, not necessarily their own, that had already been printed. This was a much truer way of creating a piece of 'community art', and one which I have subsequently adopted. I had always been frightened of someone 'messing up' and ruining the entire piece if I let a group work in this way, and yet the pupils behaved responsibly and seemed to enjoy the joint decision-making involved. It was good to watch young pupils have the confidence to alter, adapt or add to something that had been printed a day or lesson before by an older pupil. The only resentment shown at this manner of working was by some of the Year 9 pupils, who expressed annoyance if their design had been worked on by others. Generally, much of the excitement for the pupils came at the beginning of the lesson when they rushed to the printing table to see what had been added to their work.

### Broadening understanding across the arts
The same school's English teacher describes how the same artist forged links between two areas of the curriculum usually seen as unconnected.

While making arrangements for working within the textiles department, the artist expressed an interest in collaborating with the English department as well. It was decided that a wallhanging could be produced which would link what pupils do in an English classroom with what they do in a textiles room. Looking for a subject that

would be suitable for such treatment, the artist browsed through a selection of pupils' exercise books. Her eye was caught by a set of simple alliterative poems which had been written by the pupils.

In writing these poems pupils had been asked to give less thought to making their lines 'make sense' or to the representation of realistic phenomena. They had concentrated more on finding words with similar initial sounds and juxtaposing them in an innovative way: hence the proliferation of 'Terrific Toadstools', 'Galloping Gladioli' and 'Sordid Sharks' doing such things as 'Severing Sausages' and 'Trembling To and Fro'. The poems could not be interpreted in a narrative or linear way and therefore lent themselves to visual interpretation.

A number of lines were selected and groups were each allocated one. The artist talked about their visual potential and the pupils were asked to come up with a set of images that they associated with their lines. The artist went through the process of screen printing with the class and then the pupils were asked to cut out in stencils the lines they had selected. These were then printed onto the fabric.

The printing of lines from their poems encouraged the pupils to think about the accuracy of their spellings and sentence structures as there could be no rubbing out after printing. It also opened up for them and for me a new way of dealing with texts. The creation of a collage of images could be an initial stage in interpreting a poem. It could also be used to tie up points raised after the discussion of texts. Many standard texts would lend themselves to such treatment. The end of a class reader could also be celebrated with the creation of a wallhanging about it.

Concepts such as simile, metaphor and personification which are often difficult to get across to pupils could be communicated by such a visual approach. Vocabulary work could also be tied in with printing. Pupils could be given such antonyms as hot/cold, happy/sad and be asked to collect as many synonyms of each as possible. These could then be presented on a wallhanging with each antonym placed at either end and the synonyms meeting in the middle. The meaning of words could be visually enhanced with a consideration of the colours, the style of lettering and images associated with them.

### *Stimulating cross-curricular learning*

Artists can provide a stimulus for cross-curricular as well as cross-arts learning. One secondary school invited a theatre company into school for a week to perform their play *Ideal Homes* and to take workshops with pupils. The play was based on life on a new housing estate with a mysterious past which affected the people who moved into the new homes, foiling their plans for a new and ideal life. The play was intended to generate cross-curricular work. The following were some of the curriculum areas which used the play as a stimulus.

Geography:
*A level:* examination of new housing facilities; effects of living in the commuter belt; comparative study between new and traditional housing in the local area.
*Sixth form:* examination of location and extent of new housing estates, using council planning department maps.
*Year 10:* comparative study of local and Japanese housing.
*Religious Studies:* discussion on 'responsibility in the community'.
*Home Economics:* study of local shopping complex, and whether it satisfied the needs of the consumer.
*CDT:* house design project.
*Personal and Social Education:* activity based on suburbia, involving design of council estate and local amenities.

*Dance:* practical work based on territory and personal space, leading to work on invasion and aggression.
*English:* work on homes, using poetry and pieces of prose.
*Sociology:* discussion and role play based on residents versus councillors.

This was a considerable achievement for a secondary school, where it is inevitably more difficult to make cross-curricular links than in a primary school, given the sheer numbers of staff involved. The primary curriculum and daily organisation flourishes on the thematic approach to whole-curriculum design and an artist or company can easily become a focus for learning across the whole school.

### Broadening the cultural basis of the arts curriculum

A feature of many artists in residence schemes is the participation of non-European artists, involved as a strategy to increase the cultural diversity of the arts curriculum in both multi-ethnic and mono-ethnic schools. A secondary art and design teacher reflects on issues arising from placements of this type, and provides valuable words of caution in placing unwarranted expectations on artists in residence.

Community and multicultural education are based on related values and premises: in community education that children learn not only from teachers but from people and activities in the local community; while multicultural education in this country seeks to promote understanding and respect towards the different cultural groups living in Britain and to challenge the Eurocentric bias within the curriculum. The belief that children benefit from increased contact with visitors from different ethnic backgrounds in schools reflects these ideas and coincides with a growing emphasis on the contribution of artists in residence towards art and design teaching.

Artists of non-European origin can provide valuable insights into the nature of various cultures and the artwork they produce. They can extend children's understanding of non-European art forms and of the diverse relationships that exist between art and society in cultures other than their own. Within the general context of community education, the establishment of such residencies also involves links with a number of bodies such as funding agencies, arts administrators and other members of the community.

A number of assumptions upon which such placements are based require closer examination. First, it is wrong to assume that these artists will make a significant contribution to the multicultural curriculum. Many have spent most, if not all, of their lives in Britain and have been trained in British art schools: a training based largely on Western/European artistic concepts and traditions. Some have felt they were employed because of their non-European origin rather than their artistic ability.

Second, many artists are identified for placements through their capabilities in practical aspects of art, restricting their contribution to the curriculum to the practical or productive sphere. This may result in work concentrating almost exclusively on the formal aspects of making, with learning mainly skills-based. A practical example may be useful here.

Let us imagine that an artist is employed to contribute towards a teaching programme on African masks. Slides of particular masks might be shown to pupils, and the similarities and differences between their formal characteristics pointed out. Let us also imagine that some of the pupils hold prejudiced views towards black people. If the teaching programme fails to provide information about the artistic conventions pertinent to the masks and the place of artistic production in the societies concerned, which influenced the ways in which they were made and perceived, some pupils may have their prejudices reinforced. They may perceive the African masks as Western art forms and judge their aesthetic qualities according to Western artistic conventions,

such as perspectical devices or the criterion of verisimilitude.

It is important to recognise that such conventions may not exist in other cultures and information should be provided to help children learn that artistic form is shaped through a particular understanding of the nature of art and its relationship to a given society. To ask pupils to make artistic judgements without any information on which to base them is not only an inadequate teaching programme; it can help confirm negative attitudes.

Third, the view that children inevitably benefit from the presence of a professional artist in school is no more than an assumption. An Asian artist, working in a school with a high proportion of pupils of Asian origin, might succeed in raising self-esteem or increasing aspirations towards careers in art and design, but the pupils might gain greater cultural reassurance from having a number of teachers with similar ethnic origins. Such considerations are important where public money is being used to fund artists in residence programmes.

A fourth assumption is that professional artists can communicate their knowledge and expertise to the pupils. Artists may not be good teachers or communicators, and putting them in this position may disadvantage both them and the pupils. A more beneficial strategy must be to involve the artist in working closely together with the teacher in a situation which provides opportunities for each to work in the role to which they are best suited and qualified.

Finally, behind the demand for non-European artists to work in schools may lie anxiety on the part of teachers about their ability to provide more culturally appropriate curricula. Some teachers feel that they do not possess sufficient knowledge or experience to provide a multicultural art and design curriculum. Such anxiety is often based on the assumption that multicultural education is separate from education in general, an additional component rather than something which informs the curriculum as a whole. Teachers holding this view may feel that employing a non-European artist provides for the 'multicultural', expecting the artist to fulfil an obligation on account of their particular ethnic origin.

Such teachers should explore the knowledge and experience they already possess more thoroughly. To understand Monet or Matisse, for example, it is essential to be aware of the impact of Japanese or Oriental cultures upon European thought and artistic production in the early part of this century. Similarly, it is essential to know something about the nature of certain African art forms and cultures in order to understand the work of Picasso; or Tahitian culture to understand Gauguin.

The determination to reconsider what is 'known' could provide the starting point not only for a more pluralist approach to knowledge but for an internationalist teaching strategy, for Western art and design is full of cross-cultural references. The problem is that many teachers have developed a Eurocentric attitude to knowledge which is in truth culturally diverse, and this has influenced the way they present ideas and information to pupils.

To overcome such Eurocentrism, teachers need to be prepared to undertake further study, to which artists in residence can make valuable contributions. They should not be seen as separate provision for an aspect of the curriculum which teachers feel they cannot provide themselves. A deeper examination of existing knowledge, leading to different ways of presenting ideas and information, can provide a starting point from which all teachers can progress with confidence.

With so many issues to consider when inviting a non-European artist into school, it is very important to articulate clearly the aims of the project and the desired outcomes. Pupils' learning within a non-European artist's residency could be focused in one of these three areas:

- on the new forms, techniques and media which the artist brings into school and which develop pupils' and teachers' knowledge and expertise;
- on the development of pupils' experience and understanding through exploring the influence of non-Western forms on Western artists and vice versa;
- on the role of the artist in the local community and ways in which the residency might develop links between the school and its community.

One development group based a combined arts project on the work of the Indian artist, Rabindranath Tagore. An Indian dancer, who interpreted the poems of Tagore through dance, worked with each of the schools (see picture on p.128). Here she describes her work within the project.

My working situations changed from one day to the next. Sometimes we were in a school and sometimes in a gallery surrounded by original paintings. We even worked outdoors on the playing fields but every session included:

(a) an introduction to Indian dance, particularly its rich variety and close link to mime and drama;

(b) an interpretation of a poem through dance, using participants' creative ideas along with movement from creative dance;

(c) a dance by myself on the theme of the 'Golden Boat', using poetry, song, and instrumental music;

(d) an opportunity for critical appraisal through question/answer/discussion.

For my own dance I used both Indian and Western music. As we were expecting the children to be open-minded and to be able to appreciate the music and poetry from another part of the world, it seemed fair to give myself a similar challenge.

The sessions combined critical awareness with participation. The participation is important so that skills and creative imagination can be shared. So often Indian dance, a very specialised art form, seems inaccessible and is only presented in lecture demonstrations as an 'other' culture. It should be a participatory session which explores common human ground through culturally diverse material.

This dancer sees herself playing several different roles when she works in education. In (a) she is the representative of her culture; in (b) a teacher encouraging creative response in a participatory session; in (c) a performing artist; and in (d) a teacher encouraging a critical response from her audience. This is an unusually wide range of roles for an artist in school and would be too demanding for artists not trained as teachers.

It is increasingly common to invite an Indian dancer into school for a workshop or residency within the context of multicultural education. The most common reasons are that Indian dancers are very beautiful to look at, that they wear exquisite and exotic costumes, are self-contained solo performers and present an accessible, acceptable and entertaining image of Indian culture.

These reasons, however valid, may not challenge teachers and pupils in their thinking about Indian culture nor increase pupils' understanding of the differences and similarities between dance in Western and Indian culture. The dancer is often simply used as a 'visual aid' for South Asian culture and presented without the essential contextualisation of the dance performance and without planned mediation between dancer and audience. It is sometimes assumed,

for example, that an Indian dancer will take a dance workshop in full costume and when the dancer turns up in his or her practice clothes the teachers and pupils are disappointed. Would they have expected a Royal Ballet dancer to take a school workshop in a tutu, full stage make-up and in pointe shoes? The need for collaborative planning between teacher and artist applies particularly strongly in the case of South Asian dance residencies.

### Improving pupils' technique

An important issue, relevant not just to South Asian dance artists but to the curricular involvement of professional artists in general, is the teaching of technique. Primary school teachers often emphasise the importance of 'creativity' in arts education: children should explore, improvise and create their own forms with minimal technical preparation. This approach is very different from that of Indian dance artists: many have described their horror at the way in which their dance teaching has been upended and 'freed up' in the name of the free expression which has dominated 'music and movement' in the primary school.

Indian dancers work in a one-to-one relationship with a guru, who is their personal guide and mentor, for at least ten years before they are allowed to explore their own creativity. The fundamental belief is that rules have to be learnt before they can be challenged. This premise underpins classical ballet training and is easily understood by dance specialists, but not by primary generalists or by PE teachers who have not had formal dance training.

There is no easy resolution of this issue, but if teachers aim to give pupils access to a variety of dance forms and to a broad understanding of dance in a variety of cultural contexts, rather than becoming expert practitioners in a particular dance style, these differences can be acknowledged and used to increase pupils' awareness of the challenges that dance presents.

Some South Asian dance artists, like the one above, acknowledge and use the 'creative' pedagogy of primary schools. They are developing a new pedagogy especially designed for the primary curriculum, with work presented with strong cross-curricular links. The pupils see slide/tape sequences which use fascinating cross-cultural references, they learn carefully chosen aspects of the dance vocabulary in practical dance lessons and create their own dances using themes from Indian culture. In contrast, there are primary and secondary schools which include Indian dance as part of their dance curriculum and study the technique rigorously with no concessions to Western pedagogy.

### The artist as a professional

For many children, meeting an artist in school can be their first opportunity to consider the artist as a professional person following a career which they could one day follow. Valuable lessons can be learned concerning how an artist 'becomes' an artist and how an artist makes a living. The textile designer whose work was referred to earlier describes how she presented herself as a professional.

Towards the end of the first session with each group I showed them my portfolio, discussed the type of work I did and my art training and invited questions. By then they had some idea of the processes my work must have gone through. Children are always eager to find out what being a textile designer entails. They want to know what I enjoy and dislike about my work and how much I get paid per design. I also set up

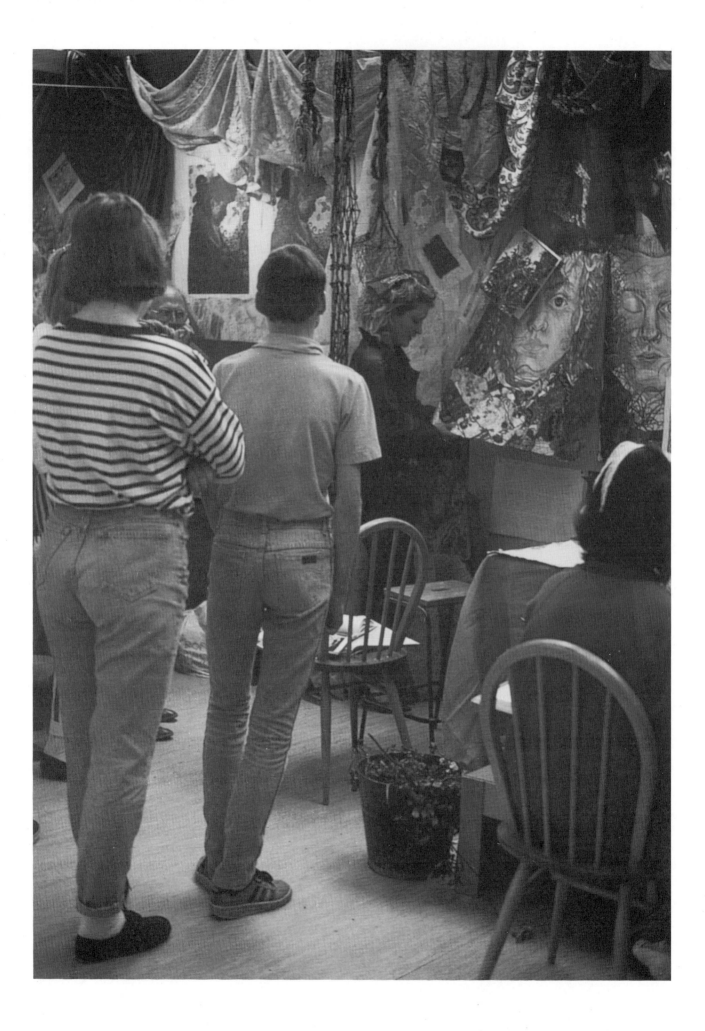

some of my work on the walls and showed them photographs of screen printing in industry to make them aware of how their own clothes had been printed using the same methods they had used but on a larger scale.

One member of staff commented on how much better than usual the children listened to my instructions. This she attributed to my being a new face, a 'professional' in the school, and that we were working in a prestigious workspace which was not only advantageous to the children but to the staff, whose curiosity brought them down to watch or to ask me questions about the mechanics and the effects of screen printing.

This artist then organised an after-school workshop for the staff. This proved a great success and teachers reacted with almost the same degree of eagerness as the children. The workshop demystified the process of screen printing and removed staff inhibitions about using the medium in the classroom. They saw how easy, spontaneous and flexible a medium it could be and expressed interest in investing in their own screen printing equipment.

### Questioning pupils' assumptions about art and artists

Meeting and working with artists can be uncomfortable for pupils as they come to terms with lifestyles and art forms which they find difficult to understand. One project in an inner city enabled a small group of fourteen- and fifteen-year-olds years to visit and work alongside artists in their studios in the local art gallery. The gallery's director devised the plan in order to place pupils in the working environment of professional artists and to observe the effect on the pupils. His main concern was that pupils should become aware of a new way of seeing the world, and encounter a new set of values. His plan for the project involved the pupils documenting the whole process through copying the work at different stages, photographing the work, discussion, writing up impressions, and recording conversations with the artist. He described this documentation as forming the basis of:

• sympathetic appreciation of the making;
• critical appreciation of the work;
• a starting point for pupils' creative work.

In practice these aims were hard to achieve. Small groups worked with the artists, copying their paintings and the way they painted. There were many administrative and organisational issues which arose from this project but here it is useful to concentrate on one particularly problematic issue which all teachers of this age group will recognise: that of finding the right strategy for presenting new ideas and values to pupils, engaging them in critical discussion without threatening their own beliefs and values too dramatically.

The pupils showed a great reluctance to talk to the artists, as the head of art describes.

The pupils became voluble once away from the studios, all but unanimous in condemning the exercise as a 'waste of time'. They appeared to resent being taken from the security of the known environment and exposed to the unknown. It became clear that not only did they lack the knowledge to question what they were experiencing, they also lacked the concepts on which that questioning could be based. Several did speak of a desire to get on with their own work and one boy even went as far as to make his mother telephone me, requesting that he be excused any further trips because he felt the trips prevented him from continuing his work!

This reluctance to take part came to a head when a deputation of girls visited me at

the end of the school day and proceeded to bend my ear as head of department. The girls were all unfamiliar to me and I did not know what approach would be most successful with them but opted for 'The chance of a lifetime', 'Like going backstage at a pop concert', with a touch of the 'Well, it's only for another couple of times' and 'You've still got your Monday lessons' thrown in. At this stage I had a real fear that the whole project would fall apart.

I telephoned the director, seeking advice. Whether because the pupils in the group working with the woman artist had the strongest reaction or contained the strongest personalities, it was their dissatisfaction with their understanding of her work that had become the focus. The director was confident that the artist could take this on board and was sure she would be able to talk the pupils into some insights about her work.

This she began to do at the start of the next session, and it was from this that an interesting development arose. During her highly personal explanation of some of the sources of her images, the girls became increasingly restless. One was trying to carry on a conversation with a friend. Another finally burst out with 'You say *you* start by drawing real things. Couldn't *we* go out and do some drawing? And then you could sort of help us; what to do next....' Both they and Janet [the artist] became very involved with the work that grew out of this.

Also worth noting is what happened during the last moments of what turned out to be the last visit. We were running late. There was already an unrealistic length of time left for getting them all back to school in time for the next lesson. The minibus was revving, and six or seven pupils were still missing. I tracked them down. Four had found their way upstairs to the gallery.

A middle school group had just started to work with another artist. The young children were all sitting in clumps around the floor, getting organised, but at the back of the

space there were our girls, deep in conversation with the artist. He had stopped drawing to attend to them. I had to drag them away. As we tumbled down the stairs we crashed into the other three I was looking for. They were hysterical with excitement about what they had discovered. It was some work in a studio behind a door previously closed. The subject matter was enlarged photographs of well-known idols, like Marilyn Monroe and James Dean; the medium, skilled air brush....

Two issues occurred to me at this stage: first, that children of this age appeared too preoccupied with their own problems over picture making to cope with the idea of an adult having (a) difficulties or (b) anything other than the representation of realistic, recognisable images as their aim. The children were delighted with the reassurance provided by the dexterity of the air brush work they had discovered and acknowledged how they really wanted 'tips' for their own work.

Second, given a lot more time and space, these attitudes would probably change. By only the fourth hour of their experience of visiting the studios, the pupils were confident enough of their new surroundings to go exploring. While the pleasure of those who discovered the air brush work was obvious, the expressions on the faces of those found talking with the other artist were of total concentration and curiosity. Yet his work was if anything more 'difficult' than anything they had yet encountered.

### The regular teacher of the class involved adds the following.

The class selected was determined primarily by the time allocated for the project. They were fifteen-year-olds with an average range of skills within this subject. Few had previously visited a gallery and involvement with painting did not form part of their out-of-school experience. They tended to be slow to enter into dialogue, especially when confronted with strangers or those with whom they were relatively unfamiliar. Their objectives in their own work and in response to that of others showed a normal Year 10 preference for finely detailed realistic representation. Their reply when confronted with work which did not fall within their narrow definition of 'good art' had often been that 'it does not look like anything'. The studio experience was certain to challenge these assumptions.

At first many pupils were bemused by the experience. Their ideas of what a 'good' painting should look like had been confronted not by pictures in a book, but by working artists. Back at school, the studios themselves gave rise to discussion: some pupils thought they would look like a school or college and one or two expected all the artists to work in one room as they had seen in television historic costume dramas.

They had been rather disturbed by being asked to copy the artists' work as it changed and progressed. This was bound to present a conflict as it is a practice usually discouraged within art lessons, where strong emphasis is placed on pupils developing their own ideas and imagery.

In his conclusions to the project, the gallery director reflected that in the preparation period not enough attention had been paid to the fact that this work with artists would conflict with the pupils' conception of 'good art'. For them 'good art' was synonymous with photographic accuracy and adolescent imagery. He realised that the early lack of co-operation of the pupils was largely because the type of language used in the studios and the way of looking at pictures was strange for the pupils and needed much more careful introduction.

Here are two pupils' comments on the artists' work.

*Mark:* Well if that's what the public wants good luck to him [the artist]. To be totally

honest, my brother who is nine could have made just as good an attempt as he did and he's no Van Gogh. I had the same opinion of nearly all the other pictures I saw there.... I was surprised when he said he didn't plan his drawing first as our teacher is always nagging us to do. Instead he said his idea could change drastically from his original idea to the finished product. Selling Nigel's finished pieces didn't bring in enough money so he had a part-time job. I think the pressure of life on his shoulder showed in his work, in the form of rough and vicious brush movements especially, as he is a small person. The only thing I think I actually learned from going to the gallery was that there is some money to be made in squiggles and rough lines on a piece of canvas.

*Simon:* We went with Roger who had the largest studio. We talked to him and watched him start his painting. He drew mainly chairs and their surroundings. We made a quick sketch of what he had done and each week saw how it had progressed. We also did some paintings of our own. It was very interesting and I think I picked up some new ideas about painting. I learnt to be bolder in my own style and in the colours I used, using different shades of the same colour. I have been less afraid of making mistakes as I have seen how the artists manage to change their work, sometimes improving it. I am less worried about making the objects I paint look exactly like they should, and paint them as I would like them to look.

### Artist as role model or teacher?

Whether or not the artist should make art or teach art has been one of the most debated questions within this kind of project. In the words of an artist from a different residency, 'I am my work and not my response to children's art production.'

Many would consider it a *sine qua non* of residencies that artists engage in their own work; in fact, this can be particularly difficult in secondary schools, where they are likely to be subject to the same timetable constraints as the teachers. If artists allow themselves to become primarily 'instructors' in their work in schools the uniquely beneficial effects of their involvement can be lost. Usually they are not trained as teachers and cannot be expected to have any experience of classroom management and control. Artists who are not used to pupils' behaviour can misinterpret it and jump to the wrong conclusions. In one workshop where groups of secondary girls were working with professional actors, their giggles were taken for unwillingness to work instead of mere self-consciousness. The girls received a telling-off from the actors which was entirely unnecessary and did not help the progress of the workshop.

In this extract one of the painters within the gallery project described in the previous section explains his uncertainties:

As the weeks progressed I became confused as to the roles of the teacher and myself. Should I really have been teaching? I was told at the beginning that this was not my job, and yet the teacher rarely stayed in the studio. One pupil seemed to regret that he hadn't learnt any tips to improve his own work. Should I have provided tips or were the students there for an entirely different reason: to see how I worked, tips or no tips? Why wasn't this clarified with the class before they entered the studios?

Did the teachers prepare the class to see artists trained in fine art as opposed to artists in general? The distinctions between the graphic and fine arts had not been made clear and I found myself using valuable time explaining that I wasn't painting photorealism badly but in fact painting loosely because that was relevant to contemporary fine art and to the history of painting in the Western world!

Surely it was the teacher's job to enthuse the pupils about professional arts practice and to act as a link between the artist and students? I found this sadly lacking. As I did not attend any of the preliminary meetings I was not fully aware of what the students had been briefed to expect. Artists should be more fully informed of the classes' understanding or misconception of what he or she does or doesn't do. It is vital to have some area of common ground from which to build up discussions and interest.

Another practitioner emphasises from her own experience that the artist cannot be left to perform the role of teacher without the presence and support of the usual class teacher.

I was impressed by the teamwork of the pupils, not only on the hangings but also on less attractive aspects of printing such as washing the screens and squeegees. There was one exception to this: a particularly negative Year 9 group. The attitude of a small number of arrogant boys set the tone for a group which resented the idea of a communal effort as opposed to printing their own T-shirts. By the end of the first lesson there had been a shift in attitudes: working together was not the ordeal they had anticipated. This group was also responsible for finishing off the hanging in their second session. While the majority had become involved, the influence of the same boys jeopardised the completion of the hanging until the girls finished filling the spaces and printed the border on their own, a choice they had made for themselves.

In such lessons my energies were dissipated by having to control the hooligans. On both occasions the class teacher was timetabled for meetings and so not present in the classroom, leaving me with the support of less effective supply teachers. The large groups generally divided themselves into those ready to print and those preparing their stencils or writing about the project. That way the print table never became overcrowded. Had I been warned of the teacher's absence I could have devised a scheme for those not printing, as the Year 9 group didn't fall into two groups in this way. We agreed that in fixing the dates of any future placement, the teacher's commitments outside the classroom should be taken into account.

### Artist as catalyst for challenging attitudes and values

In this next example, the artist was again a catalyst for much debate about arts practice, this time in relation to differing artistic and institutional values. A young Asian playwright became a writer in residence and worked with pupils of Asian origin in two secondary schools in producing the pupils' own bilingual theatre. Here the playwright describes the source of the debate.

What happens when the work of the artist helps students to make statements about their life and experience which are in conflict with those made by the school? What happens when through working in an open and challenging way the students raise questions which the school is unable to answer?

Here is an extract from the evaluation of the project by the drama teacher of one of the schools, and co-founder of the Asian theatre group.

One of the most effective ways to unlock the thoughts and feelings of a multi-ethnic group is to use an artist with shared experiences and proven expertise. I was therefore delighted to have the playwright coming to work in the department, especially with our newly formed youth theatre group. My experience of her work told me she could open doors into theatre for Asian youngsters for which I could not find the key.

Original plans to base the work within the timetable were thwarted by staff who considered drama a low priority. Add to this the prevailing belief that theatre was considered irrelevant by Asian students and it was easy to predict difficulties in setting up the project. This underestimated the strength of will possessed by the playwright, who quickly recruited more than forty Asian youngsters in the two schools to a project which involved encouraging them to use English and one or more Asian languages in theatrical exploration of British–Asian experience.

The result of six months' work was two bilingual productions: *The Mango Tree*, a wry and slightly cynical search for the promised land, and *Eighth Emergency*, a disturbing collection of docu-drama–type experiences of racism faced by Asian youngsters in Britain today.

From the first workshop the playwright established warm and sensitive relationships with the youngsters which allowed for the free flow of experiences, thoughts and

emotions. She also managed to pass on her expertise in bilingual technique, bringing the groups to a real awareness that their culture and language could be valued in school drama and theatre performance. Her opening of the channels of authentic expression within the group placed me in a predicament, becoming party to information, thoughts and experiences which as a teacher I would sooner not have known. It was however possible for me to leave the workshops and allow the dynamic of group discussions and sharing to continue in her capable hands.

It quickly became apparent that the content of the groups' work was to be a controversial but real statement of their perceptions of their lives. We set about bringing these statements to theatre. Eventually the playwright devised with the group a powerful script which became my responsibility for staging. They had already structured stunning images which simply needed technical production.

What was apparent as the groups prepared to perform was that individuals had grown in confidence to make and challenge statements about their British–Asian experiences: confidence which had developed through the recognition and valuing of their 'lived' culture.

The productions made nonsense of certain stereotypes:

- *'ASIAN CHILDREN DON'T DO THEATRE.'*
  Of the three full houses ninety per cent were from the Asian community, some coming into the theatre for the first time. Their support for the project was overwhelming.
- *'ASIAN CHILDREN ONLY DO SCIENCES AND MATHS.'*
  All the Year 9 pupils involved in the project opted to take GCSE drama.

It is impossible to capture the support, praise and pleasure which came flooding in from our community audience. It enabled me to establish a dialogue about drama in education and the role of community theatre which could not have been achieved without the residency.

One comment which captures the emotion of the moment came from one pupil's uncle:

- *'I HAVE LIVED IN THIS COUNTRY FOR TWENTY-NINE YEARS. NEVER HAVE I SEEN THESE THINGS SAID IN THIS WAY BEFORE. IT IS ALL TRUE!'*

I was not prepared for the pleasure found by parents in seeing their children taking advantage of the opportunity to explore and represent their own views on stage. More predictable was the reaction from the few members of staff who saw the performances. I have always believed that theatre should provoke thought and reaction in its audience. These plays acted as a catalyst, revealing attitudes and prejudices amongst professionals involved with the group.

The spectrum ranged from those who, like most of the audience, were amazed at the force with which the students had been able to express their ideas and who praised a project which had created a secure situation in which students could articulate their views, to those who believed the students were being forced to act as a mouthpiece for the playwright's views.

This project points to the risk a school takes in inviting an artist into school. The playwright raised an agenda for discussion which pulled staff and pupils in different directions. Similarly, in the gallery project, the artists' work produced pupil reactions which demonstrated conflicting values. But all this work plays a vital part in challenging values and attitudes. The element of risk in making and appraising art is an essential ingredient for pupils and teachers alike. The arts do not operate in a predetermined way: to assume they do is to undervalue their significance.

All the projects referred to in the first part of this chapter have underlined by inclusion or omission the vital preparation period and the importance of dialogue between artists, teachers and pupils. We look now in more detail at the implications of working with artists and offer some practical guidelines.

## WORKING WITH ARTISTS — HOW?

**Preparation**    It is essential to plan well ahead of a collaboration in order to define aims and objectives from the school's and artist's point of view. It is necessary to choose an appropriate artist and the pupils or groups of pupils who will participate. The artist should be brought into all planning meetings from the earliest possible moment so that teachers and artist can negotiate projected outcomes, materials and resources needed and the artist's timetable and facilities within the school.

In this example, of a theatre company resident in a secondary school, a teacher describes a project which suffered from insufficient preparation.

The play raised many social and political issues which staff felt they needed to be more fully prepared for in order to incorporate them into their plans of work. There was also concern at the levels of language used: some found them personally offensive, or were anxious that pupils might interpret teacher presence as condoning them. Others accepted that the language related to the characters: it was realistic in its context and part of the artistic integrity of the play.

There was a strong feeling that staff needed to be aware of the level of language prior to the performance in order to set it in its context for the pupils. The headmistress, in particular, needed to be aware of any controversial areas of the performance so she could be prepared to answer criticisms from parents. This concern over language had its positive side: it stimulated discussion about what was acceptable in what context and how to express strong feelings in various ways.

Time and time again teachers reflect ruefully on the lack of preparation that went into their projects.

... Due to the time pressure we had worked under in the planning stage, a consensus over the aims of the project had never been reached. Each of us interpreted the brief in a different way and through what we did when with our groups when working with the artists.

... In retrospect, we could have discussed this problem in more detail when devising the project so that the pupils felt happier and understood the reasons for such a course of action.

... It would have been helpful if these and other ideas had been discussed in a meeting of the whole project group, although I did understand the constraints of time and organisation which mitigated against this.

However, many residencies are well prepared, funded and resourced. In this example a primary teacher prepares for a textile artist in residence by building on the traditions that children bring to school from home. The teacher was willing to learn new art and craft forms alongside the children rather than acting as a 'bestower of skills'. This way can provide the most stimulating teaching experiences.

The school is located in a bustling residential and business area close to the city centre. It is a modern open-plan building with accommodation for over 500 pupils, the majority of whom are of Asian origin. We seek to work in partnership with our parents and the local community. The community wing is part of the main school building and provides the facility and focus for a variety of community activities seen as an integral part of school life.

We were already aware that many of our parents had first-hand experience of the textiles industry, either through their work or through their interest in embroidery, sari painting and batik work. I have always had a strong interest in traditional craft activities, but at this early stage my experience of fabrics and textiles was limited, so I hoped to acquire alongside the children some first-hand experience of textiles, especially weaving.

I asked staff, parents and children to contribute towards a textile display in the entrance hall. A wide range of textiles and fabrics in a variety of styles made the display invaluable as a stimulus. The children were especially interested in the range and scope of the techniques involved. Many were soon busily involved with paper weaving and collecting a variety of yarns such as wool, cotton, string and nylon and attempting to fashion these into small samples of woven cloth. We cut small branches to use as primitive looms and used a variety of stiff card as experimental weaving machines. Our yarn bank also grew with additions from parents and friends and we found our local recycling project an interesting source of supplies.

These initial experiments were not confined to the children. I also used the opportunity to work with a group of parents and grandparents one afternoon each week, and their attempts at woven material were displayed alongside the children's. At the end of the first term we gathered the work together to talk over successes, failures and possible developments. Many of the staff had pursued their own lines of enquiry and in addition to the early woven attempts had produced dyed and printed cloth. This workshop was invaluable as we were able to support and encourage each other.

Through the regional arts association, contact was made with a woven textile craftsperson and illustrator. She visited the school in order that we could plan for a three-week residency, bringing examples of her beautiful work and making contact with staff and children.

It was decided that the artist would mainly work with Years 5 and 6. She was to pursue

her own work, to work with small groups of children in a workshop situation and also with me in the community wing with the adult afternoon group. She was to set up her working studio in a common area of the school. Although this space was close to the children it was rather isolated from other areas of the school.

The ground was prepared for the residency and the artist stepped into an environment open and eager for what she could offer. The school and artist were perfectly matched and preparation was good.

The textile artist referred to earlier in the chapter underlines the importance of preparation from the artist's point of view.

Preparatory meetings and discussions, followed by letters of confirmation and telephone calls, are vital in preventing misunderstandings and ensuring a smooth placement. It is important for the artist to survey the work space allocated and to ensure that all required materials are properly ordered and paid for. I have to take particular note of plug sockets, heaters and sinks near the print table.

Both schools were very efficient in ordering and preparing materials. The only hitch was that at one the fabric wasn't washed and at the other it wasn't fully dried. Washing and drying ensure that the pigment bonds with the fabric. Neither placement was jeopardised but, had they been shorter, the time available for printing would have been significantly reduced.

## Meeting the cost

Funding is a major concern for all schools and teachers who want to embark on a collaborative project. A primary teacher observed the following.

The one factor which may deter use of a resident artist is the cost. This need not be prohibitive. In our case we had the luxury of funding provided by the county in support of the national project. This funding is not normally available but sharing out the artist's skills among several classes would be a way of distributing or justifying the cost. In my school parents respond well to fund-raising events to sponsor such activities. We also have a sympathetic headteacher and governors who see the need for digressions from routine and allocate whatever they can from school funds towards such events.

Alternatively, the visit could be shorter than a week, or a non-professional local artist could be used, though I must stress that professional artists lend a different dimension to the children's involvement. Viewing his work inspired many of them to greater efforts: there was a sense of importance and pride attached to working with a 'real artist'. Whichever way you choose to fund such activities, I would certainly make the effort. The rewards for the children are manifold.

## Follow-up work

An important aspect of planning work with artists is the need for their work to be reinforced by follow-up activities between workshop sessions or after the artist has departed. This is particularly important if contact time with the artist is constrained through limited funding. If artists' work is consolidated in normal classroom teaching then pupils will gain a great deal more from isolated experiences with an artist.

Two jazz musicians who specialise in work for pupils with special educational needs gave two workshops in a special unit for pupils with social, emotional and behavioural problems. In the first workshop the children worked with the two musicians who played piano and trumpet and the project co-ordinator who played flute. They learned simple tunes and basic improvisatory techniques. After the first

session the musicians made a tape for the pupils to practise with after they had gone. The teacher describes the pupils' response.

When I told the children about the musicians coming to work with them they were excited by the idea and, for some, it stimulated an increased interest in music and playing instruments. I tried to keep the excitement and anticipation to a minimum. The children needed to be prepared for the event but if they became over-excited and raised their expectations too high this would inevitably lead to disappointment. On the morning they were excited and I endeavoured to keep the atmosphere as calm and relaxed as possible. I noticed the tension begin to increase in the group and they asked many questions about what was going to happen, probably seeking reassurance.

I was pleased with the children's response to the session and interested in some of their reactions. All of the children, even those who did not participate, got something out of it. Those who did join in concentrated well and for a relatively long period of time. I could see that many of the children felt tense and insecure in this unfamiliar situation but most managed to contain their emotions and maintain a considerable amount of self-control. I knew that these emotions would be released later in the day when they were in a familiar and secure environment. I did feel that the way in which the session was organised and presented helped to relax the children and to reduce the potential tensions. The musicians were relaxed and non-threatening and there was no pressure to do difficult things. The activities were varied and didn't tax the pupils' concentration. Children who did not want to participate could refuse in safety. The children enjoyed the session and I was pleased with the way they worked.

The two musicians found the session one of their toughest experiences in special education, and extremely difficult to evaluate. They were keen to return for a second session and it was decided that the project co-ordinator should visit the unit to reinforce the work begun in the first session. He worked with the tape-recording the musicians had made.

On the teacher's advice I did not press the whole group to join in a music activity but waited to see if the suggestion would come from them. It seemed to me that giving the children this time allowed them to adjust to having me in the room. Some of the children came to show me the work they were doing and eventually they started to discuss the tunes they had learned with the musicians.

It was suggested that the tape was played and soon some of the pupils were showing me how well they could play the tunes. One boy who had refused to join in during the first workshop had obviously taken everything in and could manage the music as well as the others. It was clear that making the tape had been fundamental to the success of the work.

For the musicians' second visit it was decided that they would consolidate the work of the first session and then judge if it was appropriate to move on to new material. It was also decided to use a classroom rather than the large hall which was felt to be intimidating. The teacher describes the second session.

The difference between this session and the previous one was very noticeable. The whole atmosphere was much more relaxed and the children seemed more confident and secure. The children were excited to see the musicians again and they greeted them like old friends. The children also knew what to expect from the session and were confident that they would not be asked to do anything they could not cope with. I did wonder whether some of the children might refuse to come, particularly those

who would not join in last time, or were initially upset by the experience, but they showed little or no reluctance. Although some had to come back to the classroom before the end of the session most of them participated enthusiastically throughout the whole afternoon.

The difference between the two sessions highlights how much the children gained from the follow-up work using the tape. The children had been able to practise the tunes they had learned and many of them could play them quite competently. This led to an increased confidence in their ability to learn new skills which was revealed by the way they tackled activities in the second session. The first session stimulated the children and myself to be more ambitious in music and the tape provided a structure for lessons as well as a continuing stimulus.

The project co-ordinator underlines the value of the follow-up work in his final observations.

In this project the real development only began in the follow-up stages. Due to their own tremendous anxieties the pupils were unable to 'shine' during the first workshop but they came to the music in their own time. As long as provision was made for them to regulate their own progress they were able to succeed — as with one boy, who despite his refusal to join in the workshop, still went on to learn the tunes.

## SUMMARY

The following general guidelines may be helpful for teachers planning a curriculum initiative which involves bringing artists or community representatives into school, or taking pupils out into the community for one-off, or regular, visits.

1. The ultimate aim of any collaboration must be more effective learning and curriculum development: producing long-term changes in the nature of the arts experiences on offer to pupils.
2. Detailed planning and preparation beforehand and regular consultation and liaison while the work is in progress are vital to the success of any collaboration.
3. The artist's work should enrich and support the school's arts experience and courses, and not be a distraction.
4. Artists should be involved with schools as artists: not to cater for aspects of the curriculum which should remain the school's proper responsibility.

Essential ingredients in meeting these criteria include the following aspects of organisation.

- *Networking* — of resources linking the school, the LEA, arts venues, arts agencies, theatres, galleries, community centres, youth organisations, through which a community arts resources directory may be created.
- *Research* — finding people and materials appropriate for use in or out of schools and for the particular project planned and funding available. This can be achieved through an external agency such as a regional arts association, arts education officer or LEA adviser. The matching of artist and pupils is a key to the success of the residency. It is important not to overwhelm the artist with too much pupil contact.
- *Preparation* — bringing all participants together so that they can get to know each other and each other's work, and to align goals and

working methods. The artist can present his or her work and talk to the teachers about it, either through a demonstration, workshop or exhibition. This can provide INSET for everyone involved in the residency or workshops if new forms and ways of working are to be introduced. It is particularly important that before the residency the artist meets and talks to the pupils he or she will work with.

- *Facilities* — it is essential to discuss the resources available and those which the artist will need, the placing of the artist within the school, and the artist's timetable. Artists need specially-prepared places within the school to pursue and display their own work, which are not too isolated from the hurly-burly of school life. It helps if this space is somewhere which attracts a lot of 'passing trade' so that staff, pupils and parents who are not involved in the residency can stop by and chat or watch.

- *Publicity* — to develop a high profile within school and community in order to maximise spin-offs into other departments and with parents and governors. All timetable changes should be publicised and opportunities created for interested parties to participate or watch. Governors and PTA members, in particular, need to be convinced of the importance of collaborating with the professional arts community, especially if extra funding has to be attracted.

- *Communication* — communicate progress to parents, other staff, other pupils.

- *Presentation* — make time and space for a final exhibition, performance, display in or out of school and publicise this within the school and community.

- *Publication* — publish a report of the project, so that all staff, pupils, parents, artists and community representatives can appreciate the outcomes, and so build school and community confidence for the next initiative.

- *Follow-up* — it is important that the work achieved in artists' workshops, visits or residencies is not abandoned after the departure of the artist. Especially if contact time with the artist is limited, time needs to be planned for some kind of follow-up work to reinforce, clarify or take further the artists' achievements.

---

### A checklist for evaluating work with artists

1. Was the preparation for the project adequate? In what ways could it have been improved?
2. What roles did the artist(s) play in the project? What was the most important role for (a) you (b) your pupils?
3. What did the pupils learn from the artist(s) which couldn't have been provided by you?
4. What did the artist(s) gain from the project?
5. During the project did you publicise the work within and beyond the school?
6. After the project did you get feedback from all concerned, including the pupils?
7. Did you evaluate the project? If so, what criteria did you use?
8. In what ways did the project affect future work, either in normal curriculum practice or in future work with artists?
9. Was the artists' work followed up in any way?
10. Do you consider the project to have provided INSET for you and other staff?

# SCHOOLS AND COMMUNITIES

## INTRODUCTION

In this chapter we consider the roles of the arts in developing the community life of the school. Through practical examples we show that the arts offer particularly fruitful opportunities not only for involving the local community in the life of the school but for helping the school to recognise and to celebrate the richness and diversity of the very community which it seeks to serve.

Arts events such as performances, exhibitions and concerts can provide a context for the usual relationships within a school to be shifted and reorganised, and for staff, pupils, parents and friends to meet in a different social context from the one which school usually provides. Arts education offers pupils the opportunity to understand the community and to discover the part that the arts play in it.

## WHAT IS 'COMMUNITY'?

'Community' is a common term in the policy statements of many schools. The term can have several meanings and it is useful to distinguish some of these in discussing the roles of the arts in the curriculum.

### Neighbourhood
The most general sense of community is the neighbourhood or catchment area of the school. This is normally what schools have in mind in developing policies to involve 'the whole community'.

### Communities of interest
The neighbourhood served by any school will include many different groups, defined by common social, political, religious or cultural interests. A school community policy should aim to identify and engage with these different communities of interest within the area.

These may include a variety of arts interests: amateur and professional artists living or working in the area; music, dance, art, drama or poetry groups; and people working in different cultural styles and traditions in the arts. All of these can be a valuable resource to enrich the

curriculum of the school and to enhance the relationships between the school and 'the community'.

### The school as a community

The school itself is a community of many different individuals working within a common framework. A common policy should also address the ethos and quality of relationships within the school. The practice, performance and exhibition of the arts can be powerful forces in heightening the school's own sense of community.

## USING LOCAL HISTORY AND TRADITION

Local historical events and traditions can provide a particularly rich stimulus for arts projects based both in the classroom and in the community, as well as providing valuable cross-curricular links (see Chapter Four). In this first project, introduced earlier in Chapter Four, a comprehensive school uses local history in a thematic approach to arts work. The school is the only comprehensive in the town, whose small population is substantially increased in the summer by the tourist trade. The town has retained many features of historical interest. Although no longer a prosperous port, the fishing industry survives, and the teachers chose to capitalise on this resource.

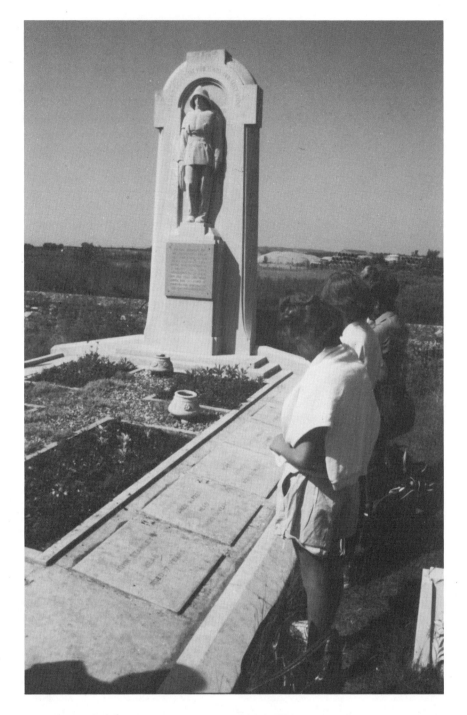

The whole school had been moved by an assembly presentation about a lifeboat disaster which occurred off the harbour in 1928. It was then a particularly isolated community depending on the sea for its livelihood and the lifeboat men for its safety. On a November night the seventeen-man crew of the lifeboat answered a distress signal from a steamer off the coast. Five minutes after the boat had been launched in appalling conditions, a message was received that assistance was no longer required, but contact with the crew was lost. After a fruitless search, the crew returned in worsening weather conditions. The lifeboat capsized 1.5 miles from safety and all aboard were drowned. The community was devastated; the whole country mourned. Even today, there are many who still recall that day. The event seemed rich in artistic possibility: for a deeper exploration of the tragedy in all its dimensions.

Having established a starting point, we needed to put ourselves in the position of learners. We built up contacts through letters, interviews and visits, and compiled a valuable supply of resources in the shape of photographs, newspaper cuttings and

diaries. Soon our colleagues on the combined arts course were fired by enthusiasm and offered their own contributions.

Ideas and resources were drawn into and pooled within the school community. We discovered, for example, the repertoire of a traditional singer that focused on the life of the seafaring community in the harbour. His songs stimulated drama (a day in the life of a harbour family in the 1920s), dance (exploration of work movements developed into a dance with the music), art (painting aspects of community life) and music (imitating the style of the traditional ballad). In turn, the children's work itself became stimulus material.

Older pupils became involved. A Year 11 and Year 12 drama group gave a theatrical presentation of events surrounding the disaster to the entire Year 7. They also took a personal interest in the processes of the younger children's learning. It was a great pleasure to have them team teaching in a workshop with Year 7 pupils. One girl was related to a crew member of the lifeboat and proved an invaluable source of inspiration and information.

Through such sharing of resources, time and children's work the school community was undoubtedly strengthened. For other teachers considering such a project we should like to offer the following observations from our own experiences.

For teachers, such work encourages:

* empathy with children as learners;
* resourcefulness and risk-taking;
* communication and sharing between colleagues;
* the development of healthy links with the community;
* cross-curricular development.

For pupils, it encourages:

* empathy with and understanding of their own community and its history;
* personal motivation and responsibility for learning;
* learning and research outside as well as inside the school;
* awareness of links between different areas of the curriculum;
* the sharing of their work with others.

In this next example, links between a primary school and its community were strengthened as the school's history was explored through the arts. The school was built in 1892: at the time of the project it had only 150 pupils (aged 5–9) as a result of falling rolls, but the building had changed little since the early part of the century when it housed over 700 pupils, with classes as large as 70. The school linked several generations in the community: a few of the pupils had great-grandparents who had attended the school, while many of the staff were former pupils and they too had forebears who had attended. A class teacher describes the project.

A topic based on the pupils' immediate environment, to coincide with the school's 95th birthday, was planned for the summer term. As part of this topic we decided to use the school logbooks, complete with the thoughts and deeds of the various headteachers, to bring the school's history to life through drama and music, involving older members of the community who were present when the events took place. This seemed an ideal opportunity to strengthen links between school and community.

My class easily identified with the children from the past through the headteachers' accounts of misdemeanours and punishments. They discovered that a child who was punished with the strap for going home without permission at playtime was the uncle of one of our dinner nannies. This made them eager to find out more about what

it was like to be naughty all those years ago. Our present headteacher, happy to oblige, dusted off the tawse and gave a frighteningly real demonstration of its use, his desk top being the passive victim.

We decided to research a more detailed incident from the headteachers' log and bring it to life through drama. Small groups developed the story, offering solutions to questions posed by an incident in which three passers-by accused a teacher of undue severity in punishing two boys, resulting in legal action by the teacher for alleged libel.

Another area of fascination was how the children of the past learned and what they were taught. Interviews conducted at home with different generations produced a wealth of information and it intrigued the children to discover that many things did not change from generation to generation. We decided to concentrate on those aspects of learning which had evidently changed.

At first it was fun sitting in rows chanting tables and reciting extracts of poetry learned by heart. The children soon realised that doing this week in, week out under the threat of punishment might not be so enjoyable. More attractive was the prospect of learning to write as their great-grandparents had done, forming letters in trays of sand, progressing to scratching onto slate and finally practising different styles of writing in their 'copybooks'. The children soon found out how easy it was to 'blot their copybook'. We held several writing lessons like this with children being seen and not heard, while I donned mortar board, cape and cane, playing the part with intense gravity. The children took much pride in their copybooks. Later a few confided that lessons like those would be great: but not too often!

The next area for investigation through drama was 'drill'. According to the log, the children of the past had been given military drill by the local sergeant major. We studied old photographs and made a list of instructions given by the drill master, drawn from older members of our community. Then it was out into the yard with military precision. I acted as drill sergeant to begin with, then employed one of the more confident class members to take over. The class took young Susan more seriously than me. Her voice was strong and authoritative and she held their attention for a full fifteen minutes before it began to rain.

To broaden the study into the community and to demonstrate to the children the skills that would have been practised in home crafts during the period the school was built, I invited into the classroom a grandmother who was skilled in the crafts of spinning and weaving. It was decided that she should work with eight children rather than the whole class to give them enough time to produce something at the end of three sessions. It was hoped that the children would demonstrate to others the skills they had learned.

Our visitor bought with her a Jacob fleece, a spinning wheel, eight spindles, some simple handmade looms and examples of her own work from fleece to fabric. She began with a demonstration on the spinning wheel, the children eager to help where they could. They were soon teasing out the wool to get the fibres running lengthways and making 'rolags' by rolling this teased-out wool into thin sausage shapes. Next they tied their yarn to a spindle stem, took it round the base and around a notch at the top. I had to be content with explanations from the children every so often, as they shrugged their shoulders at my feeble efforts to emulate them. A class was arranged with the eight children as teachers and the rest of the class, including myself, as pupils. The role reversal worked a treat: a method to develop for future projects. Many children also expressed a desire to continue during the summer vacation. This pleased grandparents who thought that home spinning and weaving was a thing of the past.

Over the following weeks we concentrated on other areas of the curriculum, trying

to 'do it as they did it', as one child put it, and decided on an end-of-term performance that would tie the project together. It was obvious from the logbooks that singing featured highly in the school's curriculum, although the entries weren't specific about the songs themselves. More first-hand knowledge was needed. The children duly conducted interviews with older generations, at home or at the local rest home.

They returned after the half-term break armed with information about the school. One great-grandmother told how the headteacher during the Great War would keep up morale by gathering the whole school together to sing songs like 'Keep the Home Fires Burning'. This was to be our starting point. We discovered from the log that the school was taken over by the military in 1915 as a billet. The thought of our school occupied by soldiers captured the children's imaginations. We also discovered that the children had celebrated an ANZAC victory by parading in the yard and singing an ANZAC marching song. Several wartime songs were arranged into a medley, with a pleasing result. The children wanted to perform them; they had been singing snippets at home and arousing interest. We decided the show would be best kept a secret until we invited their families into school to jog memories.

There was now definite interest in the community in what the children were doing at school. Information, artefacts and anecdotes flooded in. Some grandparents came in to talk about relatives who attended the school and were fascinated to see the names of loved ones on the entry register. Many talked about the songs they learned as young children, and what a pity it was that traditional local folksongs seemed to be dying out. Earlier in the year we had sung 'The Water of Tyne', so here was an opportunity to extend our summer performance with a medley that would strike a chord in the community and acquaint the children with culturally important songs. It was also soon to be the 125th anniversary of 'The Blaydon Races'. Three other songs were added, joined together by the 'Blaydon Races' motif: 'Keep Your Feet Still Geordie Hinny', 'Cushie Butterfield' and 'The Lambton Worm'.

It was suggested by a colleague that since July was the 20th anniversary of the release of 'Sergeant Pepper', with attendant media attention, we might include a Beatles medley for those parents young enough to remember them. It was the children's turn to impress their parents with songs that were as much part of history to them as the Great War was to their grandparents. The songs were more difficult to learn but provided plenty of opportunity for arrangement with untuned percussion. The summer show was taking shape.

The show was completed by drawing further upon the resources of the local community, including the amateur operatic society, school of dancing and assorted parents.

Another arts project inspired by local historical tradition took place in a grammar school and was performance-based. It boosted interdepartmental collaboration as well as strengthening links with the local community, as the head of English describes.

It was the geography teacher who enlisted my support as a 'drama expert' for his idea for a community-focused play, looking at an aspect of local history: the annual influx of hop pickers from London, and its impact on the local community. We decided to make *Hop is King* a junior production and to prepare it as a cross-curricular module.

In six weeks, while Year 10 GCSE English students wrote the script, history staff taught the tradition of hopping in the county, invited speakers from the community to share their reminiscences, sent Year 7 pupils out to interview members of the community in their own homes — a letter having been published in the local newspaper asking for information, mementoes and interviewees — and others to visit farms which still had old hoppers' huts. Year 7 geography groups were taught

the hop-growing process; Year 8 music groups wrote the music; Year 9 art groups painted the scenery; Year 12 CDT students and staff built the set; Year 7 dance groups choreographed the dance sequences; Years 7 and 8 PE groups planned a gym display.

The geography teacher produced a plotline which I gave to my Year 10 group. I broke it down into six stages, each of which was taken on and scripted by a group of four or five pupils. To achieve consistency of character we played out scenes in the hall when the scripts were first drafted and discussed the alternations needed. The drama teacher and myself then sharpened up the script and he added some short scenes to round the plotline off and to ease links between passages of dialogue and the interspersed dance and music. History students worked on a large exhibition for the entrance hall, and, one week before the production, rehearsals for the scenes, the songs, the dance and the gym display were sewn together.

For three days in July the school hall was turned into a hopfield for evening performances and a matinee for local primary schools. A hoppers' hut was set up on the stage, the raised side of the hall was strung up as a hopfield — real ones on real binds, given by local farmers — and the floor was covered in straw bales on which the audience sat. A large diagonal cross was left so the performers could move through the audience to the stage or the side platform, along which ran large cardboard panels painted with rural scenes to form a realistic and colourful backdrop to the hopfield. Authentic props were borrowed from local farmers and at the back of the hall a barrel of real ale, replenished each night, provided refreshment at the interval, donated by a local brewery in exchange for a little publicity in the programme.

The storyline was simple but the production, costing only £250 — we took £350 at the box office — was one of the most exciting I've been involved with: colourful, varied and fast moving, with the focus of attention shifting so swiftly that the audience had to swivel on their bales to follow it. It involved seven departments, eight teachers and 150 junior pupils (Years 7–10), filling the school with a common purpose for most of the summer term. It was totally home-made and home-produced. The school play will never again be English extra-curricular property.

No one carried the entire burden for the production. It was prepared within as well as outside the curriculum and it improved co-operation between staff who gave their energies to it. Links with the community were also strengthened through the project. Many who came in, or were interviewed at home or attended the performance, had had no contact with the school since its formation in 1967. Some wrote to say they'd enjoyed being part of *Hop is King* and to offer their services for the next project.

## INVOLVING ARTISTS FROM WITHIN THE COMMUNITY

As the previous examples have suggested, artistic skills and experience can be located and drawn upon in any community, ranging from amateur groups and societies, youth organisations and companies, through to the professional artists and craftspeople living and working locally. Drawing upon such resources not only serves to enhance school and community links but also:

- reminds pupils and parents alike that the arts are life-long sources of pleasure and interest as well as the professional concerns of certain people;
- helps involve in the curriculum creative and recreational pursuits enjoyed by the local community which are often not regarded as 'art forms'.

As in their collaborations with professional artists, it is important that

teachers should not feel that their professionalism is in any way undermined by community involvement. As in the following examples, such involvement should emerge from analysis by the teaching staff of the arts skills already at their disposal and the areas they would like to see developed. The degree and regularity of community involvement should also remain at the discretion of the class teacher, who must ensure that pupils' learning programmes are enhanced by such collaboration, as in the examples given.

Schools can gain much from the occasional suspension of the timetable for a celebration of the local community and the school's place in it. The arts are often at the forefront of such 'cultural celebrations'. The staff of one rural junior school enriched its arts curriculum by inviting parents into school to share skills and talents with the children.

For one summer term the whole school adopted 'Our Town' as its topic, divided into three themes: 'Caring for the Environment', 'People Who Serve Us' and 'The Community'. The overall aim was to show how individuals and organisations can help in creating a caring environment. The arts component was designed to involve the arts expertise of members of the local community, to increase the children's awareness of arts activities in their town, and to expose the children to a variety of arts experiences.

The project fell into two parts. First, each class teacher was asked to identify an area of the arts curriculum which could be enhanced by enlisting help from a member of the local community. The amount and regularity of this help was left to the discretion of the individual teacher. Second, an arts day was to be held, on which as many local artists as possible would come into school on a voluntary basis to carry out workshop sessions with the children.

The following are extracts from the class teachers' evaluations of their projects.

1. *Aim:* to introduce children to the basic principles of pottery.

I asked a neighbour and lecturer in ceramics at the local college of design to come into school to talk to the children about pottery. He committed himself to visiting the school for three sessions. His suggestion was that children should make and fire pots using the Raku method, a simplified Western version of an ancient method of firing pots which came to the West via China and Japan in the sixteenth century. In the far east it was associated with Buddhist monks and their elaborate tea ceremony.

For the first visit, after a brief preliminary talk by the potter, the class was divided into five groups and made thumb pots. Before the second visit some of the pots were kiln-fired at two local secondary schools. The children were then helped to glaze their pots. On the third visit the firing was done outside, with additional help from students from the college and from a mother who is also a teacher.

2. *Aim:* to experience a new way of music-making: handbell ringing.

The class was divided into three groups and each had one session with a local bellringer in which they learnt how to ring the bells and play a tune. Each child rang several bells and discovered that the larger the bell, the lower the tone.

It was an enjoyable experience for all the children, but most valuable to those who could not read music, who were excited that by reading numbers they could, as a group, produce a tune they knew.

3. *Aim:* to enhance classroom work on street furniture within the theme 'Caring for

the Environment'.

The first stage involved walking around the local streets observing modern street furniture. We then moved on to think about the street furniture of the past that we often passed by: lamps, foot scrapers, water pumps. Armed with pencils and paper, we descended on the market place and main street. The children were encouraged to look at both eye and ground level and to observe both decorative and working parts of the street, sketching the things they found most interesting.

We decided to take our work a stage further by photographing in black and white some of the things we had sketched. When the films were developed the children had the opportunity to criticise their efforts. We thought it would be a good idea to get an expert opinion, so a keen local photographer was invited to visit. He discussed with the children the points to think about when taking a photograph and went on to look at the photographs the class had taken, raising points we had not thought of.

4. *Aim:* to make children aware of the living traditions around them and to experience folk music and dance through local artists.

My class experienced a living tradition as they participated in, listened to and created their own folk songs rooted in local history. They watched a performance of Morris dancing and learnt something of the history of this type of dancing. They all had the opportunity to learn some of the steps, jumps and formations used. Eventually twenty-four enthusiasts had an intensive course and learnt a complete dance with great success.

A student on teaching practice and a local folksinger together introduced the children to different folk songs. They discovered that many derived from the workplace, the rhythm assisting the workers to keep at their labours. The children heard the song describing the Gresford mining disaster and were then encouraged to write a song about the disaster at the local gunpowder mill in 1916, which they had previously studied.

A local professional folk fiddler showed the children how folk music is a living art form by playing some of his own compositions. He went on to demonstrate how the folk music from different areas of Britain varies by playing dance tunes from Northumberland, Scotland and Ireland. Finally, the children learnt an American folk song, thoroughly enjoying a type of music with which most of them were unfamiliar. Through this encounter with folk dance, music and song the children had participated in traditional art forms and learnt that they could help keep these alive, and indeed participated in making music for themselves out of their own experiences.

5. *Aims:* to create a link with a senior citizens' art class and to introduce the children to a new art medium: oil painting.

Class 7's project was inspired by an article in a local paper about an oil painting class for pensioners at a nearby centre. The tutor lived nearby so I contacted her, feeling that this would integrate our arts work with our topic on the town as a community.

We visited the painting class on two occasions, taking half of the class each time. Some of the children were apprehensive about talking to strangers, but their shyness vanished as we were made very welcome. The tutor gave me a great deal of advice about the materials we would need and ordered them for us through her supplier.

Two of the pensioners had expressed great interest in the idea of children painting in oils and were very enthusiastic when I asked them to come into school to help. This link continued every Thursday afternoon, with eager anticipation on both sides. The social benefits ran concurrently with the art instruction and gave us obvious links with art and the community for young and old.

6. *Aim:* to create picture/story books for pre-school children.

The project began with a visit to the local library, where the librarian showed the class a wide range of pre-school books. We then visited the pre-school playgroup in the adjoining infants school and, using questionnaires devised by the children, asked the young children what books they liked and why.

Production then started on our own books. Storylines were thought out and divided into suitable sentences, each accompanied by an illustration. Rough copies were made and texts produced using the word processing programme on the school computer. After neat pictures had been produced, we were fortunate to have a visit by a distinguished professional illustrator of children's books, who spent an afternoon working with the children on their books.

Once the illustrations were complete, the texts were attached, the pages laminated and the books ring-bound. This was a very worthwhile exercise, involving both basic literary analysis and graphic art skills in a complementary and productive way.

The books were the result of many hours' application by the children, both in and out of school. The final part of the project took place in the last week of term, when class 8 revisited the playgroup to share their results with the children who had aided them in their research, who liked the books very much.

7. *Aim:* to give the children an experience in photography and compiling a slide/tape sequence.

Over the Easter holidays the children were asked to consider how they would introduce their town to a visitor: where they would take them and what they would tell them. The next term began with a visit to the local heritage centre, where the children were shown the sound and slide presentation made by an expert photographer, who explained how the sound tape was synchronised with the projection of the slides. The photographer subsequently came to the school and gave a talk about film developing and printing. In science lessons the children had the opportunity to make a simple pin-hole camera and to understand how it worked.

The class then formed themselves into five groups, for each of which a worksheet was produced and a short tour of the town planned. The worksheets asked the children to produce sketches and rubbings on suitable subjects for slides, and record details of the town at ground level and from ground to roof.

The help of other staff members and three parents was much appreciated during these tours. Each group was supplied with five films to use with a new camera bought by the school and, with the help of other staff members, they were able to take the photographs they had planned. Once the slides had been processed the commentary was researched, compiled and recorded.

The school's arts co-ordinator describes the culmination of the term's work.

An arts day provided a further opportunity for the children to sample activities they had not previously experienced. The activities encompassed visual and performing arts as well as rural crafts, all involving a high degree of pupil participation.

The day was divided into three working sessions and each child chose to do three different activities from a choice of eighteen, each led by a member of the local community, including parents, governors, friends of staff and teachers from the neighbouring secondary schools. The leaders ranged from professional artists to enthusiastic amateurs and all provided a high standard of expertise. The activities offered were: flower arranging, knitting, cane and raffia work, painting, singing, oil painting, drawing (including computer art), chalk/charcoal pictures, art, drama, dance workshops, music, pottery, country dancing, pop mobility, bell ringing, kit drumming, and wrought ironwork.

The project as a whole will be long remembered by the participants. The benefits came both in the children's participation in activities they would not normally have experienced and in the development of links with sections of the community which would not normally have been involved with a primary school.

The treatment of community involvement on two levels — a one-off experience and a class project — was a good mixture. If such a project were to be repeated, the arts day might come first, followed in the next term by class projects developing one aspect of the day. This might be more helpful for staff who were pushed in at the deep end in having to think out an area for themselves. It is a tribute to the commitment and enthusiasm of the staff that so many interesting class projects were devised.

As an exercise in community involvement I would recommend such an initiative to any primary school. We were amazed at the variety of talent on our doorstep and at how eagerly services were offered. Excluding lunch, the arts day cost us only £25, mostly for travelling expenses or materials such as clay. In the headteacher's words, 'I look back on that day as one of the highlights of my time at this school. It was a day of co-operation between the staff, parents and the community, who combined to give the children a day they won't forget and introduced them to a skill which perhaps will be of value to them in the future.'

## USING COMMUNITY ART FORMS AND RESOURCES

**Community quilt-making**

An unusual project in a large secondary school in an isolated rural area involved parents and the wider community in making as well as sharing art. The aim of the project was to make two friendship quilts. These are pieced textile quilts which are made in blocks and put together with embroidery, appliqué and quilting. These have been made traditionally since the early nineteenth century by neighbours who each worked a patch of their own, and then met at a quilting bee to sew the blocks together. The textiles teacher who organised the scheme outlines the project.

The first quilt was to be given to the local community, depicting our island in geographic relief, showing areas of population, use of land, schools, churches, buildings of community interest, libraries, corner shops, local industry, agriculture. Its design was to be created by sixth-form GCSE (mature) and CPVE students; the local community — adult education classes, local artists, townswomen's guild, local industry — was to contribute equally with the school to its production. It was to be used as a symbol of friendship between the school and the island.

The second quilt was to be kept by the school as a central display designed to represent the island historically, to the present day, as a study of architecture, the pupils' homes and environment. The design was to be a compilation of individual studies of local buildings by participants in Year 10 art in the built environment (ABE) modules and City and Guilds courses. The studies were to be personal responses to the brief of the quilt: that it should have a three-dimensional surface, with doors that open and views through and into archways and openings.

The completion of the quilts was to be celebrated in a non-denominational service at the local abbey for the students, members of the community and of local industry involved in making them. Both would be displayed permanently, one in the school and one in the community.

The project started in January with design work for both quilts and discussion of publicity and community involvement. Work in fabric was started by a Year 10 ABE group. Video and stills cameras were used

to record stages from design to fabric. In February the project was introduced to the Women's Institute group by the adult education unit, and the adult education groups were approached. The sponsorship and publicity drive continued and local newspapers were involved in recording and advertising the event. Quilting kits were prepared for volunteers. During March correlation and support meetings were held by community volunteers and both quilts were put together at a quilting bee: volunteers, students and their families were invited to the stitching together and to a meal prepared by students. Sponsors and local press were also invited. By Easter the quilts were complete and the Dedication Service at the Abbey was in June.

The same teacher describes the process of working with the community.

Through community participation the existence of pieced quilts made by children on the island either just before or during the last world war came to light. These had been raffled for war funds and bought by an island family who used them as bed covers for many years. The final threadbard remnant was being used as a car seat cover.

Community participants were introduced to the project by the head of adult education, based at the school, who made contact with likely organisations and classes. It was difficult to gauge the level of support from the community since by the time I had assembled fabric, threads and designs the completion date was only six weeks away. This time factor demanded a strong commitment from participants,

which worked in favour of sustaining interest up to completion.

Meetings had been arranged for community participants during and after school time. These were thinly attended due to the ladies organising their own group meetings as part of craft clubs or coffee mornings. Individual enquirers felt able to pop in to school informally to ask questions and seek reassurance. One particular member of the home economics guild of the Women's Institute kept me informed of progress and took an interest in the school quilt by bringing her news to the Year 10 lessons. This helped greatly in giving the pupils insight into the progress of the other quilt.

The Year 10 students began their research and design work at the start of the spring term. The manner in which they gathered information and resources led them into research within their own family and environmental area and generated insights into the relationship between home and school communities. By the end of January they were ready to start work in fabric, seven working weeks before completion date. Their enthusiasm was sparked by the responsibility they felt to produce a finished and publicly displayed article.

## Responding to cultural diversity

Involving community art forms brings different challenges in ethnically diverse areas. One of the project's inner-city development groups took as its brief the following:

to explore how the arts can increase the relevance of the school curriculum to students from diverse cultural backgrounds and how this can be aided by the development of community links.

The schools involved took on a wide variety of arts projects which tackled this issue in different ways. One secondary school transformed the display areas within the school over the process of a year to reflect the Asian community of the school. They also invited a black photographer to be resident in the school to create an exhibition of photographs of the local community.

Several schools invited a range of artists and local craftspeople into school to work with pupils in a range of new art forms and crafts which reflected the school community. One primary school used the theme 'Festivals' to explore a wide range of cultural traditions and during the course of the three-term project invited large numbers of friends, artists and community representatives into the school for workshops and presentations. All the contacts were made in the local neighbourhood through talking to parents and passing the word around.

In any catchment area great care and attention need to be taken that the content and style of the school's arts provision has the support of the local community. In several project schools, for example, the teachers developed strategies for building a sympathetic and confident relationship with a predominantly Muslim community.

We all felt a great need to involve parents as we believed there was much to learn about Muslim culture, and that this would benefit us professionally. We wanted to have first-hand knowledge of the culture to which so many of our children belonged in order to enrich our curriculum and make it more relevant to the children. First-hand knowledge was necessary because attitudes varied according to the mosques that families attended and some might therefore find particular areas of the arts curriculum contentious.

We began by having a meeting with a school governor who was head of the city's Islamic Foundation and two mullahs (religious leaders). We discussed the arts and they were generally supportive while suggesting that we should not attempt dance or representation of the human figure. They also suggested that if we offered a community room where Muslim parents, in particular, could congregate then we would have taken the initial step towards getting parents more involved in school.

## Links with community arts provision

There have been a number of schools where community arts programmes have resourced curriculum work in some way. The work of the mask maker described in the preceding chapter, for example, had evolved in a community arts programme before it was brought into schools. Some schools use these programmes to enhance their normal curriculum provision. A dance teacher describes how a community dance programme, organised through the youth service and supported by a dance animateur, supports her school teaching.

The formality of structure at the community dance programme's studio is one step removed from curriculum dance and school dance clubs. It functions outside the school environment and many of the classes offer different techniques to those offered in school. Jazz dance is a popular class and as it is not part of the school dance syllabus the classes offer the pupils an opportunity to extend their movement vocabulary and dance styles. The atmosphere is very relaxed at the studio and the students are there voluntarily.

The youth groups provide the pupils with more opportunities for choreographing and performing in frequent dance concerts. However members have to be very committed to the companies because of the intensity of work. Weekly rehearsals have a strict structure in terms of attendance, punctuality and effort in company class and the development of stamina for long rehearsal periods, particularly for the senior youth group. The dancers are aware of the length of time needed in order to obtain a high standard and they achieve satisfaction when all their work comes to fruition in the dance performances.

## SCHOOL ART CONTRIBUTING TO THE COMMUNITY

## Mural painting

The following two examples underline the community role of the visual arts and their potential contribution to school and community environments. First the head of art at a large inner-city boys' comprehensive describes an innovative project for GCSE. (See pictures on p.129.)

When I joined the school I walked around the local area with a camera taking pictures of anything I found visually interesting. On the side of a house which can been seen from the school grounds was a fine mural, three stories high. Pupils could see this work of art on their doorstep without having to go to a gallery or museum. One of the deputy heads shared my desire to see more colour in the school environment, and there were already interior murals along some of the corridors.

The aim of the mural project which developed was to encourage students to personalise and feel more at home in their environment. I also wanted to give them the opportunity to respond to a real design brief, to make art which responded to a real context within the environment and, in common with fabric printing, to give them the opportunity to work on a large scale. Mural painting is essentially a public art, involving interaction with the client community. Bringing a professional practitioner into school — in this case, the creator of the nearby mural — increases the reality of such work and the interaction with the outside world.

The mural artist had already been into the school to talk about his work in the past. I was particularly keen for him to show the groups his preparatory sketches as teaching pupils to use, value and document the preparatory process is a major element in any GCSE art and design course. Showing slides of murals from around the world, he talked about how murals were linked in scale and location to graffiti art and advertising. He also talked about their relationship to large-scale painting, tapestry, tile work, mosaics and architecture. Descendants of Palaeolithic cave and Egyptian tomb paintings, murals were later found in stately homes and churches, illustrating religious stories. More recently they have been used to express political messages or to create employment during periods of economic decline.

Particular artistic challenges are involved in designing and painting murals. Unlike a painting which can be moved, a mural has a particular environmental context. It must fit in with the buildings around it. It must work when seen from a number of different angles and from a distance, so it must be painted in a radically simplified style. Small details and subtle colours lose their impact. The themes 'music' and 'art from other cultures' also opened areas for enquiry in the relationships between different arts disciplines and in moving away from a Eurocentric view. I also planned a trip to the exhibition 'Heroes' at the local gallery, which included work by an artist who produces 'fan' paintings of rock and roll heroes like Elvis Presley and Chuck Berry, as I wanted the murals to reflect the pupils' own interests and perceptions of music.

Badly designed or painted murals can disfigure schools, of course. I would not consent to murals on surfaces designed by the architect to be left untreated; an answer here was to use plywood panels. Consulting with the local community to find appropriate sites outside the school could also become a valuable aspect of other mural projects. I intend to go on encouraging individuals and groups to undertake this sort of work at the school, leaving memorable traces of their skill, effort and personality in the school environment. I also hope to obtain funding to secure a mural artist in residence for a term to make a lasting creation within the school grounds as well as to help train mural artists of the future.

The second mural project involved CPVE students, working collaboratively rather than individually, at an inner-city college of further education. (See pictures on p.132.)

Our mural was created by a CPVE art and design group of fifteen students, aged between sixteen and nineteen and from many different ethnic and geographical backgrounds. Some had virtually no previous experience in art, others had a GCSE. In order to find a project we could undertake I made enquiries of several neighbourhood office managers and made contact with a man who ran a dog obedience training club on a local estate which had just been allocated a new hall for this purpose. He was very enthusiastic and had many suggestions as to the subject matter and style of mural he and his members wanted for their hall. The project was to form part of the students' CPVE coursework, the criteria for which emphasise that where possible work should be integrated — in this case, combining art and design, communication, numeracy and work experience — and student-directed.

The first term was spent considering the wider context of public art and murals. We visited three exhibitions: Diego Rivera, Ferdnand Leger and 'Day of the Dead' (Mexican surrealism). We also looked at slides of work by other muralists, including Stanley Spencer. Students made detailed individual studies of composition and colour in public art — including tiling and mosaics on the London underground, New York graffiti and church art and posters — and these were linked to the theme of 'communication'. We discussed political themes, symbolism and the visual impact on the environment.

The next stage began with a visit to the site by the whole group to meet our client and hear what he wanted, to view the kind of lighting on the wall (daylight and artificial) and to take exact measurements so that we could provide an accurate scale-drawing. We had to meet a deadline for the completion of our proposal as I planned to carry out the painting as a three-week work experience block. We were greatly helped by a member of the local schools environmental project, who came into college to show us slides of other work the group had done and some design drawings from his own portfolio. He also worked with us throughout the design stage and offered valuable technical advice when it came to preparing the wall and choosing materials.

Every aspect of the work was discussed and agreed upon as a group: materials and techniques were chosen after a session experimenting with different kinds of paint and application. We used various methods to arrive at consensus: splitting into small groups then regrouping to discuss outcomes. Everyone carried out a scale-drawing of their own idea, source material for which included drawings from life (a dog, plants and leaves), from books and from photographs taken of dogs in the park and at the club. There were many very good ideas, particularly that of a board game on the wall (like snakes and ladders) about dog training.

Due to time constraints, our chosen medium and our client's preference, we eventually opted for a frieze, to be carried out mainly with stencils and spraycans. The main lines of the drawing were planned but there was room for individual creativity in the execution of the work. For the three weeks during which we carried out the work students' tasks were allocated each day: stencil cutting, masking and taping, cleaning up and making tea, and so on.

A notable achievement of the project was the group spirit which was generated. Enthusiasm and teamwork were stimulated by pride and a sense of achievement as the work progressed, and the care about craftsmanship showed in the results. As the work took shape students were discussing the composition and making artistic decisions together naturally without direction from me. The degree of skill and finish achieved was enhanced by the group process, and the lesson in co-operation was as valuable as those in designing and making, communication and numeracy.

**Beyond the school**

Several project schools prepared presentations or performances for hospital patients, old people or other local community groups. A visual art teacher from an inner-city school devised a project through which her pupils' work contributed to the local hospital. The school was firmly committed to the breakdown of barriers with its community and there were several curriculum areas where links were already thriving, including careers and industry — involving pupils in work experience placements — and community service, in which pupils helped out at playgroups, neighbouring schools and local residents' homes. The textiles department had also been working successfully on community-based projects, and it was decided to continue this liaison with pupils designing and making wallhangings for the hospital.

The project was a successful example of how a school-based art project could establish liaison between the school and the community, with mutual benefits. The walhangings were well received and their presentation to the hospital gave an opportunity for the patients and students to meet and talk. The work was all the more satisfying for the pupils because they could see a reason for working: to provide something of worth for people outside the classroom walls. The hospital staff were keen for groups of pupils to work with patients in the geriatric ward on screen printing projects, giving them the opportunity to become teachers themselves.

## SUMMARY

This chapter opened with a discussion of the ways in which the concept of community is used in education: to refer to the community of the school itself; to the neighbourhood or catchment area of the school; to the groups within and across that wider community defined by cultural, religious, political or artistic interests.

The examples cited in this chapter explore the possibilites of all these uses of the term. They demonstrate the ways in which local communities can support the arts curriculum, providing it with rich resources in terms of history, tradition and cultural diversity. The skills of parents, local craftspeople and artists, as well as the national arts communities which offer programmes for schools, can all contribute to the creation of arts curricula with a fully-fledged community focus. Such curricula enable schools to celebrate and endorse their own sense of community and pupils to contribute positively to the communities served by the school.

The arts are ideal forms for establishing school and community partnerships. By their nature many of the social forms of dance, drama and music generate participation, the essence of 'community'. It is through the arts that communities establish and express themselves, and the arts experience — whether singing, dancing or making music — provides the shared experience which brings people together to celebrate their collective self-identity.

In the same way, the arts can transform the ethos of the school. School concerts, exhibitions, festivals and productions can breathe life into the school and give pupils a sense of being part of something vivid and exciting. For many children these memories of school life remain with them far beyond the examination syllabus or set text.

Joint participation by parents and pupils serves to broaden both groups' perceptions of the arts themselves. The extension of pupils' arts experiences by drawing upon forms and styles beyond their cultural experience should be balanced by exploring, valuing and celebrating the variety of local traditions expressed through the local arts communities. This involves recognising and challenging the traditional hierarchy between 'high' and 'low' art expressed through the common exclusion of popular cultural forms, traditional and contemporary, from the curriculum.

Arts projects which involve research into the history and traditions of the local community underline the roles the arts can play in celebrating the richness and diversity of everyday life. When pupils discover that artists live and work in their local community and are not rarified, remote beings then the arts make more sense for them on the timetable. A gallery director involved in a project described in the previous chapter observed the following.

The pupils were introduced to the working processes and environments of artists. This is not new: pupils studying current affairs or government will visit the law courts. Neither should the existence of artists as part of the community be seen as strange or new. Artists work in every town, with different degrees of attention being drawn to them. Their existence is just as important as that of the local bobby.

**A checklist for evaluating the arts' contribution to a school's involvement with its community**

1. To what extent does your arts curriculum reflect the diversity of the school's community?
2. How do you involve the extended community of your school through arts work?
3. Do you seek advice from community representatives regarding the school's arts provision?
4. How do you involve the extended community of your school through work in the arts?
5. Do your pupils' parents contribute to the arts curriculum in any way?
6. To what extent are you aware of, and do you use, the arts resources in your local community?
7. In what ways do your pupils contribute to the local community through their work in the arts?

# DEVELOPING THE ARTS IN THE CURRICULUM: AN ACTION PLAN

## INTRODUCTION

This final chapter offers a plan of action for schools to develop their arts teaching. The ideas presented reflect the working methods of the Arts in Schools project: the phases which the teacher groups went through and the different kinds of initiatives which they explored. Each section represents a phase of action and each phase relies on the success of the one before. These sections are:

1. Reviewing the arts
2. Designing policy
3. Planning strategies for INSET
4. Developing resources
5. Developing and evaluating classroom practice
6. Describing attainment and assessment
7. Designing programmes of study and course guidelines

The plan depends on a group of teachers, or a whole staff, working together in consultation.

## 1. REVIEWING THE ARTS

The first phase is necessary to establish the current state of the arts in the school and to identify areas of need. Information needs to be gathered to establish a broad picture of what is already available and of existing practice. Information is needed on:

• range of provision
• staffing
• timetabling
• resources and budget
• teaching content and styles
• record-keeping and assessment

Within the project the most usual way of collecting the information was by questionnaires which allowed *all* staff from one school an opportunity to offer their views. In this way it was also possible to

evaluate the status of the arts within the school. Ideally this questionnaire was backed up by a one-to-one interview.

The interviewees should include: headteachers and deputy headteachers from more than one school; specialist secondary department heads; pupils; parents and governors; ancillary staff.

## 2. DESIGNING POLICY

Using the information gathered in the review, it is possible to evaluate the balance and range of arts provision in terms of the principles presented in Chapter One.

- Are the arts considered as a generic area of the curriculum?
- Is there a range of arts disciplines taught in the school?
- Is there a balance of *making* and *appraising*?

The review should also ask:

- to what extent does the school ensure that arts teaching is part of a continuous process for pupils aged 5–16? (In answering this question cross-phase dialogue between schools and across clusters of schools in the same phase is essential.)
- are the arts in the school taking account of cultural diversity?
- are all the arts accessible for all pupils, including those with special educational needs?
- do the arts in the school promote equal opportunities for boys and girls?

The next step is to design a policy which will develop and expand the arts work in the school. The policy should address each element of the review.

This process must be part of a consideration of whole-school policy so that the arts reflect, and are represented in, the policy for the whole curriculum.

## 3. PLANNING STRATEGIES FOR INSET

In order to implement the arts policy and improve the use of resources in and beyond the school, it will probably be necessary to devise strategies for INSET.

In previous chapters we have described many different kinds of INSET, particularly in Chapter Six. The following were the most common:

(a) *school-based*
- professional days for the staff of primary schools, or the arts teachers of secondary schools;
- artists in residence;
- visiting specialist teachers and pupils from another school;
- support from advisory services;

(b) *out of school*, where teachers with or without their pupils participated in courses, conferences and events
- teachers' cross-phase and cross-arts development groups;
- teacher exchanges;

- arts festivals;
- joint performances and workshops between classes and between schools;
- involving artists and arts organisations in the classroom;
- visiting arts venues for performances, exhibitions, lecture demonstrations, concerts.

There were examples of all of these strategies within the project. The most fruitful enabled teachers to see new ways of working with their own pupils. Support in their own classroom teaching was the most empowering use of specialist expertise.

It is not always necessary to import specialist support. Secondary teachers often have skills and knowledge which are not used in conventional subject organisation. Collaborations between the teachers in one school can often provide specialist support. These can involve the teachers within a department, across departments or across the whole curriculum.

## 4. DEVELOPING RESOURCES

Resources may have to be developed or refocused. Chapter Three described teachers as the most important resource for the arts and described how a primary school needs some specialist support in the arts and also a curriculum leader for this area. For a primary school that role is particularly important if an arts policy is to be devised, implemented and sustained. This leader may be a class teacher or the deputy or headteacher, but it is important that the responsibility for the arts is designated. Without this role, material resources can be wasted and continuity can be neglected.

At secondary level, it is important that all of the disciplines are recognised in the staffing of the school. Whether in combination or separately, teachers should represent specialist knowledge in all of the arts. It is also important that secondary arts specialists have time to meet and discuss their teaching in order that the school arts policy is coherent and implemented.

For both primary and secondary schools it is important to organise the vital resources of time and space appropriately for the different disciplines. The time-based performing arts in particular will need extra time allocated for performance and presentation. All the arts will need appropriate and thoughtful allocation of space. Ideally, for music, dance, and drama, these spaces should be sound-proofed or distanced from quiet study classrooms and, in the case of dance, with an appropriately surfaced and sprung floor. The provision of space with good light for the visual arts is of equal importance. Adequate space for exhibition and performance needs to be planned and catered for as an essential resource for the arts and in the case of drama and dance, at secondary level particularly, there needs to be provision for black-out and stage lighting.

Each discipline requires its own materials and all need to use and explore the resources in the community. Avenues to explore include:

- local artists and craftspeople, including parents;
- local arts venues — galleries, theatres, community centres, concert halls, arts centres;

- national and regional arts organisations, particularly those which employ education officers and have programmes which can be brought to the school.

## 5. DEVELOPING AND EVALUATING CLASSROOM PRACTICE

During the project the most successful curriculum developments were those where teachers initiated and designed classroom projects for their own pupils. This process involves the following.

(a) *Locating an area of concern*
Through discussion with colleagues, teachers choose an area of concern in their own teaching: i.e. something which is currently confusing or missing in their own classroom practice.

(b) *Planning a programme*
Teachers design a programme of work which addresses this issue. This may be a straightforward series of lessons involving no extra resources. It is essential that aims and objectives are carefully and thoroughly described.

(c) *Recording and monitoring*
Recording and monitoring the experimental lessons is essential. This can be done in diary form. It is also important to keep and/or record the pupils' work during the series of lessons and to include the pupils' evaluative comments, either in taped interviews or in pupils' diaries. Video recordings can be helpful at different stages of the work and, ideally, a 'critical friend' (a colleague, artist or advisory teacher) should visit all, or some, of the lessons and record his or her perspective.

(d) *Evaluating*
Through discussion with the critical friend, teachers should analyse and evaluate the outcomes of the work and consider ways in which their regular practice could be modified.

For many teachers the most important aspect of this process is the opportunity to reflect upon their own practice and reconsider their priorities.

## 6. DEFINING ATTAINMENT AND ASSESSMENT

Having completed such a project of classroom research it is necessary to consider the assessment of pupils' attainment. With the outcomes of the programme recorded and monitored, and teacher's and pupils' diaries on hand, it is possible to address more detailed questions and make a new set of decisions.

Using the experience of that project teachers should consider the following.

- What do you count as attainment in pupils' work?
- What outcomes do you use as evidence of that attainment?
- What criteria of assessment do you use for different kinds of artistic outcome?
- What methods of assessment are appropriate?

- How will your monitoring have contributed to continuous assessment?
- How are you catering for differentiation in your assessment? By differentiated tasks? By differentiated outcomes?
- How will you record this assessment, to whom will you report it, and how will you act upon it?

Chapter Five outlined the range of ways of describing and assessing pupils' attainment in the arts. Some of the project's teachers experimented with methods of self-assessment and with different kinds of record-keeping, profiling and continuous assessment within their daily classroom practice. At its best, assessment is an integral part of teaching where pupils are fully aware of the criteria for the assessment and contribute their own views and judgements.

## 7. DESIGNING PROGRAMMES OF STUDY AND COURSE GUIDELINES

After consultation with teachers from the other phases of education, other arts disciplines, and teachers of pupils with special educational needs, it is possible to prepare programmes of work in a logical progression from 5 to 16, avoiding unnecessary repetition or contradiction in the pupils' learning.

If a cluster of schools are collaborating in this preparation, there can be helpful overlap between schools: expertise and knowledge can be shared. Aims and objectives can be agreed or challenged and detailed programmes in all of the arts can be devised. These will help ensure a balanced and progressive arts education through the phases of education which uses and develops links with the local community and the resources of the professional arts world.

Teachers seeking additional resources with which to work with colleagues in developing school policies are recommended to consult the related publication, *The Arts 5-16: A Workpack for Teachers.*

# Appendix: the Arts in Schools project, 1985-89

In 1982 the Calouste Gulbenkian Foundation published the report of a national committee of inquiry, *The Arts in Schools: Principles, Practice and Provision*. The report argued that all of the arts have essential roles in the education of all pupils in primary and secondary schools. It also found that in too many schools arts provision is inadequate and needs urgent improvement. The arguments and recommendations of this report were applauded by LEAs and firmly endorsed by the Department of Education and Science. In September 1985, with the support of many LEAs and arts organisations, the School Curriculum Development Committee established the Arts in Schools project as a major initiative '*to give practical support to teachers, schools and local authorities to improve education in and through the arts for all young people*'. The detailed brief of the project was developed at a national seminar of teachers, advisers, teacher educators and arts organisations.

The aims of the project were:

1. to identify constraints on the arts in schools and practical ways of overcoming them;
2. to enable teachers to develop curriculum initiatives in the arts;
3. to document, analyse and disseminate examples of valued practice;
4. to publish curriculum guidelines;
5. to increase public and professional awareness of the roles of the arts in education.

The project was concerned with all of the arts and with the whole 5-16 age range and was organised in partnership with eighteen LEAs in England and Wales. Each authority appointed a full-time co-ordinator to work in consultation with the project's central team, and convened a development group of teachers from primary and secondary schools to plan, carry out and document practical work in schools. The project involved more than five hundred teachers, headteachers, advisers and professional artists and generated practical curriculum initiatives in over two hundred schools.

## The central project team

*Director*
Dr Ken Robinson

*Project Officers*
Gillian Wills (1985-86)
Dave Allen (1985-88)
Jill Henderson (1986-89)
Phil Everitt (1988-89)

*Information Officer*
Mike Cahill (1986-89)

*Administrator*
Andrew Worsdale

*Administrative Officers*
Kathy Bradley (1986-87)
Catrina Edmondson (1987-88)
Helen Bradbear (1988-89)

## Members of the monitoring group

| | |
|---|---|
| John Tomlinson (Chair) | Professor and Director, University of Warwick Institute of Education |
| Glennis Andrews | Deputy Head, Tyldesley County Primary School, Wigan |
| Madhu Anjali | Assistant Education Officer, Berkshire |
| Godfrey Brandt | Senior Education Officer, Arts Council of Great Britain |
| Helen Carter | Professional Officer, National Curriculum Council |
| Robert Fowler | Principal, Central School of Speech and Drama |
| Daphne Gould (from 1988) | Headteacher, Mulberry School for Girls, ILEA and Member, National Curriculum Council |
| Dr David Hargreaves | Chief Inspector, Inner London Education Authority |
| Dr Seamus Hegarty | Deputy Director, National Foundation for Educational Research |
| Pat Martin | Head of Drama, Stratford upon Avon High School, Warwickshire |
| Robin Peverett | Headteacher, Dulwich College Preparatory School, Kent |
| Sue Robertson | Director of Education Programmes, South Bank Centre |
| Julian Watson (to 1986) | Headteacher, Castlecroft Primary School, Wolverhampton |
| Roger Williams (from 1986) | HMI |

(Posts are those held during the lifetime of the project.)

## Project co-ordinators

In its development phase (1985-88), the Arts in Schools project involved partnerships with groups of teachers in eighteen local education authorities. The co-ordinators of these groups were as follows:

BERKSHIRE
Hamish Preston
Veronica Treacher

CLWYD
Mike Evans

DEVON
Shirley Page
Keith Rattray

EAST SUSSEX
Phil Everitt

ESSEX
Colin Humphreys

HAMPSHIRE
Jack Brook

HARROW
Jill Heller

HUMBERSIDE AND LINCOLNSHIRE
Gordon Beastall
Christine Humphrey
Jillian Lewis

ILEA
David Sheppard

KENT
Maggie Anwell

LEICESTERSHIRE
Jim Dutton

NORTHUMBERLAND
Tony Murray
Clive Wright

NORTH YORKSHIRE
Sally Hull
Brian Sellors

OXFORDSHIRE
Michael Knightall
David Menday
Bridie Sullivan

SHROPSHIRE
Janet Bacon
Roger Turner

WEST GLAMORGAN
Margaret Phillips

WIGAN
Glennis Andrews
Dennis Lavelle
Bob Mason

## Teachers and artists

The Arts in Schools project involved more than 300 teachers and artists in practical initiatives in schools. We have drawn on all of their work in preparing these publications. We are particularly grateful to the following whose case studies are used in this book.

| | | |
|---|---|---|
| Chris Bell | Rita Hindocha | Anne-Marie Quinn |
| Janet Bell | Chris Hull | Kevin Renton |
| Alan Benson | Colin Humphreys | Chris Rose |
| Liz Bevis | Linda Jasper | Jan Rule |
| Jackie Binns | Peter Johnson | Ruth Rundle |
| David Blaker | Jacquelyn Jones | Joan Sandison |
| Moya Brewer | Mike Jones | Bisakha Sarker |
| Les Buckingham | Steve Jones | Phil Sargent |
| Tim Cain | Rosie Killick | Christina Shamaris |
| Dennis Carter | Michael Knightall | Anne Shaw |
| Alison Coath | Dennis Lavelle | Judy Shepherd |
| Venita Cook | Gillian Lenton | David Sheppard |
| Kim Cotgrave | Elizabeth Lewis | Jezz Simons |
| Graham Cox | Allan Lindsay | Elaine Smith |
| Richard Crabbe | Ruth Macgregor | Rosalynde Smith |
| Cecilia Darker | Sylvia Mackenzie | Sue Spark |
| Liz Darley | Usha Mahenthira- | Annette Stuart |
| Kay Dowdall | lingam | Jo Tasker |
| Veronica Durkan | Joyce Mallon | Neil Taylor |
| Jenny Foreman | Margaret Marshall | Peter Taylor |
| Jackie Froggatt | Tony Mealings | Sue Taylor |
| David Frost | Kay Miller | Bruce Thomas |
| Jane Gaudin | Geoff Molyneux | Sally Thomas |
| Jackie Goodman | Sarah Monk | John Towson |
| Susan Hackling | Peter Newell | Frankie Tracey |
| Wesley Hall | Christine Nicholson | Hazel Waddup |
| Pauline Hammond | Sandie Pare | Bernadette Walsh |
| Tim Harding | Jyoti Patel | Jonathan Wicks |
| Katherine Harrison | Melanie Peter | Marion Wilkinson |
| Jill Heller | Toos de Peyer | Anne Woolley |
| Steve Herne | Martin Plaster | Gwen Wort |
| Pam Hibbert | Adrian Postle | Lucy Zammit |

# References

Arts in Schools project team (1990a) *The Arts 5-16: A Curriculum Framework,* Oliver & Boyd for the National Curriculum Council.

Arts in Schools project team (1990b) *The Arts 5-16: A Workpack for Teachers,* Oliver & Boyd for the National Curriculum Council.

Calouste Gulbenkian Foundation (1982) *The Arts in Schools: Principles, Practice and Provision,* Gulbenkian Foundation.

DES and Welsh Office (1985) *The Curriculum from 5 to 16* (Curriculum Matters 2), HMSO.

DES and Welsh Office (1987) *National Curriculum: Task Group on Assessment and Testing: A Report,* DES.

DES (1988a) *The Curriculum from 5 to 16* (The Responses to Curriculum Matters 2), HMSO.

DES and Welsh Office (1988b) *English for ages 5-11,* HMSO.

DES and Welsh Office (1988c) *Mathematics for ages 5-16,* HMSO.

DES and Welsh Office (1989a) *English for ages 5-16,* HMSO.

DES and Welsh Office (1989b) *Design and Technology for ages 5-16,* HMSO.

DES and Welsh Office (1989c) *National Curriculum: History Working Group Interim Report,* HMSO.

DES and Welsh Office (1989d) *Records of Achievement. Report of the National Steering Committee,* HMSO.

Warnock, M. (1978) *Special Educational Needs. Report of the Committee of Inquiry into the Education of Handicapped Children and Young Persons* (Command Paper 7212), HMSO.

*1981 Education Act,* Chapter 60, HMSO.

*1988 Education Reform Act,* Chapter 40, HMSO.

# Index